Creative Careers in Photography

Making a Living With or Without a Camera

WITHDRAWN

Michal Heron

ALLWORTH PRESS
NEW YORK

Dedication: To my family

Acknowledgements: My great appreciation goes to the generous professionals who were interviewed for this book. Their experience and advice in their profiles provides an invaluable tool for those starting in photography.

The Allworth Press staff, as usual, performed with extraordinary skill, understanding, and patience. Thanks to Nicole Potter-Talling, Derek Bacchus, Michael Madole, Cynthia Rivelli, Katie Ellison, and Tad Crawford.

Finally, I owe a great debt of gratitude to Cynthia Matthews and Helen Marcus for their insightful contributions to this book and for many years of friendship.

© 2007 Michal Heron

10 09 08 07 06 5 4 3 2 1

Published by Allworth Press
An imprint of Allworth Communications, Inc.
10 East 23rd Street, New York, NY 10010

Cover design by Derek Bacchus
Interior design by Mary Belibasakis
Page composition/typography by Integra Software Services, Pvt., Ltd., Pondicherry, India
Cover photo by Jeff Babitz

ISBN-13: 978-1-58115-469-6
ISBN-10: 1-58115-469-0

Library of Congress Cataloging-in-Publication Data

Heron, Michal.
 Creative careers in photography : making a living with or without a camera / Michal Heron. — 1st ed.
 p. cm. — (Creative careers in photography)
 ISBN-13: 978-1-58115-469-6 (pbk.)
 ISBN-10: 1-58115-469-0 (pbk.)
 1. Photography—Vocational guidance. I. Title.

TR154.H47 2006
770.23—dc22

 2006035276

Printed in Canada

Contents

Preface *vi*

PART I THE WORLD OF PHOTOGRAPHY

1 Understanding the Profession *4*
Being a Photographer—Careers with a Camera • Specialties • Stock •
Digital • Being a Picture Professional: Careers without a Camera

2 Making Choices *12*
How Do I Choose? • Criticism—Can You Handle It? • Lifestyle Choices •
Working Freelance • Working on Staff • Ownership Issues • Power of
Organizations • It's a Business • Understanding the Trends

3 Who Uses Photographs? Buying and Selling *23*
Are You a Photographer or a Seller? • The Other Side of the Desk:
Are You a Client or a Buyer?

PART II THE PHOTOGRAPHER: CAREERS WITH A CAMERA

4 Photography for Publication *34*
Advertising Photographers • Corporate Photography • Editorial • Media/
Publicity • Catalog • Other Specialties in Publication Photography
Profiles with: Stephen Wilkes, Melanie Stetson Freeman, David Seide,
Ron Gould

5 Consumer Photography *59*
Types of Consumer Photography • Weddings • Portraits • The World
of Event Photography • Marketing Consumer Photography
Profiles with: Andy Marcus, Jim Roshan, Joe Slayton

6 Service Photography *78*
Real Estate Documentation • Forensic Photography • College and
University Photography • Medical and Scientific Photography • Museums •
Government
Profiles with: Charlie Walsh & Drew Webb, Carl Leet

7 Fine Art Photography *90*
Styles in Fine Art Photography • W. Eugene Smith Memorial Fund •
Crossover: Can You Do Both? • How to Be a Fine Artist • What Media
to Use • Finding a Gallery • Marketing • Fine Art Photographers
Profiles with: Joyce Tenneson, Karen Amiel

8 Stock Photography *107*
Definition of Stock • Digital Stock • Careers in Stock Photography • How Is Stock Photography Marketed? • Rights-Managed versus Royalty-Free • Portals • The New Economics of Stock • What Is Your Place in Stock? • Getting an Agency to Represent You • Plan for the Long Term • Using a Portal to Market Stock • Marketing Your Own Work
Profiles with: John Kieffer, Jim Pickerell

9 Digital Photography *127*
Speed of Change • Digital versus Film • The Client's View on Digital • Getting A Handle on Workflow • Small Business Digital • The Art of Digital Photography • Imaging Software • Digital Photography Books
Profiles with: Sanjay Kothari, Jessica Oyanagi

PART III PICTURE PROFESSIONALS: CAREERS WITHOUT A CAMERA

10 Buyers, Sellers, and Dealers *140*
Overview of Photography Uses and Users • The World of the Photo Buyer • Who Buys Photographs? • The World of the Photo Seller • Representative/Marketing Coordinator/Creative Management • Stock Photo Agent • Fine Art Galleries and Curators
Profiles with: Angela Gottschalk, Jennifer LaFond, Chrissy McIntyre, Karen Amiel

11 Location and Support Services *167*
Photographer's Assistant • Production • The Crew • Services off the Set
Profiles with: Catherine DeMaria, Sam Willard, Victor Frey

12 Careers in Teaching and Writing about Photography *183*
Being a Photography Educator • Writing about Photography
Profiles with: Chuck Delaney, David Walker

PART IV STARTING A CAREER

13 Education—Traditional and Online *192*
Flexibility • Educational Choices • Evaluating Educational Programs • Workshops as Continuing Education • On-the-Job Training • Education for Picture Professionals • Organizations—Join As a Student • Broaden Your Education
Profiles with: Jeff Wignall, Bryan Peterson

14 Finding Work in Photography *202*
Assisting and Interning • Starting in Freelance • Going for a Staff Job • Running Your Own Business
Profiles with: Maria Lyle, Tracy Mack-Jackson

15 Building Your Business: Overhead, Pricing, and Negotiating *210*
The Economics of Photography • Overhead • Negotiating • Being in Business

16 Marketing *224*
Begin with Design • What's in a Name? • Plan Your Work and Work Your Plan • Marketing Tools • Marketing Consultants • Portfolio • Web Sites • Web Site Design
Profiles with: Maria Piscopo

17 Copyright: What Do We Own? *238*
Copyright Overview • Model Releases and Invasion of Privacy

APPENDIX A: Photography Schools/Degree-Granting Institutions *248*
APPENDIX B: Workshops *251*
APPENDIX C: Organizations *252*
APPENDIX D: Promotion/Source Books *254*
APPENDIX E: Photography Publications *255*
APPENDIX F: Photography Museums *257*
APPENDIX G: Manufacturers *258*

INDEX *259*

Preface

There is an allure, an appeal to photography that defies explanation. It helps us find intimacy with the world; it ties us to places and people in a way that seems almost magical. We are transported by the touch of light on golden fields, stark buildings, or cherished faces present and past.

Historically, in other cultures and other centuries, there was the belief that photography steals your soul—a concept that may not be so farfetched. At the very least, photography borrows it. When we study nineteenth-century photographs of a sod-hut frontier family or a twentieth-century Dorothea Lange portrait of an impoverished Depression-era worker, we feel the power of that soul coming to us across time.

Photography has an addictive affect once it takes hold of you and can influence and enrich a lifetime.

If you love photographs, and want to find a place in the world of photography, where on earth do you start? For those who are drawn to images, photography often becomes a passion. But when trying to choose a career it can become downright dizzying to face the variety and complexity of ways one can work with photographs.

The purpose of this book is to give you a good look at the array of possibilities available in photography. It's a beginning, an opening of doors to what it means to work in photography. Enjoy the information but don't feel stifled or overwhelmed by the choices. Like a meal that offers too many rich foods, it may seem indigestible. Don't worry that the need to choose an immediate path will imprison you.

You may not know right away if what appeals to you now will be satisfying later. As you'll see, many, many, many professionals have started in one part of the photographic world and then moved into another. As one colleague put it: "I've morphed myself into several different photographic specialties." That's not to suggest that one should be a dabbler. Wherever you start in photography, give it your "all." Dive in as if it will be your lifetime work, but comfort yourself with this thought: if your first choice isn't right, other opportunities may present themselves as you develop skill and knowledge of the professions.

Next there is motivation to consider. What is your impetus for wanting to enter the world of photography? Glamour, money, creative satisfaction, travel, learning? Are these incentives realistic or illusory? Is it an inspired calling or merely a pie-in-the-sky fantasy of a cool way to earn a living? The motivations are many and could be misleading. A good first step is to try to analyze your own interest in photography and reasons for wanting to enter the field.

But maybe you don't know enough yet to fully understand why you like photography or why you are considering it as a profession. Perhaps you just have a yearning for some satisfaction that you think photography can provide. That inclination, that keenness for the visual, is essential to success in every aspect of photography. Enthusiasm and determination will carry you through the hard work and difficulties to a place that suits you in the world of photography. Learning more about the field will help you to sort out a daydream from a genuine attraction to being a photographer.

And it's not just working with a camera. Who says you have to be a photographer? Certainly you can pursue that dream. But there are dozens of creative ways to work with photographs that don't require being the person to take them. Many people don't discover the range of fascinating picture jobs aside from being *the* photographer until they've spent a few years knocking their heads against the wall. They finally learn that they prefer *not* to be behind the camera. Leave that pressure to someone else. For example, as a photo editor you get to select from among the great photos available and influence what appears in a publication. Or as a stylist you work on the set as part of a team, in the middle of the creative electricity, but with less of the pressure on your shoulders or gaining the praise or incurring the wrath of the client. Or, as a teacher, you'll see delight in the eyes of a student you have inspired with your love of the medium.

The people working in these other non-photographer careers are often referred to as "picture professionals." The basic division of this book reflects that distinction between working *with* or *without* a camera, but your career doesn't have to be either/or. Lots of people blend a shooting career with one or more of the picture professions—photography is an intricate but marvelously flexible world. Many picture professionals I've known didn't start out with that in mind. They yearned to be

photographers but got sidetracked into something that suits them as well or even better. Or, as in my case, they started out as a picture professional (photo editor) and were inexorably attracted to the pleasures of doing the photography—and jumped into the cold waters of being a freelance photographer.

This book will help you find the area of photography that best matches your dreams as well as your practical goals. It is written in an effort to give as complete an overview as possible of the many ways you can work with and around photography. I have tried to be a clear-eyed guide to these professions, showing the hard realities while still encouraging enthusiasm. No matter what area of the profession appeals to you at this moment, I'd suggest reading all sections of the book to fully understand the almost inextricable relationships between photographers and picture professionals. It will give you a valuable understanding of where everyone fits.

You'll meet some photography professionals in the interview profiles. These interviews with photographers and picture professionals give personal insights into how each has arrived at their place in the photographic world. In reading the interviews you'll see that some fascinating and circuitous routes have led people to wonderful jobs in the industry. Listen to the advice and experience from these successful professionals to see how they resonate with you. There are some vehemently held views to consider, some at opposite poles. I don't agree with everything said by everybody I interviewed. But they are all valid opinions from established professionals. Read and decide. These various points of view will be valuable to weigh as you decide what best fits your idea of a career.

In addition to an explanation of the types of careers, there will be practical approaches to the education, skill requirements, and career paths best suited for each area. Institutions providing photographic education are listed in the appendix, and a list of professional organizations will provide further guidance.

The exploration in chapter 1 of lifestyle choices will help you understand whether you are best suited to being a photographer or a picture professional, to being on staff or having an independent life running your own business.

Some of the text is specific to a particular branch of photography or being a picture professional. Other sections, such as the chapters on copyright and negotiating, have relevance to virtually all segments of the business.

A word about the competitive nature of the business. Some writers on the subject of photography can be discouraging about the prospects because it's difficult to break into photography or, for that matter, any of the arts. When considering writing this book, I thought long and hard about encouraging people toward a career that is so competitive. But I realized that an overview of available career possibilities would be a valuable tool for anyone interested in the field. And I don't think the readers will be naïve enough to assume it's a walk in the park to become a professional. But the key, and a realistically optimistic view, is that every year some

people will leave the profession, providing openings for you. Even as some markets shrink, others evolve. In the consumer market, there has been an upswing in the number of couples having traditional weddings, and families will continue to value having portraits taken of their children just as much as ever. Forensic photographic specialists tell me that more civilians than law enforcement personnel are being hired as forensic photographers than ever before.

Finally, every year there are art directors and editors looking for fresh vision, new energy. So there will always be place for some newcomers, especially if you are a dedicated person with passion and drive—it can happen for you.

The profession of photography is unusual in the extraordinary range of abilities it demands of a practitioner. It combines artistic and technical skills; it requires one to understand the physics of light, the manipulation of color and form; it necessitates the mastery of digital technology to capture, enhance, and deliver images. Plus, you must have physical, organizational, mental, and emotional strengths as well. You must be at once left- and right-brained—in short, you must do it all.

The joy of photography is in its challenge, adventure, and satisfactions. It is a "profession" in that it is a way to earn a living; it is also a profession of our faith in the artistic side of our nature. When you first love photography you are embracing an addiction—to the pleasures of creating with light, to a fascination with seeing, and to the delight of sharing the visualization of your emotions and your intellect. And, it's fun.

The field of photography is broad. The careers listed in this book range from the seemingly mundane to the esoteric. The book is not intended merely as a job listing but as a way to excite your interest and open you to the possibilities of working with photography. If you've come as far as picking up this book then you have the interest. Our purpose here is to help you find a place that suits your skills and your passion. Read on and explore the paths open to you for a rich and rewarding life in photography.

Part I
The World of Photography

The most basic division in the photographic world is between those who create new photographic images, *the photographers*, and those who work with those images after (and sometimes even before) they are created, the *picture professionals*. Following that fundamental difference, this book is divided into the career paths of photography with and without a camera. Many persons who start out being photographers move into ancillary photographic fields and find great satisfaction. Others make the journey from the opposite direction, perhaps starting as a photo researcher or photo editor and ending up shooting pictures full time. Though you can start with the most fundamental choice—do I want to shoot pictures or work with them?—you'll see it's common to blend several aspects of the photographic world to create a satisfying career.

1

Understanding the Profession

The emotional power of a photograph flows to the viewer. Those who work with pictures may experience the same love in viewing photographs that photographers feel in taking them.

This chapter provides an overview of the work of a photographer and of a picture professional and gives some insight into how each of them function.

BEING A PHOTOGRAPHER—CAREERS WITH A CAMERA

A photographer is one who creates new images—but you already knew that. Since this book is concerned with ways to earn a living creating those images, we have to look at the types of uses for the photographs we take. And, more to the point, how do we earn money for making photographs? Often, we earn money by being hired to take specific photographs for a client. This is generally termed *assignment* or *commissioned photography* when we are generating brand new images. *Stock photography* is the term for earning by selling rights to existing photographs, ones you have already taken and own. Significant earnings can come from selling prints of photographs. They might be prints of portraits, weddings, and events—or as fine art gallery prints where signed limited editions can affect their value.

What Are the Pictures Used For? Who Are the Buyers?

Whether the photo income is from assignments, stock photography, or sales of prints, we can break down the purpose of photographs into general, sometimes overlapping, categories based on the type of use of the final photograph. These are *photography for publication, consumer photography, service photography*, and *fine art photography*.

Photography for Publication

These photographs are used by a client and "published" in many ways. Getting work published can be more than being featured in a magazine or newspaper—that's a narrow definition of a publication. Publication as it's used here indicates that the image is made available to the public through many vehicles. Indeed, images may be reproduced in a publication such as a newspaper or magazine article as part of the story, the editorial content. Also, the photograph may be published by being used in an ad for a product in a magazine or in other advertising uses as far-ranging as on a billboard, product package, or point of purchase display. Photographs are also published in brochures or annual reports prepared by a corporation for its stockholders.

Publication photos are generally reproduced for a large audience. Their purpose in being published can be to give information, to advertise a product, or perhaps to highlight the activities of a corporation. Don't forget all the other places we see photographs "published"—in calendars and greeting cards, on posters, mugs, or placemats. Essentially, at the risk of oversimplifying, published can mean simply to reproduce for the public.

The photos themselves may come from being assigned (commissioned) by a client for a specific use or researched from existing photos on file in photo archives. The thread here is that in most cases a client will actually license rights to use a photograph for a specified purpose, not buy a photo outright. This is quite different from consumer photographs, as you'll see. As to licensing rights, you'll learn more about copyright and licensing rights in chapter 17.

Consumer Photography

Consumer photos can be said to exist primarily, or even exclusively, for the use of the consumer who paid for the photograph. The physical print is usually the final product and goes from the photographer directly to the customer. Portraits, wedding photos, or photos of pets or even of a house are among the common types of photographs that have virtually no other life but in an album or on the mantelpiece of the customer. It's rare that these photographs are used for publication. Essentially these photos are for private use.

Most portrait, wedding, and event photographers retain the copyright and certain control over the reproduction of these consumer photos, generally for economic reasons, since billing for additional prints may be a significant source of income. A photographer ordinarily does not put consumer photos to any other use except for display in a Web site or other portfolio promotion of their professional work.

Service Photography

These are photos that serve a particular industry or institution, sometimes for documentation purposes or sales reference. Examples are real estate (pictures of houses

for real estate sales companies), forensic (documenting a crime scene), museum (photographs of paintings or sculptures in a collection), colleges or universities (recording every imaginable aspect of college activity), and government (with all the variety one can imagine). These photos generally do not have further use beyond what the institution needs them for. However, there can be some overlaps, as in museum photographs of artwork that might be used also as publication photography. You could say these photos serve a primarily pragmatic purpose.

Fine Art Photography
This category is self-explanatory. Fine art photographs can be said to exist for their pure artistic merit. Their purpose, depending on the point of view of the photographer, is to be beautiful, meaningful, express an intellectual or emotional concept, or make a graphic statement.

Fine art photography comes in many styles, from an elegant documentary to luminous, quiet landscapes and can include incisive portraits as well as outrageous statements. The fine art photograph is intended to delight the eye, arouse the intellect, or shed light on the human condition. The imagery can be subtle or over the top. The photograph may serve any purpose you, the artist, choose.

The final image is intended for display in galleries or museums, and it showcases photography as an art form. The work is usually available for sale to collectors, whether individuals, galleries, museums, or corporate collections.

The type of artists working in this field is changing. It's not only photographers doing fine art photography but also, with increasing frequency, you'll find that a fine artist trained as a sculptor or painter may create works for which they happened to choose photography as their medium.

SPECIALTIES

There is a further breakdown in these four areas (publication photography, consumer photography, service photography, and fine art photography) where a photographer may carve out a specialty niche.

As a photographer in *publication photography*, you can work as a generalist—one who wears many hats and can offer a client services in such varied areas as editorial, product still life, medical, lifestyle, and portraiture. Or you can develop a specialty in a topic or branch of photography that you find especially appealing or to which you are well suited. Examples of specialties include: architecture, nature, children, travel/destinations, food, fashion, glamour, beauty, sports, aviation, or underwater—and that's the short list! The decision may be forced upon you by the demands of the market in your geographic region, or you may decide to buck the tide and carve out a niche in the specialty of your choice.

As a photographer for the *consumer* market, you may need to be a generalist based in a studio that offers portraits, weddings, school groups, or social events like bar mitzvahs or sweet-sixteen parties. Or you may concentrate just on weddings or solely on schools portraits. This may be decided by your geographic location and a need to provide all services to all customers. Sometimes in a large metro area, specializing is more feasible. But deciding to do, for example, only event photography as opposed to studio portraits isn't limited by geography.

Service photographers generally stick to the special needs of an industry or institution. It's less likely that a photographer of paintings ends up photographing real estate. But it can happen.

The *fine art photographer* will create a specialization defined simply by his or her vision. The style will determine a specialty to some degree. Subject matter can also define a specialty. Some fine art photographers do nothing but close-ups of flowers; others do allegorical photographs of women nudes, while another might shoot haunting vignettes of industrial decay.

Overlap

Many photographers work in more than one area of the profession. Though you may specialize in an area in terms of content, the uses for those types of photos may be many. For example, here's what can happen with the same photo or types of photos:

- A nature specialist might find his photograph of a deer in a snow-covered landscape chewing tree bark used with a scientific journal article on feeding patterns, or the same photo might be published as an illustration in a children's book on the seasons (winter).

- A sports photographer might see a basketball photograph of two players fighting for the ball used in a publication such as a magazine covering the sport, or it might be used for an ad for a financial institution with the tag line "determination."

- A photographer specializing in animal or pet photography might find the same image of a perky pup in a specialty magazine on dog training and in an ad for dog vitamins.

Those were examples of particular images having overlapping uses. The same holds true for photos you will shoot on assignment. You can serve a variety of clients outside your primary assignment area.

- The photographer who runs a consumer portrait studio may also shoot product still lifes for local corporate clients.

- Someone who shoots consumer photography for weddings may also photograph lifestyle stock with a romantic or glamour approach.

- The person who shoots fine art portraits with a unique style might be hired by a client to use that special style on corporate portraits in an annual report or for a head office gallery presentation.

Really, you are limited only by your imagination and determination from expanding on your original specialty.

Types of Photography

☞ Publication photography. Photographs reproduced in magazines, newspapers, advertisements, and company publications, and on products like mugs, calendars, or billboards. Public use.

☞ Consumer photography. Photos such as portraits or wedding photos whose end use is usually reserved to the customer who bought the photos. Private use.

☞ Service photography. Photos that serve a particular industry or institution for sales reference or documentation but have little further use. Practical use.

☞ Fine art photography. Photographs intended for display in galleries or museums to showcase photography as an art form and available for sale to collectors. Aesthetic use.

STOCK

As a major specialty that crosses all of the boundaries, stock photography is given an entire chapter later in this book. This is just an overview. Stock photographs are existing photographs (ones you own) that you can license for use by lots of different clients. These existing stock photographs are distinguished from assignment photos a client hires a photographer to do; i.e., photos yet to be taken.

When drawing the distinction between assignment and stock, particularly in the area of publication photography, it's mostly a matter of how you like to work as well as how you earn money with your photographs. Is it through being hired to shoot new work, by selling existing stock photos, or a combination of both?

Assignment photography can be appealing because it is an opportunity to create new work. It provides the challenge of working with different people and the stimulus of shared ideas as you work to solve visual problems. It also offers the inviting benefit of knowing there will be an immediate financial reward. For the client, commissioning assignments provides the opportunity of fresh, never-before-published work for their project. There can, however, also be a great deal of risk. For the client, the risk comes from having to pay out money without first knowing exactly what the results will be. The photographer, on the other hand, is constantly gambling that all of the preparations, equipment checks, model selection, and lighting design for an assignment will work out as planned, and that the final images will contain the drama and excitement envisioned at the outset.

Stock photography offers an alternative to the pressure of assignments, which some photographers opt to avoid. Instead, stock photography provides the same opportunity to produce exciting work without many of the limitations presented by clients. You are free to create photographs as you see them, without a client's restricting your creativity by nagging about budgetary discipline. This doesn't mean, however, that stock photography allows total and unbridled freedom. You, not a client, will front the expenses of photography, and the financial rewards may not appear for many years. Therefore, to make a go of stock, you must be stricter than any client in controlling time and costs. The risk for you will be in producing photographs that clients will want and pay to use. Many photographers find that a blend of assignment and stock provides a satisfying combination, each complementing and rejuvenating the other.

For now, just understand that whatever your area—publication, consumer, service, or fine art photography—it can yield stock, or you can shoot stock as an adjunct to your main preoccupation. It's an important area of the business that encompasses almost all types of photographic careers—the photographic creators and numerous picture professionals such as photo editors, agents, and stylists.

DIGITAL

Everything is digital. There is no way to place the extraordinary array of skills and talents summed up in the catch-all word "digital" in just one place or in one chapter. Digital permeates every aspects of photography. Photography, regardless of technology, will always be the art and science of allowing light through a lens to create an image. But in terms of the tools used to bring about that transformation of light to image, it's safe to say that photography today is almost completely digital. Even among those still shooting film, most are obliged to scan the film and provide digital files to a client or a stock agency.

That's why "digital" should not be segregated from the mainstream discussion of photography—as it might have been as recently as five years ago. Assume that the use of digital techniques could apply to everything discussed in this book. However, in order to go into greater detail on some of the fine points of digital technology and art, there is a separate chapter devoted to the subject. It is a pivotal area to understand and will be highly significant as you decide on your career path in photography.

Finally, for those who dream of a career as a photographer, being the person creating the images, there are many ways to achieve that goal, and the information in this book will help you judge which area best suits your talents. I hope, too, that you'll give serious consideration to the wonderful and often prestigious possibilities open to you by *not* being the photographer.

BEING A PICTURE PROFESSIONAL: CAREERS WITHOUT A CAMERA

There are lots of exciting, challenging careers working with photographs, many of them prestigious. Don't dismiss the idea of having a career as a picture professional. These careers are not "also-ran" careers. Do not think of them as professions for those who couldn't cut the mustard as shooters. They are integral to the life of a photograph, in seeing it on its way to a useful or sometimes noble purpose downstream from the camera. The image finds its power to affect sensibilities, convey information, or touch hearts only after it leaves the camera (and the loving nest of the photographer). Without the work of all the professionals who help it along the way, a fine image might stay unseen, unheralded, and ineffectively languishing in the photographer's file. In many ways, the other photo professionals raise the bar for the photographer. They present a much-needed cool, critical appraisal of the marketplace or the real-world gallery that helps keep a photographer up to snuff.

In the context of this book, a picture professional is anyone who works with or around photographs other than the person with the camera. Here's a sampling:

- Those who assign a photographer to a shoot (art buyer, photo editor).

- Those who assist a photographer before or during the shoot (location scout, stylist, casting agent).

- Those who assist a photographer during the shoot (photo assistants).

- Those who assist a photographer during the shoot (digital support, such as a digital tech expert downloading and managing files on the set).

- Those who work with the photographs turned in by a photographer after the shoot (digital postproduction, art buyer, photo tech).

- Those who select the photos to be used (art director, photo editor).
- Those who retouch and/or manipulate photographs (production person/ digital artist).
- Those who search photos from stock (photo researcher).
- Those who work in a stock agency (photo agent, photo editor, photo sales rep).
- Those who represent photographers, show the portfolio, negotiate assignment prices and rights (agent or photographer's representative).
- Those who prepare photos for reproduction (digital tech production). Those who write about photography (columnists, critics, authors).
- Those who educate (teachers of photography).
- Those who sell camera, lighting, and computer equipment (retail sales).

And that just scratches the surface.

Interrelationship—Blending a Career

Photographers and others in the photo business rarely work in a vacuum. Professional or commercial photography is almost always collaborative in nature. There is interdependence among the people who carry a photograph from its origin—the light hitting the lens—through to the use on a finished product, whether that is a magazine, a studio portrait, a wedding album, or a forensic report. With few exceptions, such as some aspects of fine art photography, it takes concerted efforts by many professionals to complete a product or service using a photograph.

We like photographs because they are visually interesting, informative, and compelling. The best of them have both intellectual and emotional appeal. The meaning, the feeling, the design, and even the utility of a photograph are pleasing. It's perfectly realistic for a person to build a satisfying career blending a number of bits and pieces of the photo world. What unites people in this world is a passion for the visual as expressed through photography.

C H A P T E R **2**

Making Choices

If you have a clear, unwavering determination to become a specific type of photographer or picture professional, great—then just follow your dream. However, if you have some uncertainty about where you want to be—or can be—in the photographic world, then take a step back and look at the possibilities.

HOW DO I CHOOSE?

First, relax and take heart. Understand that making an initial choice doesn't necessarily confine you forever to one area of the business. Photography is a marvelously flexible world. Once you realize that there are many ways to fashion a career from the jigsaw puzzle pieces in front of you, you will have the courage to move forward. Start by matching yourself in the most practical terms to what seems to be both suited to you and available. Always remember that you may not be closing doors each time you make a choice. It bears repeating that, as a field, photography is wonderfully adaptable. You'll find evidence in the professional profiles later in this book how almost every one of these successful professionals has moved and changed more than once, often working in many areas, sometimes simultaneously.

Abilities

Assess your talent, skills, and education in relationship to each type of career. Take stock of where you are and what you need to get to the next step of photography. As you explore the careers later in the book, you'll get a deeper understanding of what each career offers and demands. You'll see what education and background are advisable. You'll see where you are and what you have to offer—or, what you'll need to get there in terms of education and experience. And at the end of this chapter pay attention to the section on research—so valuable in taking your next steps.

Temperament Evaluation

In order to know where you fit and what style of work will best suit your temperament, examine, and make a realistic appraisal of, your personality. Given an interest in photography, we'll take creativity as a given. Creativity is an outlet available in almost all the jobs as a photographer and picture professional. A level of technical aptitude is necessary for all the professions. But deciding whether to be out front shooting pictures as an independent photographer or working in the various support professionals depends in large part on your temperament. Before you consider how you want to work—freelance or staff—take a hard look at your personality characteristics. It will help you decide your direction. What are your goals and do they fit with your emotional makeup?

Goal: Photographer

Do you want to use photography to inform or move the viewer as a photojournalist or editorial photographer? Do you want to decorate with strong graphic images working with design houses and advertising agencies? Do you want to embellish a product working in a still life studio? Do you want to stay in your home neighborhood building a local business in a portrait studio? Do you want shooting pictures to be the keystone of your career?

Goal: Picture Professional

Do you love photography and working with pictures but don't have the technical interest in equipment and lighting or a taste for the competitive pressure of being a professional photographer? Do you want to add your creative touch to the wardrobe, makeup, or hairstyle of models on a shoot? Do you want to work with photographs, deciding which should be used in a magazine, newspaper, or book? Would you enjoy working as part of a creative team to assign photographs, edit, or select the photos to be used? Might you like to work in a stock agency fostering the creative work of photographers? Or work in a gallery selecting and hanging shows of top creative work? Are you satisfied with a blend of doing your own shooting while working along side other creative professionals? Confirm your leanings by taking a look at yourself. How many of these words (yes, many are synonyms) or phrases fit you:

- Determined
- Ambitious
- Dedicated
- Persevering
- A self-starter
- Takes the initiative

- Passionate
- Adventuresome
- Aggressive

These characteristics are useful for success in every profession and in all modes of work, freelance or staff. But for the freelance photographer you must have them in spades—a double portion.

If, on the other hand, your character could be described primarily as:

- Cautious
- Methodical
- Security-minded
- A team player
- Enjoys interaction with other staff
- Avoids undue pressure

Then you might want to stay away from freelance photography. Find one of the very satisfying professions that don't rely on being on the front lines. You can blend your ability to shoot pictures with many picture professions—and have it both ways. That's the beauty of it.

CRITICISM—CAN YOU HANDLE IT?

As a professional in the photographic world, one thing you must get comfortable with is criticism. This holds true for photographers or picture professionals, whether on staff or freelance. It cuts through the profession. Actually, it's inherent not just in photography but in performance, music, acting, all the arts. In the arts, you are fair game for opinions—informed or otherwise.

As a picture professional you may be open to criticism for choices made in a layout or photos not found in your research. But that is a glancing blow compared to what a photographer faces. Criticism is more hurtful when it goes to the heart of your "art." Also, as the photographer you may be criticized in both economic and artistic terms—a double whammy. You may hear a criticism of your price structure—"What, you want to charge me that?"—which seems to reflect on your worth in the marketplace. But also you can hear criticism of your work itself. Someone might say "I don't like that picture so much," and it's the opening page of your portfolio, your favorite.

You need to separate what somebody thinks of that picture from whether or not you're viable as a professional. It's a balancing act. Your passion to impress and to wow people visually will be what drives you. Of course, you must maintain

confidence in your ability. But in order to progress professionally you need to be responsive to input. You can't have a zero tolerance for criticism in this business. Evaluate all criticism to learn from the part that's valid and discard anything that's unfounded or based on ignorance. Excessive sensitivity confuses the issue. Criticism is valuable to progressing professionally.

If you can learn about criticism, viewing it from the back seat, that may help develop your armor or another layer of thickness to your skin. Being an assistant is one way to view criticism from one step removed. (There'll be many references to the values of being an assistant throughout this book.) Being an assistant allows you to see a professional dealing with criticism. Someone else is in the hot seat, and you can watch and learn in real time. You can see all the stress swirling around the photographer when the client doesn't quite like the creative approach and can learn in relative safety how the photographer handles that moment.

Looking ahead to the various educational possibilities open to you, take note that workshops, (covered in chapter 13 and the appendix) can be wonderful safe havens for learning and growth, not just at the early stages, but throughout a career. There you can get constructive criticism in a protected, supportive atmosphere.

LIFESTYLE CHOICES

Now that you've considered being a photographer versus being a picture professional, it's time to look at the choice between freelance and staff. This is essentially a choice between seeking a staff position with the benefit of relatively regular hours and salary or working freelance and running your own business. How do you earn your living as a photographer or a picture professional? Lifestyle preference and circumstances (such as what jobs are available) will largely determine whether you work on staff as an employee or as an independent businessperson/entrepreneur.

Career path choices:

Photographer	→ Freelance
Photographer	→ Staff
Picture Professional	→ Freelance
Picture Professional	→ Staff

WORKING FREELANCE

Being an independent photographer means you are in business for yourself, whether you work as a sole proprietor (just you) or run a photography studio with a full staff. This lifestyle offers variety, creative challenges, the possibility of a higher income than a staff position—and sometimes fear. Along with the excitement and satisfaction

of running your own operation comes the pressure of maintaining an overhead with an uncertain income flow.

For the picture professional, the choice between staff and freelance isn't so clear cut. Certain professions are designed to be staff positions, such as retail sales, digital lab managers, and so forth. Other picture professionals have a choice, since a photo researcher, stylist, or production manager, among others, could be either on staff or work freelance.

A word about words. The term "freelance" is widely used to describe the independent photographer and is just as widely misunderstood, even by photographers themselves. The dictionary meaning is clear but narrow: "someone who works in a profession, selling work or services by the hour, day, or project rather than working on a regular salary basis for one employer." The word is often misused and is sometimes understood to have an unprofessional connotation of a rather casual commitment to a profession—"Oh, you're a freelancer, how nice, you can work when you feel like it. . . ."—while to others it is a merely a euphemism for being out of work. Freelance can also conjure a romantic but unrealistic image of a footloose photojournalist, camera bags swinging while boarding the last helicopter out of today's trouble spot.

What is clear, no matter the terminology, is that as a freelancer you will have flexible but long hours (running your own business means you are never finished), with interesting jobs, but lots of pressure and competition. You'll deal with the feast or famine syndrome: one month is so busy you can't breathe—but the next month the phone never rings. Imagine the cash flow dilemma it can cause. On the positive side, you have tremendous variety and space to grow artistically. If you are successful, there's a good measure of respect and status from both clients and peers. It's a great life, but only for the stalwart. It helps if you are driven and obsessive—and enjoy change.

WORKING ON STAFF

Staff jobs are available for both photographers and picture professionals. Obviously, some positions are by their nature staff jobs, such as a sales associate for a retail camera store or a rep for a photo equipment company, or working as an educator or a gallery manager.

Staff photographers are employed by companies as varied as newspapers, book publishers, or medical audiovisual producers, as well as by institutions ranging from museums and universities to governmental agencies—actually, whenever an institution has a large enough volume of work to keep a photographer busy you may find one or more staff photographers. Catalog studios are more likely to

use staff photographers because of the relatively large volume they turn out. (Catalogs were one of the first outlets to use of digital photography before it became widespread.)

Staff jobs tend to pay a relatively modest salary but usually offer the security of regular income, benefits, access to expensive equipment without the overhead of maintaining it, and an opportunity to gain practical experience in a variety of photographic areas. Staff jobs can also provide continuity, often offering the photographer the opportunity to work with the same people or on the same types of projects, and sometimes even to become a specialist in one field. I've had several photographers tell me it was great "earn while you learn" experience. They had the opportunity to experiment, use a level of equipment they couldn't afford because they had access to company owned equipment. Also, they got the chance to experiment with new lighting styles without the danger of disappointing a client. A staff employer sometimes encourages experimentation in a way a freelance client would not. The client assigning a freelance project expects the photographer to have enough experience to bring a variety of creative styles to a project. Others argue that being on staff may stifle creativity a bit. They say it can make you complacent and not open to creative experimentation. It all depends on the individual. (Maria Lyle's profile in chapter 14 presents a strong argument for doing a stint on staff before setting out on your own.)

The availability of staff photography jobs swells and recedes with the economic tide. Times change. In a lean economy when budgets are tight there is a tendency in some corporations to bring work in-house to a staff photographer. At that moment, freelancers are viewed as too expensive. When times are flush, corporations may spend the money to find new creativity by searching out freelancers with a fresh vision. It's a hard knock and a source of frustration for the staff person who is bypassed for the big creative jobs.

OWNERSHIP ISSUES

As a photographer, the ownership of your photographs is a central issue dominating your choice of a career as a freelancer or a staff photographer.

Freelance photographers, if they've had the good sense not to sign away their rights in a work-for-hire contract (see chapter 17), will own the copyright and be in a position to license rights to these photographs for many years to come or to bequeath them to their heirs. In addition to the economic benefit of ownership is control over your creative output. This can be a key deciding factor in your choice of lifestyle.

Staff photographers generally do not own the copyright to the photographs they take on the job. If they are employees, the company owns the image, the copyright,

and all rights to what is done with the image. You'll see in chapter 15 that "work for hire" is an aspect of the law that can determine who owns the copyright. In most cases, if you are employed, the images you create are "works made for hire" and belong to the company. Of course that doesn't apply to photographs you take on the weekend, on vacation, or on freelance jobs, for that matter—photos taken any time you aren't under the supervision and control of your company. Rights to those photographs belong to you just as to the freelance photographer.

Research

As early as possible, when you first have a glimmer of an idea that you hope to work in the photographic world, start two things simultaneously: get trained in photography, including full digital skills, and do research into the kind of internships, assistance positions, and jobs that are possible. Note that training in photography is extremely valuable for picture professionals just as it is for those who want to become photographers.

One caveat: there is almost never enough emphasis on business training in photography schools. In later chapters we have given you a start on the business of photography. But if the course structure in your school doesn't include business, you may have to do some digging beyond what it offers. Add the trade publications to your reading list. Most importantly, try to attend the seminars and presentations of various photography organizations (see the information in the appendix).

POWER OF ORGANIZATIONS

In many photography books, information about photographic organizations is tucked in the back in an appendix with barely a mention of the extraordinary force these groups have in the field.

It is critically important to become familiar with the range of organizations in the photographic field that could be of benefit to you. A few times when I have touted the value of joining a photographic organization I have heard this response: "I'm not a joiner," or "Why should I give them my time and money?" Shortsighted doesn't begin to describe that attitude.

These organizations have one overriding concern and that is improving the professional lives of their members. The power of what a large group can do has been seen over the years in strides in copyright and business practices. In addition, these organizations share technical information and provide arenas in which to meet the top people in the field. You can benefit from attending meetings or seminars open to the public even before you are eligible to join.

STAFF JOB		FREELANCE BUSINESS		TEMPERAMENT AND SKILLS NEEDED
Satisfactions	Frustrations	Satisfactions	Frustrations	
	No ownership of photos taken on job.	Ownership of copyright; ability to license rights		
Job security, income guaranteed.	Limited freedom to do other photography.	Independence, freedom to choose.	Uncertain work flow; feast or famine.	Fervor, passion.
Benefits paid.			Must pay health and other insurance.	Accepting of the inevitable.
Predictable, limited hours; paid vacation.	Must work a full week; No flexibility.	Flexible hours.	Long hours; work seven days; never finished.	Dedication.
Salary, steady income.	Salary, limited income	Potential for higher earnings.	Cash flow unpredictable; slow payments from clients.	Nerves of steel.
	Sometimes work is merely routine.	Potential for very interesting jobs		Find creativity in all projects.
Equipment provided.			Equipment must be purchased.	Sense of control over tools of trade.
Work with others, satisfactions of "team effort."			Alone; out front; take both blame and praise.	Independent spirit.
Somewhat less pressure.			Pressure burnout.	Drive.
Respect/status from peers.		Respect/status from peers		
Less anxiety/insecurity.			Vulnerability to client criticism.	Self-confidence.
No overhead.			Considerable overhead.	Business acumen.
Less competitive nature.			Severe competition.	Initiative, perseverance.
	Moderate budget and deadline pressure.		Severe budget and deadline pressure.	Nerves of steel, logistical ability.
	Paperwork.		Paperwork.	Tolerance of mundane details.

These gatherings provide places to meet and to learn—ideal for networking. You can sometimes make connections, find mentors, or learn inside information on business practices. Don't wait until you are established in your career before joining. Now is when it can be most beneficial. Later, when you have enough experience, you can "give back" to the profession by volunteering to work on various committees for your chosen organization. The value of the camaraderie and information gained is incalculable. Most of the organizations have chapters across the country, so unless you are in an extremely remote area you will find chapter meetings within a reasonable distance.

Many of the organizations publish magazines for members, maintain online discussion groups, sometimes provide discounts on equipment, travel services, insurance, digital services—and hold educational seminars. Some professionals are members of more than one organization depending on the area of special interest. There is great power in these groups. Tap into it for yourself. Go to this book's appendix for full contact information for organizations such as the American Society of Media Photographers (ASMP), Advertising Photographers of America (APA), The American Society of Picture Professionals (ASPP), Professional Photographers of America, Inc. (PPA), National Press Photographers Association (NPPA), North American Nature Photography Association (NANPA), and Picture Archive Council of America (PACA).

Over the years I have been a member of ASMP, ASPP, and APA. Having served on the National Board of ASMP and on various committees, I've made it clear that I'm a true believer in the value of professional organizations. Even if you don't share my fervor, what have you got to lose? You can learn from committed professionals ready and willing to share their insights. It's a gift. Don't turn it down.

To get an idea of the rationale behind these organizations, go to the Web site of ASMP to see its mission statement. Once you see the ASMP stated goals, echoed by other photographic organizations, how can you as a professional turn aside from such valuable advocacy?

IT'S A BUSINESS

No matter how dearly you cling to the notion that when you take photographs you are a creative person making art, you must face certain realities and make a choice. Either you pursue that art regardless of whether you can earn a living with it, or you find a way to be creative *and* support yourself. Some picture professionals actually make that choice by working, say, as a stylist to earn a living but reserving their remaining time and energy to create photographic art. This way they are involved in the photographic world, making a valuable contribution on the set, but also able to make art with their personal photography.

But for the rest of the photographers looking to earn and be creative, it is critical to convey the sense that photography is a business, and photographers are businesspeople. Business isn't a dirty word. It can be an honorable exchange of goods and services. The words used reflect the way photographers think of themselves; the sooner photographers recognize that in addition to being creative people they are also businesspeople, the more likely it will be that success and contentment will follow. Read the profile on Sam Willard in chapter 11. He has some valuable insights into the value of treating the profession as a business.

UNDERSTANDING THE TRENDS

Perhaps the simplest way to described today's climate—and style—in photography is to say that there are no holds barred. Virtually any style, past or present, may be used by clients in advertising, corporate, or editorial to sell a product or illustrate an article. Stock photos are increasingly less generic and more edgy. Portrait studios have to be able to provide the full range of moods, from classic Rembrandt lighting to high-key, diaphanous lighting. Even people in service photography are seeing the changes, as real estate photos of houses for sale must have "curb appeal" as never before. Wedding and event photographers are having digital assistants print photos during the reception so guests can take home a print of the wedding couple or a mouse pad of the bar mitzvah boy as they leave. Innovation is the key.

Looking at History

Twenty years ago the casual perception was that to be an editorial photographer, all you needed was "a couple of Nikons and some fast film." At that time, advertising photography was characterized as a business of large productions in a studio with set constructions, legions of assistants, models, and stylists, using huge amounts of strobe light, most often with a medium- or large-format camera. Then things came full circle. Now editorial shoots often require sophisticated lighting, models, and sometimes sets. They may be more production/illustration than traditional documentary/editorial. At the same time, the advertising pendulum has swung; the style sometimes mimics the gritty look of real life instead of polished perfection that once was standard. The scenes and models are still carefully controlled and of high production quality, but shot with a grainy look and staged to create the feel of spontaneity. Fine art photography and photographers have been added to the mix, as advertising clients search for the novel, provocative, or the simply elegant photograph to sell their message. Stylistic distinctions are now blurred and technical demands are equally high for all areas of photography. Photographs are an increasingly powerful method of selling goods and services because the world has become so focused on visual media.

At this stage in the game, your options are wide open. Because digital is the standard, there are infinite ways of manipulating your images so you can create exactly what you want to create. Technology has essentially upped the ante on photographers so that on location there are no longer just the usual cameras and lighting, but also laptops, digital wiring to shoot tethered, and an assistant who can manage digital files in addition to all the equipment.

Picture professionals are generally exempt from needing a heavy investment in photographic equipment, but the technical training is still essential. Everyone from newspaper photo editors receiving overseas transmissions to their ftp site to photo researchers creating digital light boxes while searching stock agency files must be skilled in handling digital images.

The good news is that the manipulation available through Photoshop and the vistas opened by the digital revolution are exciting beyond anything imagined in the past twenty years. Images and imagination are still valued, but the tools at our disposal are more flexible and powerful than ever before. And you, just entering the field, have a leg up on some of the veterans. In most cases, you have worked with digital technology since your earliest school years, so these tools are as natural to you as breathing. Embrace the new advancements as you embrace photography.

Who Uses Photographs?
Buying and Selling

Who needs photographs? Who uses photographs? Who are the clients? What are the markets? The framework for your future business as a photographer rests on an understanding of the world of photo buyers. Or, if you want to be in the buying end of photography, then knowing what a photographer requires to provide you with the right image is crucial. It will help them solve your visual needs. In this chapter you'll see how the careers of photographer and photo buyer interrelate, and you'll realize the benefits of each understanding the other.

Throughout this book we will speak casually of photo *buyers*. In some areas of photography, photographs are literally bought, and the physical property of a print changes hands—obvious examples being family portraits or pictures documenting a wedding. However, in other parts of the profession, such as photography for publication, photographs may be assigned or selected from stock, and certain rights to use those photographs are licensed for use. In that case, a client will pay to reproduce a photograph with specific limitations as to the usage, such as where, how, how big, and for how long or how many times (such as, editorial, magazine, inside, half page, 500,000 circulation). When you're ready for more specific information on licensing and negotiating, take a look at chapters 15 and chapter 17.

ARE YOU A PHOTOGRAPHER OR A SELLER?

Both, because you "photograph" and you "sell" services, rights, or prints. The buyers—the people who use photographs—are your clients, your customers, and your market; they are integral to your life in photography. Get to know about buyers and their needs as early as you can, even while you are still in school. Or, if you are making a

career change, try to learn about the buyer's side before you jump into your new profession. Photography schools do their best to train you artistically and technically. Most of them give you the tools to research the information you need and to learn about the business as well. They rarely teach the business skills needed to protect you from the chill wind of the real world or from the bumps and bruises of dealing with buyers. So it's up to you to learn more about the commercial aspects of photography. Don't forget my impassioned speech in chapter 2 about becoming involved in organizations where you can learn from working professionals. Most importantly, do not wait until you think you are "ready" to learn about photo buyers and marketing. This is a vital aspect of your career that must be integrated with your preparation for photography.

Remember, if your goal is to earn a living, you don't work without buyers. They are the yin to your yang, the bread to your butter and your sine qua non—do forgive me but I want to make the point, if clumsily, that the buyer is more than a person who pays you for work. A buyer is part of the equation determining how your photographs are seen and used. Yes, used. In your photography, unless you confine yourself to fine art, then your photographs will take on a life of their own when they are sent, in the hands of the buyer, out into the world. Instead of your piece of "art," they become someone else's "useful image." They serve a useful purpose. They can illustrate an article, decorate a mouse pad, or advertise a product. The more you understand that the buyer has a utilitarian need, a practical problem to solve, and that the solution will be finding the right, most suitable photographic image for the purpose, the closer you will have moved toward being a professional. Sometimes the buyer wants stunning aesthetic quality, and you are happy to oblige with your finest photographic work. Unfortunately, another client may need such a simple, standard photographic approach that you find it mundane. Don't give that request short shrift.

Embrace the buyers' needs. Understand what they want to accomplish. Do everything you can to help them. It will get you involved in the business of photography faster than anything else.

It's a Business

So, on the photographer side, the first step toward comprehending the business world is by appreciating the concerns of a client or customer. That is the linchpin to success. Too often at the outset in the first blush of creative satisfaction, your joy in photography, the delight in skills attained and artistic accomplishment may overwhelm all other considerations. In other words, it becomes all about you. It's all about the photograph and the client may be forgotten. Naturally, you must have pride in your work, with both self-esteem and strength enough to consider entering this competitive profession. But don't let pride turn into arrogance. Whether real, or feigned as protective coloration, arrogance has been the downfall of many a talented photographer.

If you are going to be in business, you must comprehend that a good part of your satisfaction can come from giving buyers what they want. Not from sacrificing your artistic or business integrity—but from being a member of the creative team. Seeing your photograph well used, in a dignified setting, nicely reproduced on good paper stock, is a thrill. And hopefully there are only a few of the down sides, such as when your image is awkwardly cropped or printed on crummy paper. With luck and good choices in your marketing, you should find many more of the former. Let's not forget about money. If you continually give buyers what they need—and make the experience pleasant—they'll come back to hire you again.

THE OTHER SIDE OF THE DESK: ARE YOU A CLIENT OR THE BUYER?

Both. If you are a person involved in assigning photographs to be taken, or if you are finding or selecting photographs for usage, then you are a buyer. In this capacity you may be an art director for an advertising agency assigning a photographer to shoot for a new ad campaign; or a photo researcher combing the archives on a stock agency Web site for a specific image; or, possibly, a director of the media center at a university acting as a buyer/client when directing a staff photographer's work. Even a customer arranging for pictures to be taken at a daughter's sweet-sixteen party, though less likely to be reading this book, is still a photo buyer. You may be paying for the prints or simply licensing usage, but it's all part of being a buyer.

As a person (client/buyer) assigning photography, the more you know about the basic technical aspects of photography, especially the most current digital work flow, the better you will be able to choose the right photographer or photograph. It will help you judge the experience and capabilities of photographers under consideration. Further, it will enhance your ability to explain your needs once you've decided on the photographer for your project.

What Is Important to You as a Buyer?

- Quality. The esthetic quality of the photograph should center on image style and interpretation. In addition, technical quality must include the photographer's skills in transmission and proper postproduction digital abilities.

- Communication ability. Does the photographer pay attention? Do they understand what I need as opposed to what they'd like to do? Can they explain their alternative approach convincingly? Do they ask insightful questions?

- Intelligence and creativity. Does the photographer perceive beyond the obvious. Do they suggest interesting alternatives?

- Schedule. Can they get it done on time? Do they have a track record of meeting deadlines?

- Budget. Are they realistic in agreeing to your price? Or will they need to cut corners in order to come in under budget?

- Personality of the photographer. Are they easy to work with? Do they seem cooperative? How well will they work with others on the project.

Communication

Since your goal, as a buyer, is to get the photograph you need or want, be as open as possible with your photographer or photo source, such as stock agent. Try not to withhold information about your project as if you are hiding heirloom jewelry from a potential sneak thief. Don't act as if it's a security breach to let a photographer see a layout. It's amazing to photographers how often clients hold the cards so close to their vest that photographers can't get an inkling of what they really want. The more the photographer knows about, say, the importance of the image to your brochure or the way a photograph is to be used in your ad campaign, the better they can use their talents to please you. By allowing the photographer to understand the purpose of the photograph, he or she can better execute what you want. It's that simple. Tell them what you want so they can do it. You're paying for the photography, so get your money's worth—let them help you. Once you've explained what you need, be open to alternatives. If a photographer seems to resist your creative approach for a project, it may not be willfulness on his part. Find out if he has an interesting variation to suggest before throwing cold water on the idea. If it's not workable explain why. "That could be a nice effect, but not for this campaign—our biggest competitor did something similar so we have to differentiate our approach." If you've chosen the right photographer, then you'll learn that working together yields the best results.

Occasionally it seems as if a photo buyer doesn't answer a photographer's questions about photo needs because she just doesn't know the answer. That might indicate that she is new to the field and fearful of exposing her ignorance to the photographer. She might also be uneasy going back to her boss with questions. If you, as the buyer, find yourself in such a pickle, not knowing how to answer a photographer's question, honesty (as always) works best. You can certainly phrase it in a dignified way without making yourself appear a simpleton. "Listen, I'm fairly new to this department, so tell me what you need to know and I'll see who can get us the information."

I've had clients act as if I'm being a nuisance by asking too many questions. As a photographer, you might feel intimidated when a client clams up in the face of

your probing. But a photographer needs information, and not asking questions could be much worse since later the results might not measure up to the client's expectations. The client may have assumed the photographer would use one style presented in the portfolio, and the photographer assumed a different one was requested. But when you're not certain, the old adage holds true: if you must assume, assume you're wrong.

If you're the photographer encountering a close-mouthed or insecure client, use the "As I'm sure you know..." routine, which I've always found works best when you are sure they really don't know. Try saying: "As I'm sure you know, I can give you a better job if I understand how the photograph will be used. What shape is it in the layout? Horizontal or vertical?" If, because they don't know, they respond: "Never mind, just give us both." You can counter with "I would be perfectly willing to shoot both vertical and horizontal versions; however, *as I'm sure you know*, since we have limited time with the CEO, we'll get better coverage if we know which shape is definitely being used."

Whether you are the buyer or the photographer, don't be afraid to take the lead either in explaining what you want or in asking what's needed. Develop your own style to elicit information or give clear instructions—all depending on your side of the desk.

Do you have time for a story? I once had a really good client who was extremely vague about what she wanted. She was experienced, bright, and knowledgeable but somehow didn't spell out exactly how she wanted something done. When starting a project, I listened as carefully as I could to her presentation, gleaning every available detail. At this stage most clients would offer specific terms of how they wanted the photography handled—or ask for your opinion. But when she left the details murky, I had to jump in. I simply outlined how I'd approach the job and waited for a response. For example, I might summarize: "Well, if you need to have these stories done in the next four weeks and you want them shot on location, I'll need someone out in New Mexico to research and get permission to work with a Native American tribe within a one hour drive of Albuquerque. I have a contact at the museum there who can do some the ground-work for us on getting access—their fee will probably be about $1,000. Once we get permission, we'll concentrate on the family scenes you need as first priority. You'd like three families with a final yield of five to six photos for each. Close-ups of the crafts and other cultural artifacts will be second priority but will be optional if we have time. I'll shoot color in RAW format. In addition to my regular assistant, I'll get a second assistant to handle the digital post-production so we'll be ready with final files by X date." Usually after a small pause I'd finish up: "Shall I budget for this approach and put it in a memo—or do you see it a different way?"

Inevitably she'd respond by agreeing to the plan or by making alterations to what I'd proposed. At the end we were both clear what she was authorizing me to do. But it was the only method I found for pinning her down. It turned out that a mutual friend also shot for this same client. He occasionally shared with me that he had a difficult time getting guidance, never quite understood what this client wanted, and felt at a loss by the vague instructions. They never really hit it off and after a few assignments the relationship dwindled. What's the moral? Just two things: use your own style to communicate with every type of buyer. And don't be intimidated out of getting the information you need.

Delicate Relationships

Despite your best efforts, the balance between buyer and seller is sometimes precarious and can slip down to the less pleasant aspects of life. Adversarial relationships, intimidation, and breaches in ethics can bring grief to work that should be productive and rewarding. An ability to recognize and deal with these pitfalls is fundamental to a healthy professional life.

Intimidation

Learn that not everyone will like you or your work. There will always be moments of disappointment when your favorite work is not well received. But suck it up. Sometimes you may receive valid criticism that can help you improve, if you're not done in by self-pity. But you may run into a shabby person who is gratuitously unpleasant about your work. Understand that if such people find the need to express a demeaning attitude, then they are the ones who are being petty, not you. Confidence should come from the belief that you are doing the best and most honorable job you can and not be measured merely by fame and fortune.

So, if you can stay strong and reasonably confident, you will be able to observe behavior rather than succumb to it. You may learn to recognize when someone is playing intimidation games with you. The person who tries to intimidate may be just taking your measure.

Another anecdote. One time, early in my career, I was surprised by my own ability to handle an intimidation game. It was an event I've never forgotten. A small graphics company had assigned me to do photographs for one of its publisher client's books. As we gathered for a meeting in the conference room, I found myself left alone with the creative VP, while the art director and photo editor were rounding up missing layouts and schedules. The VP, whom I'd only met once, was rustling through some papers, glanced up at me and said, "Well, look here, I've got a proposal from a photographer on the West Coast who'd like to work on our books—and at 30 percent less than you've quoted. What do you think of that?" In an instant of

inspiration and without skipping a beat, I said: "Well if his work is good, if he can organize the shoot, get the location scouts, cast the models, do creative lighting, and provide detailed captioning while meeting the deadline—then he's a bargain and you should use him." He gave me a nod with a slight smile and went back to his papers. I supposed he might have been thinking. "OK, not bad."

Somehow, at that moment of confrontation, my brain had processed several facts: one, that you can't compete with everybody, and two, that if this person were as good and as cheap as it appeared, he'd be hired no matter what I said. So it was pointless to be threatened or act defensive. And, trust me, I can be as fearful as the next person. Only later in the day did I have the realization that it been a test. The VP had been baiting me to see my response. The upshot was that I went on to do assignments for his firm over a twenty-year period, including working on location with him on an assignment in Spain.

Ethics

There are a surprising number of times in a photographic career, whether as a photographer or picture professional, that sticky situations arise—things that may lead you to question the propriety or the ethics of a circumstance. Most people maintain honorable dealings, but from time to time you may be forced to make tough decisions or perhaps learn some unpleasant attitudes about people you had respected.

One day a colleague and I were commiserating about the trials and tribulations of assignment work when I explained how, on a recent shoot, I'd made a dumb mistake. I had shot a scene not noticing a problem with the model's feet—she had taken her shoes off to be comfortable while we were adjusting lighting. Neither my assistant nor I had noticed it. It was back in the days of film. When I saw the film I called the model back and re-shot the scene without charging the client. I felt it was my mistake. We could have asked the client to crop out the bare feet but that would have been an awkward photograph. So I re-shot. My friend said: "I wouldn't go to all that trouble just to save them an awkward cropping, not at their fees—they're not paying enough for that kind of effort." That attitude seemed shocking. To consider holding back and not giving your best for a client struck me as holding yourself cheaply.

As a photographer, it seems self-evident that you would do your absolute best on every assignment you accept. If you agree to the terms then you abide by them. If the fees are too low to do your best work, then don't take the job. If you do your best then you are a professional. If you take a low-fee job but hold back, giving less than your best, you become a hack. And the word gets around. Plus, I don't think you'll respect yourself as much.

Getting Along

Helping out will often be helping yourself. Call it karma or simply the pragmatic view that "what goes around comes around." At the very least, it's enlightened self-interest. When you come to the aid of clients, above and beyond what's expected, you'll often get a payback later when they remember that you were generous and helpful.

Early in my career, I specialized in photographing Native Americans. I got a lot of requests for my stock photography of various tribes. One day I got a call from a photo researcher who hadn't quite done his homework. He was asking for a color photograph of a topic that didn't exist in color. Rather than giving him a "Sorry, I don't have that," the polite but cool brush off, I suggested a collection at the American Museum of Natural History that might have the images he wanted. I explained that he was asking for Native American religious ceremony that had ended in the early twentieth century, so none of us living photographers could have covered the event in color photographs. But the museum would have historical black-and-white imagery. In addition to getting what he needed, he was able to show his editor the flaw in the article. He came back to me often over the years for photos I did have in my stock files.

The photographer and client do not have to be adversaries, any more than photographers are necessarily battling with each other. Sharing information, helping make someone else's job easier, is the right thing to do and may have residual benefits. It's quite common for photographers to refer clients to another photographer if they are busy or are not expert in a particular specialty. I've had clients come back to me after I have sent them to my competitors when it was best for their project. For example, I can shoot still lifes, but they are not my area of expertise. Sometimes a large assignment will require about 5 percent of studio shots. I will handle those and deliver good, usable images along with the people on location I generally do. But if a client calls and wants highly specialized still-life work, I am likely to send them to a colleague.

Friendship

It was a happy awakening in my first year of being a freelance photographer to learn that buyers are often people well worth knowing. Starting out it may seem as if the gulf between photographer and buyer is too great, since the buyers hold your economic life in their hands.

But friendship between photographer and client is a pleasant byproduct of the process. Virtually every photographer you meet has developed some friendships with clients. Certainly, if you travel and work together on assignments, that will create a bond (or in rarer cases an antipathy) in short order. Photographers and

clients manage to continue engaging in complex negotiations over jobs, yet are still able to enjoy the common interests, openness, and professionalism on both sides that allows these relationships to flourish.

A look at the list of types of photos and buyers in chapter 10 will be a help in deciding where your talents and skills may be best appreciated and also most saleable, since earning money doing what you love is usually the goal.

As in so many places in this book, I urge you to look at the great information on photography organization Web sites. ASMP, PPA, and APA have sections with tips on what to look for in a photographer or how to choose a photographer.

Part II
The Photographer: Careers with a Camera

In Part II, you'll get a look at the many ways you can earn a living taking pictures. In chapters 4 through 7 we'll look at the individual types of photography careers that use a camera. Also, there are chapters on stock photography (8) and digital (9), which overlap all of the photographic specialties.

Photography for Publication

Some people associate the word "photographer" with the stuff of movies, wherein the glamour and excitement of the profession is portrayed: a photojournalist under fire, a photographer on location in the Caribbean on assignment on a high-fashion shoot, or an advertising photographer in a mammoth studio surrounded by expensive equipment, elaborate sets, assistants, stylists, and handlers of all sorts. They may think also of someone at work in a photo studio creating elegant portraits, or photographers shooting at weddings, making beauty out of a chaotic day. What they don't see is what it takes getting to that stage of the profession.

As you saw in chapter 1, photographs for publication are photographs used by a client and "published" in many ways, including books, magazine, newspapers, advertising, or corporate use, as well as on products. The photos themselves may come from being assigned by a client for a specific use or found on file in stock photo archives.

The basic distinction within photography for publication is by market, that is, the type of usage. Each of these markets, though all are for publication, differ in the fee level paid, the skills and style needed, and the amount of competition.

The markets in photography for publication are:

- Advertising

- Corporate

- Editorial

- Media/Audiovisual

- Specialties

- Catalog

ADVERTISING PHOTOGRAPHERS

The following comments from *PDN* (*Photo District News*), a leading trade journal for professional photographers, are an excellent summary of advertising photography: "Over recent years, advertising was opened up to include a wider range of styles and techniques that let the handiwork and the humor of the photographer shine through. Slick ads were out, soft-sell was in, and new, more emotive and experimental styles of photography were showing up in national ads.

The following comments are from a recent edition of PDN. "Advertising photography can represent both good advertising and good photography. The best will balance the sensibility and self-expression of the photographer with the demands of the client, the agency, and the marketplace."

Photographers working in the advertising market may be generalists, handling a variety of types of photography, or they may specialize in one area. In a large metro area you may do well with a specialty, though in a small-market region being able to do everything will open doors to more work. For a good idea of the variety of photos needed by advertisers, just consult the ads that bombard you with messages everywhere you turn. It's easy to do the research. Make a clip file of the topics and styles you find. Advertising clients may need photographs of everything from lifestyle photos of people, whether glamorous singles or a young family at the beach, to a close-up of a computer chip.

Advertising photographers may work on location around the country (or the world) or in a controlled studio setting—or both. Some of the major areas in advertising photography follow.

Lifestyle

Photography of people in daily activity, almost always looking deliriously happy—with their spouse, children, beer, diamonds, watch, golf clubs, or insurance coverage—is just a sampling what you are already familiar with in advertising photography. Elaborate scenes are shot as exteriors on location or there can be interiors on a created set or a real interior location. These photographs have what is called "big production value," meaning that every detail is perfected and usually with a large budget to help carry it off. Generally the common denominator is the need for a staff of professionals (stylists, assistants, set builders, etc.) to pull it off. Management of all the services needed is a key to the success of an advertising photographer.

Still Life/Product

Primarily this work is done in the studio, though there are occasions, depending on the product, when still life is done on location. Making the product look good

is the bottom line in this kind of photography—style is the only difference. Certain clients want a simple approach, using clean, straightforward lighting, to use in a catalog or an ad in a trade magazine. But if the product is a high-ticket (or high-profit) item to appear in a national ad campaign, such as perfume or jewelry, then the style of the still life photography will probably be more sophisticated. Controlled, evocative lighting may be called for with expertise in handling reflections on high-gloss surfaces. A meticulous, patient personality suits this type of photography. (And sometimes a taste for loud music to fill all those concentrated hours in the studio!)

Fashion and Beauty

Though fashion can be considered a key part of advertising photography, it is really a specialty of its own, since fashion is also a component of editorial content in many magazines from *Vogue, Elle*, and *GQ* to the *New York Times Magazine*. Creativity is important in every specialty but in fashion the constant search for a new look ratchets up the creativity quotient a few notches. Whether yet another brand of jeans or the super-glam garment is being photographed, fashion photography makes use of every conceivable location, from industrial tunnels with glowering models to golden fields with winsome lasses in blowing skirts.

The approach to fashion photography changes, if not weekly, then monthly. Recently the "Style" section in the *New York Times Magazine* featured a spread on rock climbers in all their wrinkled and natural funkiness wearing such designers as Yves Saint Laurent, Burberry Prorsum, and Louis Vuitton. Change is everything in fashion. It is even more demanding than other specialties, but to the person with a taste for being on the edge and, of course, great style sense, it's a dream job much sought after in photography.

The person suited to this field might be described as having a wildly self-confident imagination.

Beauty photography works hand in hand with fashion, but there are the obvious differences in product lines for makeup, shampoo, teeth whiteners, and other "personal" products. In addition to needing the skills of a makeup artist, lighting is a key to this work. Knowing how to make skin tone look perfect or get rid of the under-eye shadows on a model who was out too late the night before is required. Though much can be fixed in Photoshop, most clients still want the image to be close to perfect when it gets to them.

Advertising photography makes use of many other specialties. Virtually all of them—from food photography to nature to automotive specialties—overlap with the other styles and markets of photography.

CORPORATE PHOTOGRAPHY

A corporation promotes itself in many ways. Virtually every company has some form of corporate promotion using photography. The most well known are the annual reports sent to stockholders. But corporations produce all manner of publications such as brochures, in-house newsletter publications, and event photography. Various audiovisual shows, in PowerPoint format, are done for employees. Presentation displays in lobbies or at the company's booth at a trade show will feature photography. Even calendars and posters are produced. Often appearing as a subtle form of advertising or promotion, the effect of these corporate promotions is to make the company known to its stockholders and the general public in a favorable light. The results of corporate photography aren't so obvious or seen as often by the public as are advertising or editorial photography, which are part of our everyday lives. Annual reports used to require photographers being sent around the world to photograph (and make look stunning) industrial installations and the activities of the company. That is still done, though, due to shrinking budgets, it's not so prevalent as it once was. Some corporations now rely on stock from their own files, with assignment photography filling in the gaps when coverage is needed of a new building, installation, or facility, or corporate executive.

The corporate photographer may need to travel and coordinate photography in many locations in a short time period. It's an asset to have logistical skills in addition to creative vision and technical excellence. Speed—without any loss of quality—is what's demanded by corporate clients who want a photographer who can go in, set up fast, and get out with a great shot.

Executive portraits are a mainstay in corporate photography, so expertise with lighting people is required. Corporate portraits are usually of busy executives who don't know (or care) what kind of time is needed to make a professional portrait. Negotiating with their underlings to get access to the location (CEO's office or factory floor) ahead of time to fine-tune lighting and shoot samples with a stand-in is a step forward. The rub is that you seldom are given as much time with the executive as you think you need for an excellent portrait.

A bent for architectural photography wouldn't hurt, as buildings are often featured in corporate photography. (You'll find more about architectural photography in the professional profile of David Seide in chapter 4.)

EDITORIAL

The specialties under the heading "editorial photography" include photojournalism (magazine and newspaper), documentary, book publishing, and travel; and much of the photography on the Web would be considered editorial. In many ways, editorial

photography is simply storytelling. (There is an on-line group for editorial photographers that is a useful source of information, *www.editorialphotography.com*, which you can join for a modest fee.)

Photojournalism

For photojournalists, working for newspapers or magazines means telling news or human interest stories and doing so with as complete a lack of bias as possible. Certainly the choice of what to photograph as well as the lens, angle, or style used can impart the photographer's point of view to a picture. Some argue that it is not possible to be truly unbiased. But most top-rank photojournalists do their best to tell the story visually with as much authenticity as they can. And certainly digital manipulation of an image to distort its contents is strictly off limits for any photojournalist.

Documentary

Considered by some the purest form of editorial photography, documentary photography purports to reflect, with true impartiality, the lives of a group of people or a region. In many ways it's a style or an approach to photography as much as a specialty. Documentary and photojournalism are close cousins; often it may be only the subject matter that distinguishes them and the depth of the coverage. A documentary photographer may do an in-depth photographic study of a topic that isn't necessarily newsworthy, though the style used might be similar to a photojournalist's.

Books

Book publishers are big users of photography—though the casual observer may think of uses limited only to photographs in coffee-table books or on book covers. In terms of category, photographs on book covers are actually considered an advertising usage. But interior photography, whether in trade books (for the general public) or textbooks, is considered editorial. (The reason to care about this distinction, as you'll see in the copyright chapter 17, is that editorial and advertising have different requirements regarding the need for model releases.)

The style used in books can vary from a decorative, graphic style for part openers or chapter openers to the traditional informational-style photo in the main section of a book.

Books, especially textbooks, are a hidden market for assignment photography. Imagine all the language textbooks in French, Spanish, and German that need illustrations. Some of these photos will come from travel stock, but specific,

detailed scenarios not available in stock are often assigned. Imagine further all the textbooks used by your siblings, friends, or kids such as health, science, math, or social studies textbooks for elementary school, high school, and college. Or look at upper-level career instructional books like emergency medical technician textbooks or the automotive career textbooks—and many, many other disciplines. All use photographs. Since many involve detailed, step-by-step photos of procedures, the work is not the most glamorous. But you meet interesting people in these fields and can find ways to make what seems mundane into a clear and interesting photograph.

To get an idea of the range of content in these textbooks, and to see if it fits your photographic abilities, go to the Web sites for some of the textbook publishers: Addison Wesley Longman; HarperCollins Publishers; McGraw-Hill; Prentice Hall; Addison Wesley & Benjamin Cummings; Allyn & Bacon/Longman; Ginn & Company Ltd.; Harcourt Brace; Holt, Rinehart and Winston; Jones and Barlett Publishers; Scott Foresman-Addison Wesley; Silver Burdett Ginn and search their catalogs for book titles. Go to bookstores that carry textbooks, such as university bookstores or used bookstores, for a look at the amount of photography being used. Assume that if you are looking at used books, the next edition will be more up to date in its style of photography. Encyclopedias also use mountains of photographs but they are most often researched from stock.

Travel Photography

A travel photo reflects the photographer's impression of a people, a city, or a destination for the purpose of giving information, as well as the mood and style of that place. Travel photography tends to portray people and places in a flattering light to make them appealing to prospective tourists. Travel photography may be the single most desirable, most fantasized career goal in photography. It's sad to have to tell you that it is glutted with competition (as if you hadn't figured that out). Many people who don't need to earn a living at photography enjoy themselves (and write off their equipment) recording their travels. Your competitors include the quintessential "I'm a brain surgeon but do photography on the weekends" types. There are professional travel photographers making a good living. But the competition is fierce. So if this area interests you, you should realize that a special zeal will be necessary, along with your talent, to break into the market. And if you are driven to try it, consult the excellent book by Susan McCartney, *How to Shoot Great Travel Photos* (Allworth Press).

Travel is a mixed bag in terms of its usage category. It can be editorial when published as editorial content in an outlet such as a magazine, book, or newspaper. But it will be in the advertising category when used as an ad for a location, whether

a resort or an entire country. This becomes relevant when you are pricing work, since advertising commands higher fees than editorial. It also has consequences regarding your need for model releases of people in the photographs.

Fee Structure

Editorial has historically been the lowest paying area of publication photography. Since fees are lower for book and magazine photographers, the editorial photographer must get satisfaction from the value of the photography to offset a lower income.

Ethics in Editorial Photography

Editorial photography generally has a favored place in terms of what you can show in a photograph without needing a model release from the people shown in the photograph. The guiding principle is the "public interest." If the photograph is providing newsworthy and educational information, it is in the public interest and is allowed, in certain circumstances, without a release. I've heard this principle also described as "the people's right to know," which protects editorial usage.

It's a complex subject but one that is important to understand. See chapter 17 for more on privacy issues and model releases.

Editorial photography appears to photographers (like me) to have a privileged position under the law, because editorial usage is usually governed by the freedom of speech section under the First Amendment to the Constitution (there will be a fuller discussion of legal questions relating to photography in chapter 17), but there are even more stringent ethical standards applied to editorial photography than to other areas. Since the advent of digital technology and its ability to make inaccuracy look believable, a debate has been ongoing as to the need for disclosure of any manipulation. One of the earliest digital controversies involved a *National Geographic* magazine cover in 1982. In order to accommodate a cover design two Egyptian pyramids were "moved." The original photograph had been horizontal, but in order to fit on a vertical cover the two pyramids were pushed together electronically. The editor called it "a retroactive repositioning of the photographer," further commenting that the photographer "might" have taken that photo from another position. This sparked a debate about the authenticity of photography in the digital age. Arguments were made that it was acceptable to make changes if the photograph was labeled as "Manipulated."

For a fascinating look at the subject, see Fred Ritchin's *In Our Own Image: The Coming Revolution in Photography* (Aperture, 1990), particularly pages 15 and 16. The book is an intriguing exploration of the ethics of digital manipulation; and although the technology has changed drastically since the book was written, it holds

as much truth today as when it was written. In the words of the author, a leading writer on photography and ethics, "One person's enhancement is another person's alteration."

MEDIA/PUBLICITY

The heading "media" or "audiovisual" often includes publicity and public relations photography. Public relations (PR) is designed to promote a person, place, company, or organization, chiefly through favorable media coverage. Many entities use photographs in the public-relations materials they put out to the media. Instead of buying advertising space, a PR person will try to create interest by providing ready-made news items.

One mainstay of PR photography is the "grip-and-grin" photo. Often taken at social events or trade shows, the photographer will be hired to "cover" an event by taking pleasing pictures of invited guests and celebrities doing their meeting and greeting. These photos, along with a press release, are sent to the media. Many photographers who have gone on to careers in advertising and editorial started by doing PR assignments. It's tiring work; you are in a hectic situation snapping photos of virtually everyone in attendance.

In this field it helps if you are quick and personable. The fees can be on the low end, but if you do a good job and make contacts with company representatives at a PR shoot you might segue into more lucrative corporate work.

CATALOG

Catalog photography takes a high-volume, sometimes assembly-line approach to photographing products, clothes, tools, and virtually anything that is made and distributed—and needs a catalog to show to retailers and consumers the wares available. In some cases there are high-end catalog jobs, which allow for some fine-tuning of the photographs. Other catalog shoots can be a grueling cranking out of mountains of images per day.

In order to control the environment and increase the yield of photos per day, catalog shoots are often done in a studio. In the case of fashion, or high-end wares (Williams Sonoma comes to mind), an outdoor setting enhances the product. Think of all the catalogs you see online or in print. Each item had to be photographed. It's an area where still life photographers often start out. Assisting a catalog photographer is trial by fire but a quick way to learn.

OTHER SPECIALTIES IN PUBLICATION PHOTOGRAPHY

There are many other specialties that are subject matter oriented rather than being clearly in one market or another. These cross over from advertising to editorial, and to a lesser degree to corporate and other markets. Some photographers have developed an interest in certain topics and developed knowledge, a specialist's fount of information—and usually a passion for the topic. Quite a few photographers will have a small group of related specialties such as animals, wildlife, and nature. Or you can be as specific as simply dog portraits (Google that to see how many there are!). Medical and scientific are natural partners. If you have an area that interests you or a sport that you know intimately, these might lead to a satisfying specialty. A former sports photographer I know, Harold Roth, began in New York shooting a broad base of sports topics, which led to having his own company photographing race horses in Lexington, KY. He's published several books and has photographers on staff to cover the races around the country. Your passion can lead you down unsuspected paths:

- Agriculture
- Animals
- Architecture
- Automotive
- Babies & children (editorial for magazines such as *Parents* or advertising for Gerber Foods
- Celebrities
- Horseracing
- Medical
- Nature/natural history
- Scientific
- Sports
- Theatrical/dance/movie stills/TV stills
- Underwater/marine

Finally, in all the areas of photography, the brains you bring to the party will affect your success. Don't forget how important your intellectual interests are as a part of what you have to offer a client. If you can demonstrate talent and skills with intelligence and organizational ability, you've given the client more reasons to hire you.

PROFESSIONAL PROFILE
NAME: Stephen Wilkes
PROFESSION: photographer, fine artist
WEB SITE: *www.stephenwilkes.com*
HOME BASE: Connecticut

Stephen Wilkes on location.

© *Alex Herring*

What is your attitude toward advertising photography?

I appreciate, understand, and really like advertising. When I do commercial work, even though it's a function of how I earn my living, I'm always fascinated in creating pictures that push the medium and in the end really get the client noticed. That's what our job is. It's beyond making pretty pictures. I always keep the questions in mind: how's this going to run, where's this going to run, who is the audience.

How has digital affected the creative and approval process in advertising photography?

In many ways when we shot film, you got it or you didn't. Either way you were finished. The film went to the lab and you were done. Now, I'm in it longer. I can't walk away. Because of the computer, it's easy to create a multitude of versions of the same image. Digital allows for so many changes, sometimes you look at the finished picture and say, was that my image?

Do you take a stand when you disagree on creative grounds?

You have to. So much of what I'm doing commercially is about a "look" that they wanted based on seeing my work. You need the guts to hold to your creative idea. Since you are only as good as your last job, you have to protect yourself from letting the client dilute the concept. Also, you are protecting your client from getting something mediocre when they ask for too many changes. It's like if you serve up something and they start deciding that they're going to change the plate on you, then you take the food away. In the end your real job is to make sure your client doesn't sabotage their brand by making bad decisions.

What's your advice to students?

I tell young photographers how important sticking by their guns can be to their success. Dealing with clients over the years I learned that being meek and indecisive about your creative direction really hurts you in the end.

What I found is that they hire you based on your reputation and on what you've executed previously. And that's what they really want.

How do you approach an advertising project? Do you get involved in understanding the business of your clients?

I look at it in terms of solving a problem. First I listen to the concept, trying to understand all sides of the issues before trying to execute it. I want to know their business model, how do they work, how do people see them? The more information I have, the deeper and broader perspective I get on the client. That enables me to communicate my points creatively in a much clearer way. If you really understand their business—where their fears are, where their anxiety lies, and where their aspirations are—you're in a better position to debate your points on the creativity issues. They hire you to make an "aspirational," beautiful picture that people are going to want to stare at, which, hopefully, will create a brand for them through which they can redefine their business and the way people see them. For some clients their goal is to make a statement, which, in a sense, reinvents what they do and the way the general public sees that particular brand.

Do you consider educating the client an important part of the process?

When they hire you as the photographer, you're immediately in an educational position. You must raise their awareness of what you are trying to do and why you are going in a particular creative direction.

I start that process from the moment I pick up the phone, through all stages of production to the moment I have created the final picture. And it doesn't stop there. Actually I will go to the client and try to sell the specific image I think is best, explaining why I think it's better than the others from the shoot or even better than what we envisioned at the outset. That's the process. You have to engage everyone. This business doesn't work unless it is collaborative. They come to me, giving me the freedom to bring my ideas, my passion, and my craft to their problem. But in the end, if I don't really understand the dynamics of how they need to use the picture, I'm really not solving their problem—I'm just giving them another problem.

The trick is to establish boundaries that encourage and protect your creativity but at the same time encourage collaboration. It's a delicate balance.

How important is communication in dealing with clients?

I emphasize this to young people all the time. You can have talent, but without people skills and an understanding of the art of communication you won't go far. The key is being able to pick up a phone or walk into a meeting and "sell"—to

articulate your ideas in a way that communicates to these people on their level, speaking in their language not just in arty phrases.

Do you continue to change your style? In your work for Arizona Jeans over several years, there is a distinct change in the look; how did that come about?

I think of it as an evolution in style. My early work was very romantic in feeling. But photography has gone through a major shift in palette and in the way people see the world. It's the celebration of the banal to a certain degree. In the early days I'd photograph only at sunrise or sunset—I'd never think of taking a picture at midday. Then I became more interested in that other palette, in that time of day when most people didn't shoot. I wanted to start looking at the light at midday.

As we developed the campaigns for Arizona Jeans it was at a time when everyone in fashion photography was doing dark, moody stuff. So we decided to do something completely the opposite. What we came up with was a really stark white, glaring light that we got from shooting in the desert at White Sands. The subject matter, the whiteness, the glare, gave an element of surprise—it all worked. It worked for them and for me. I was charged about it because I had never done anything quite like that

Which came first, advertising or fine arts?

My attitude with my work these days is that every time somebody thinks they've got me pegged, think again—'cause I'm going to change. It's not that I'm changing just for the sake of it. I'm always evolving. I try to go with my artistic instincts and those are driven, at the core, by my personal work. That's where the center is. I allow my personal work to expose people to that side of me, where my soul is. In many instances it drives my commercial assignments. People see things in my personal work and say, "That's so cool, could you try something like that for this project?" I didn't wake up one morning saying this is what I'll do. It's been a long process to figure how to bridge the gap. With each assignment I might show something different I was experimenting with in my personal work and they'd respond by asking if we could try it for them.

As far as the separation between personal and commercial, my personal work comes from inside of me, it's part of my soul, and I can't have somebody telling me what is in my soul. But, that said, my core is artistically such that I can't go out and shoot something in commercial work where I don't look for the inspiration. I still have the same artistic process even though it's a commercial project. Also, I have learned how to deal with all the other distracting elements on a shoot so as not to contaminate that part of my brain.

What was your style in your early career?

I began as a photojournalist, but quite soon—when they cropped a photo and I realized I didn't like that—I understood that I was losing control. My frame was sacred and I didn't want people screwing with it. My experience with photojournalism taught me to catch the moment. So I became a street photographer, studying body language, people, gesture, nuance—all those subtleties that define an emotion or a moment in the spontaneity of life. I developed my skills. I call what great street photographers do "taking pictures." But I realized that, commercially, people don't pay you to take pictures, they pay you to "make" pictures.

Then I had to learn how to make pictures. In the process, I referenced my interior visual library, all those images that I had picked up doing street photography. It's the language of the "moment" and of the "gesture." By understanding it, that language became a fluid part of my vocabulary. It allowed me to direct the moment. I'm something of a hybrid. My core is recognizing things as they happen and at the same time, taking elements and making pictures. It's been an exciting journey to be able to work on that level.

It's spontaneity from control.

My goal is to push further, to do something no one's ever done. We're all problem solvers, but I try to raise the bar by doing things more complicated or different. I like to challenge myself like not wanting to revisit the same lighting I did before. I try to put myself in situations where I'm not that comfortable. It's only through taking risks that you grow.

What is your background?

I was lucky to find my passion very early in life. I started at age thirteen and by fifteen had a business doing weddings in the neighborhood. While still in college I went to see Jay Maisel looking for assisting work. Jay said, "Kid, you're too good to be an assistant." I replied "But I'm too poor not to assist." So he took me under his wing as an associate.

I took a course at Parsons with *Life* photographer Bob Adelman who told me, "If you really want to make your pictures speak to people, you'd better understand the world we live in." It was the greatest advice I've ever had. He said I should get a good liberal arts education and recommended including business courses because photographers are lousy business people. I did a dual major in marketing and communication at the Newhouse School at Syracuse. Once out of college I did very aggressive marketing based on what I had learned in college. I created the brand "Stephen Wilkes." My plan was to sell myself like Coca Cola. I had saved all my bar mitzvah money and used it to buy my first ad in the *Black Book*.

Your use of light and color are unique and seem prevalent in both your fine art and commercial work, is this intentional or intuitive?

Light and color are important to me. I'm very much attuned to the way light affects color and how you perceive color. I tend to ask myself how can I optimize that color or what's the optimum way of looking at that color? For example, spring green in front light looks one way but spring green with backlighting is what I consider the optimum way of looking at spring green. The essence of that color is most intensely perceived with back lighting.

When you've seen a certain color in nature in a number of different ways—being in open shade, to being in dappled light, to being in direct frontal light or in back light—the way you perceive that color changes. I'm very sensitive to the way light and colors interact. I tell students to take the time to revisit a scene at different times of the day to see the changes light makes on color. The color might be deeper more dramatic than on your first visit. Your initial instincts might not be best.

How does your work in the book **Ellis Island: Ghosts of Freedom** *reflect your interest in light and color?*

In my Ellis Island work people are captivated by the color of what I've captured, but the subtext, I believe, is in the light. The history and the energy in these rooms come from the light. And that energy is really human energy. This was a first for me, that I could go into an empty room and make people feel something in a picture other than an empty room.

I wanted to "get" you, the viewer, get your attention through the incredible, striking color, the unbelievable patina and texture on the walls. Those are all the surface things that draw you to a place but the subtext is about the humanity in these rooms. That's really what I want you to feel. I have to bring you in some way and I'm hoping you'll stay long enough to feel what I really want you to feel. That's the reward for the viewer. That's become an element in most of my photography is that I layer things. I'm not just interested in surface, I want to go deeper, and I want you to feel some kind of an emotional charge when you look at a picture and to get the story. The greatest thing about a single photograph is that we have the ability to tell a whole story in one image. That's the great power of our medium.

How has digital affected your work?

Now, after thirty years, I still find it exciting to realize what an incredible visual language we have at our command. And digital has changed it. With digital it's like having a larger thesaurus to work from. Digital gives me elements of information, renders detail in a way to highlight the shadows, for example, that

allows me to have more information in a picture, hence another level of story to convey. Something else now has significance that was before insignificant.

That's an exciting thing to an artist; digital is another tool, a tool that's enabling me to expand my story, what I'm seeing and feeling in a particular scene. I love that ability and the technology will be going even further.

You shot the Ellis Island work with film. Shooting it today would you consider digital?

Yes, I would. I used 4x5 transparency for the Ellis Island work because at that time a digital back would only allow a 30 second exposure. My exposures on film were several minutes long, sometimes 15-minute exposures. I took some risks with reciprocity, but I knew I wanted transparency film because the project was all about depth and detail. Transparency film has such depth—the greatest black, the richest saturation—and that's what you have in lead paint. In those rooms, the feeling comes from the depth of the color in the lead paint. Without the richness of transparency, you would not get the same physical or emotional response to the color. My goal is to see how closely I can recreate my personal experience for you. I want you to feel what I felt when I stood in those rooms—to experience the paint, the light, the color, but, most of all, the humanity.

As improvements are made in digital, aside from the image capture and storage issues, we'll have much larger file sizes. For my own personal work, I'm excited by the larger file sizes becoming available because it gives me more information to tell my story. I'll be able to render details in a photograph that I might not be able to render now. It's going to come closer and closer visually to having an experience of what we see with our own eyes on a daily basis.

Eventually photographs will be able to be rendered where they actually look like you're looking through windows as opposed to looking at flat art. Photography is going to start to reflect the gamut and range of information that you see with your own eye.

PROFESSIONAL PROFILE

NAME: Melanie Stetson Freeman

PROFESSION: Senior Staff Photographer, the *Christian Science Monitor*

WEB SITE: *www.csmonitor.com*

HOME BASE: Boston, MA

What do you value most about your life in photojournalism?

I value the honor of being let into people's lives and seeing some of their most private moments. I have seen a baby born—been there when a new being came into the world!

The other moment I always remember is from when I was doing a story following a little Russian orphan as she was being adopted. I was there in Moscow when she met her adoptive parents for the first time. I was so moved. It sometimes surprises me how much people trust you and let you into your lives.

Melanie Stetson Freeman (center) at the Democratic National Convention.

That's one of the greatest parts of this job.

Do you have a philosophical approach to your work?

I do, though I wasn't always aware of it. I find the world can be pretty overwhelming and it can tend to be very sad, so my approach is to look for signs of hope, to look for the enduring qualities of goodness and dignity in people. I look for answers to the terrible situations that happen. That's how I myself survive, and that's what I try to say in my work—that there's always hope, there's always an answer, even in the midst of horrors.

What is your background in photography?

As a child I loved animals and didn't have any of my own, so I got a camera and photographed every dog in my neighborhood with an old Polaroid. I did all the dogs, and then all the cats. Finally I worked my way up to people. In high school I took a photo class, and after majoring in history in college, I went to graduate school at the University of Missouri, Columbia, for a masters of journalism with a major in photojournalism.

What's the best thing about your profession?

I've learned that one person can make a difference in the world, and most of them are people you've never heard of. But they're the people I remember best and who move me the most, people

Djakarta, Indonesia. Students celebrating a change in government.

who have figured out a way to change the world with a great idea and the means to carry it through.

The other thing I love is that sometimes you get to witness history. Once, when Daniel Ortega was the president of Nicaragua, they held a democratic election. He lost the election, which was a huge surprise to him. They couldn't even find him until three or four in the morning to get him to concede. Listening to his unprepared speech, watching a communist fall in an election and then speak about it impromptu but eloquently, I realized this is how history happens: it gets made as we go along.

Sometimes it's just fun to be right in the thick of what everybody in the country is concerned about such as the political conventions. Ordinarily I don't like the conventions because I don't like "pack" journalism. But sometimes it's nice, it's kind of fun to be there in person with all your colleagues. Mostly we work alone, which I prefer.

In my job I get to travel and see other cultures. It's different every day and goes from one extreme to the other—some days I'm stuck at my desk working on the computer, other days I'm out meeting people and seeing things I would never see in my day-to-day life. People let me into their homes and their lives, which is a marvelous way to understand how differently people live.

What's the worst thing about your work?

Well, the simple annoying facts of this life are that the equipment is very heavy and the schedule is unpredictable. When you're traveling, you're always dragging the camera equipment and computer on and off the plane. And schedule-wise, you're always on call, so it's hard to buy tickets to a concert or make personal plans.

But the truly hardest thing about the job is the pressure that you feel. Unlike a writer who can call back later and get a quote or have somebody tell them what happened, we photojournalists have to be there for it when it's happening. You have to get it, be there and click the shutter at the right moment; you can't go back to improve it. The stress is very great. Most of us agree that when we're first starting out on an assignment that's the time of worst stress and pressure. Then as you have more images under your belt you calm down and enjoy it more. Compared to writers, the pressures on us are more short-lived and immediate but very intense. For a writer the pressure is spread out over a longer period of time.

Do you shoot digital or film?

Naturally, I started with film. When I came to the newspaper, the *Monitor* was full black-and-white, which I loved. We had a great lab technician who would run our film and make most of the prints. We'd often go on four- or five-week

trips overseas and come back needing to make 200 or more prints, so we helped with the printing. In those days you had to ship the film home, which was terrifying, though I never had anything lost.

Then in January of 1989, the *Monitor* went full color throughout the newspaper—from one extreme to another. They made us shoot slides. That was a dark day for me because I didn't like color much at the time. It was a huge shift to go overnight from black and white to full color but now I like it.

We had to learn to shoot slides and even do some of the color processing. Mixing all those chemicals wasn't fun. But we learned to handle how accurate the exposures had to be with slide film, so when digital came out we were prepared since it also demands dead-on exposures.

At first digital was such bad quality that I used it as little as possible. But as the equipment improved I switched over completely. The transition was tough. My first digital camera cost $13,000 and the quality was awful, simply awful. At that time they decided to send me to Kuwait to cover a possible reinvasion by the Iraqis, the start of another war. I had to rent the camera, teach myself how to use it, and learn how to transmit the files all at one time—it was very stressful. I hated the camera. The color was terrible, it was pixilated, there was noise, and the file sizes were small, with just devastating quality. The good news was that the UN brokered a peace deal and there was no war.

Next I had to take this $13,000 camera to Indonesia. I only had the one camera body when I was used to shooting with two, one with a long lens on it and the other with a wide angle. I was constantly switching lenses—it was horrible. I went to Jakarta to cover the student demonstrators demanding a change in government. Once the government fell, the students got into this big, shallow pool where they were celebrating. I remember debating if I should get in the pool with this camera because it was so expensive, but to get the photos I had to, and luckily I didn't fall down. Now I love digital because the quality is there—I can't imagine shooting any other way.

Do you specialize in any type of photojournalism?
Since we have a small staff at the *Monitor*, we are pretty much generalists and do a wide variety of subjects. I may do everything from fashion to food and still life, but mostly it's portraiture and human interest documentary photo stories, which are my favorite. We do a lot of environmental portraits, where the background tells you something about the person. It can be quite evocative if done right.

What do you see as the future direction in photojournalism?
There will continue to be contraction in print since newspapers are cutting back on staff in general, but the Web is expanding. I was brought up with the print

version of newspapers, so for me to feel fulfilled I still like to see my work in print. But there's a lot you can do on the Web that is very powerful. You can do slideshows with sound that are very exciting. There are going to be all kinds of ways to use our work on the Web. Lots of photojournalists are doing both still and video—that's something that's developing.

What type of background would you advise for newcomers in the field?

Internships are very important. It's all about building a portfolio—having a variety of situations, lighting situations, and topics like sports, news, features, and portraits, to show the range of what you can do.

For me it worked well to complete a graduate degree in journalism, because I'm kind of shy. But plenty of people can do it on their own without the degree in journalism—it depends on your temperament.

For me graduate school was the best. Taking courses is a great way to get into the field because you get a foundation that builds confidence and gives you contacts. You learn how to apply for jobs and you meet people that can help you. During that time the *Picture of the Year Contest* was being held at Missouri, so I had the opportunity to watch the judging of the contest, seeing all the great professional work being done. Looking at other people's work is a great way to learn.

But nothing beats an internship, shooting every day, getting multiple assignments in a day. You start with internships at small papers and work your way up. I went from the University of Missouri paper, to the *Simi Valley Enterprise*, to Jacksonville, Florida, and then I was at the *San Jose Mercury News* for a month. Some of it's just timing. I walked into the photo director's office at the *Mercury News* the moment they needed someone to help with daily assignments because one of their photographers was on a special project for a month. So I got to work at a very prestigious newspaper with some of the best shooters in the country.

The great thing about internships is being around other professionals, watching and learning from working with the photo editors. They expect a lot from you. I got some internships because I was in the photojournalism program.

My first full time job was at the *Orange County Register* in Santa Ana, CA, on the weekly section. They were hiring young people out of college but our editors were older, experienced, and gave us great guidance. I began doing some freelance for the *Christian Science Monitor* in Boston. Then I was very fortunate to find an opening at the *Monitor*, where I've been now for twenty years.

How does someone find work?

The first way is to follow up on contacts you've made as an intern and by showing a strong portfolio. NPPA [National Press Photographers Association,

www.nppa.org] is a really important organization for someone to join. They have job listings, which you have to be a member to access. It's a great source. Also they have contests you can enter and an informative magazine. I joined in graduate school; they have a student membership category. Primarily, try to find people, photo editors or photographers, who are good mentors. Then simply shoot as much as you can.

PROFESSIONAL PROFILE
NAME: David Seide
PROFESSION: architectural photographer
WEB SITE: *www.definedspace.com*
HOME BASE: Chicago, Illinois

How did you get started in photography?

While growing up in western New York, I discovered photography in high school and kept it as part of my life through college. While in my junior year at the University of Illinois studying architecture, I was accepted into the study abroad program in Versailles, France. While on a sketching trip to Germany, I found myself using my camera more and more each day. It was during this time the thought occurred to me that being an architectural photographer would be an exciting job, although I didn't act on that idea until many years later.

Armed with a degree in architecture, I worked in an engineering firm for a brief stint before deciding that it just wasn't for me. Then, after fumbling around for a couple years and with the cajoling of family and friends I answered an ad for a large Rochester-based portrait studio and was offered the job. Over the next several years, I worked with a few different portrait, group, and event photography studios across the country. While I enjoyed this, I needed more of a challenge and began to investigate the field of commercial photography. I began freelance assisting with several photographers

David Seide on rooftop, Chicago.

© David Seide

Crown Fountain at Millenium Park, Chicago.

in different fields. As soon as I worked with an architectural photographer, my earlier notion of a creative and fulfilling career in photography was re-ignited

I assisted Jim Cavanaugh, an established architectural photographer, who along the way has become a wonderful mentor. We worked together for several years. He introduced me to the American Society of Media Photographers [ASMP] and the business side of the profession. As I became more knowledgeable and developed my own style, I knew it was time to move on from assisting. And that meant I was most likely going to have to leave western New York for a larger, more prosperous area of the country.

I decided to move to Chicago, a city rich in architectural history and one where I knew a few of my former classmates from my U of I days were now registered, practicing architects who might potentially have some assignments for me. To get a feel for the market, I continued freelance assisting for about a year, and then became a full-time associate photographer at a now defunct local architectural-photography studio. I knew that my next step would put me out on my own. And here we are.

What was your approach as you started your own studio?

My very first step was coming up with a studio name. I wanted something that said architectural photography without literally saying it. "Defined Space" made it to the short list because it's easy to remember and the initials are the same as my name.

Starting out, I knew my initial objective was to simply get assignments. I needed to make enough to pay the bills. So with portfolio in hand, I pounded the proverbial pavement. I networked like a madman, attending every industry event I could find. I joined the American Institute of Architects (AIA) as an associate, became a member of the Chicago Architecture Foundation (CAF), and attended lectures at the Graham Foundation (an institution dedicated to nurture and enrich an informed and creative public dialogue concerning architecture and the built environment) and the Art Institute of Chicago. After doing a fair amount of research to find decision-makers within each firm, I made a lot

of qualified cold calls. I would introduce myself and Defined Space, explaining my background, objectives, and mission so as to set myself apart from the pack. I tried not to be shy about asking for large jobs and leaned on my ASMP peers to guide me through some uncharted business territory. While I was aggressively seeking new clients, I think people not only liked what they saw in my portfolio, but also took most notice of my energy and high regard for the profession of architecture.

Now, five years later, I've photographed more than a hundred assignments and I'm on much sturdier financial ground. I've been able to switch from survival mode to pursuing potential clients whose work I admire or find intriguing. I truly enjoy collaborating with designers and architects, but, as I look ahead, I plan to allow time for taking on some self-assigned projects. As an artist, this will allow me to experiment, push myself to try new things, and follow my instincts while continuing to develop my vision.

What type of clients do you work with?

Architectural firms, interior designers, lighting designers, landscape architects, engineers, commercial real estate companies, even product manufacturers. I still get a "high" by working directly with a good designer. It brings me back to the days in college, spent in studio when we would discuss theory and concepts.

How have you turned your love of architecture into assignment work?

When I first moved to Chicago, many friends asked me if I had a favorite view of the skyline, and if so, had I photographed it. Many of them were interested in buying a print to hang in their office or home.

For the next few months, when my assignment schedule allowed, I'd go out in search of skyline views. At that time the Adler Planetarium had just finished undergoing an addition. Without talking to the designer, it was obvious to me that it was meant to resemble a spaceship. On that assumption, I wanted to include just part of the planetarium, keeping the backdrop of the city in full view, to create a sense of intrigue and drama.

Since a clear blue sky isn't always the most interesting background for a building, I kept going back at different times on different days to experience the variances in light. When I heard on the radio that a front was moving in and there were small-craft (boat) warnings, I looked to the sky and saw some really crazy cloud patterns developing—I knew there was a chance for something special to happen. Since I had visited the site several times, I knew what I was going to try and exactly where to setup. The sky was changing very rapidly as the winds were howling. I tried a series of long exposures while painting the

building with hand-held tungsten light so the backlit Adler didn't become a silhouette. In using 4 × 5 transparency film and because the lighting condition was changing so rapidly, I wouldn't know the results until the next day when I picked my film up from the lab and viewed it on a light table. When I did, I was speechless. After several visits to the site I had finally created a truly memorable image.

Research was my next step . . . to find the firm who had designed the addition. As luck would have it, I already knew their marketing director. He liked the photograph enough to show it to the firm's principal, Dirk Lohan, the grandson of legendary architect Mies Van Der Rohe. Dirk Lohan's comment: "David Seide's photograph of the Adler Planetarium and the Chicago Skyline beautifully captures the exposed location of the Adler at Chicago's lakefront. As the designer of the Planetarium's expansion, I am thrilled to see how he has caught the futuristic quality of that building."

Not only did Dirk love it, but that image turned into a full-fledged assignment and the firm has become an ongoing client. All of this because of my initiative to create a view of the city that was uniquely mine.

What's your approach to an architectural photography assignment?
Typically, there are three parts: walk through, scout, and final photography.

During the walk through, I employ a combination of things, including my educational background, my creative intuition, and the architect's insights. Frequently I will walk the site with my client, listening, looking, and asking questions without a camera getting in the way. From this walk-through and conversation, I then develop an estimate.

Once we are on the same page with a signed estimate regarding expectations and usage of the images, terms, and conditions, we proceed to the scout. During the scout I explore the site again, now possessing the designer's conceptual background, searching for vantage points, framing compositions, while thinking about lighting issues. I like to spend a fair amount of time truly getting to know the place or space. The next day I edit down the scouting images for presentation to the client. We then get together and decide which views best showcase the design, which are the best vantage points, etc. From here, final photography can take place.

What are some things you value most about your life in photography?
Creating images for a living is very gratifying. Since my passion is my profession I feel blessed. As an architectural photographer, I value having the freedom to explore a place or space and then translating that experience into an image or series of images.

PROFESSIONAL PROFILE
NAME: Ron Gould
PROFESSION: photographer
WEB SITE: *www.rongouldstudios.com* and *www.panoramicimages.com*

Photographing celebrities has a certain glamour to many people. What's it like?
It's fun, but it's like any other photography job except that there are a number of rules—but those rules are often set up by other people, not the celebrity.

How do you handle celebrities?
As naturally as possible. I approach them with courtesy and professionalism but in my own style. Most celebrities are much nicer than their handlers. The handlers can be uptight and nervous about what you might do to unsettle the star. Often they'll give you a long list of dos and don'ts. They'll place restrictions such as "don't touch him, don't stand too close, remember you only have five minutes." You learn the best way to work is to follow your instincts. I go up and adjust a collar if I need to. Other photographers will ask first: "Do you mind if I straighten the shoulders of your jacket?" Use your own style is my best advice.

Secret service coverage is another level to deal with. They often have concentric circles of protection around not just presidents but ex-presidents. George and Barbara Bush were under threat of a contract hit from Saddam Hussein for several years, so their protection was on a higher level. Even there if you are discreet and take your time penetrating those circles of protection, you'll get the access you need.

Why are you called for high-end celebrity shoots?
For one thing, I've been vetted by the Secret Service, so has my primary assistant. I've been briefed on the protocols for visiting diplomats and government officials, so clients know that we're ready to go when the call comes. Often, my corporate clients sponsor events attended by celebrities from both the entertainment and political world. One client hired Tom Jones to do a private concert for their media clients. We may be there just to do "grip-and-grin" of all the corporate guests with the celebrity. Or we may be asked to do portraits of the big name themselves.

Not all celebs are cooperative but many are consummate professionals. Michael Jordan is invariably pleasant, hits his mark every time, and gives you the exact angle you need.

To do celebrity photography you need people skills in addition to technical skills. You need to keep your cool—and you need to be fast, fast, fast.

How or why are you different from the paparazzi?

Those of us who photograph celebrities separate ourselves from the paparazzi as being those who are "Inside the ropes" or "Outside the ropes." The former are those invited to photograph as opposed to those just crowding around on the outside of an event. When you are invited in, assigned to shoot, you often wear a tux or at least a good suit and tie. You blend in with the event by keeping a professional demeanor in the way you dress and carry yourself. You make your client look good by providing quality photos of the invited diplomat or politician and also by a dignified bearing that reflects well on that client.

What are the ethics involved with celebrity photography?

You are not looking to expose the celebrity or make them look ridiculous. You keep any compromising or oddball photos in the vault. In that way you build trust with the client and the celebrity.

What is the best thing about your profession?

I wear many hats. My experience in teaching, giving important information to the student, has been a great joy. As for photography, I just love the work. And travel photography is a great outlet. I also love doing panoramics, which I license through *www.panoramicimages.com*. I use a stock agency here in Chicago, Custom Medical Stock, which handles the medical photography from my corporate work. So I'm involved in many aspects of the business. They all work together.

What is the worst thing about your profession?

Bill collection from a bad client.

Where is film in the future of photography?

I've been 100 percent digital for three years. I did have a few clients, small non-profit organizations, who held out the longest for film, but have now all of them have upgraded to digital.

How does someone find work?

I find work more through the Internet than any other way. I am listed with at least six sites that send me leads, or direct potential clients to my Web site. It also takes the follow up phone calls, e-mails, mailing, and just perseverance. Having an effective, well thought out, easy to navigate Web site is just as important as having a phone! The Web site will usually get you more work than a yellow page listing, since it goes international and costs less.

Consumer Photography

In the area of consumer photography it is generally members of the public who use the finished product. Instead of dealing with a client such as an art director photo buyer as you do in photography for publication, the consumer photographer specializing in family portraits, weddings, bar mitzvahs, and similar events has a more personal connection with the customer. And that customer has a deeper emotional investment in both the choice of photographer and the outcome of the pictures. Often, the photography surrounds a specific, never to be repeated, event. Re-shoots aren't an option. There are pressures in most types of photography—but the levels of tension faced by a consumer photographer are at a different level. The air often crackles with family anxiety. This requires a special person as the photographer— one who can be kind and calm with the family, be efficient but unobtrusive, and work fast but never seem rattled. Topping the list: the photographer must love what he or she does. That passion will show in the attention to every detail. The best photographers consider it an honor and a trust when a person or family allows them to record life's precious moments.

TYPES OF CONSUMER PHOTOGRAPHY

Many areas of consumer photography are common in our lives. Whether we've been there as the volunteer family photographer or as an invited guest, we've all seen the photographer at work at weddings or other family events. But there's another part of consumer photography that is sometimes overlooked—the expanding world of "event photography." In event photography, the photographer works with individual consumers but also may get assignments from companies. This specialty within consumer photography has a good growth potential, as you'll see later in this chapter.

Consumer Photography at a Glance

Weddings

Portraits: family, children, and pets

Portraits: headshots of performers

Baptisms, christenings, and confirmations

Bar mitzvahs and bat mitzvahs

Sweet-sixteen parties

Quinceañeras parties—the traditional celebration for Hispanic girls at age fifteen.

Portraits and group photos of schools, day care, dance and theater schools, camps, etc.

Event photography from car races to proms to corporate awards.

WEDDINGS

The good news for wedding photographers is that traditional weddings have been back in style for a while and it looks like they are back to stay—that is, weddings with pictures from professional photographers. Not long ago there was a trend toward simple weddings, often with the only pictures being taken by family members. Consider that there are around two million weddings a year in the United States. This figure has been relatively stable since the 1950s. Some are second weddings, and some are low-key weddings. However, many are traditional, first-time weddings with all the trappings, including full photo packages. That translates to a lot of "big days" that need documenting around the country. The field is open to the enterprising photographer who can balance the need for "TLC" of the family with offering the newest digital gizmos as a way to induce new customers.

Entering the Field

The field of wedding photography has a certain built-in job security due to the fact that every year, inevitably, there is a new batch of weddings. Though there is plenty of competition, at least it's a field where customers need a live photographer. They sure can't get their photos from stock! They need you.

If you are considering a career in wedding photography, understand the balance between the traditional need for gentle handling of a family at a stressful, if joyful, event with the requirement by today's tech-savvy bride for the cutting edge of creativity and technology. The "wow" factor in wedding photography is a recent development, but it's here to stay. Every type of technology available can be applied to wedding photography. Your best approach is to research wedding photographers in your area and try to get a post assisting at the top-of-the-line studios. The most successful wedding studios now hire two to five assistants for any large wedding. Doing a stint as one of these assistants would be a valuable apprenticeship. Also, look into the programs on wedding photography that PPA (*www.ppa.com*) has for its members.

Psychology of Wedding Photography

You'll be well suited to wedding photography if you like people—like them and have the patience to understand their anxieties and expectations. A bride or her mother may not care exactly how you get the job done, they just need to believe that you can and will cover every moment perfectly. They may want both formal portraits and documentary-style coverage. They may want shots of all invited guests, including those cutting up on the dance floor, plus all the traditional moments like cutting the cake or tossing the bouquet. They want the bride to appear serene and elegant while the party has a loose and lively look. You (or your staff) will have to be everywhere at once—without it appearing that a photographer is in the room. You must maintain calm in the face of chaos, as Andy Marcus so aptly describes later in this chapter.

Before the Event

Disappointment is not an option if you are to succeed at wedding photography. The happy customer will tell five friends, who will tell five friends. Having a happy customer depends on your ability to meet and *exceed* expectations. That's no small challenge, since customers for wedding photographs may start out with an unrealistic idea of what's possible on their budget. Your job is to explain the choices and prices so that expectations are met—theirs and yours (so you can charge enough to stay in business). Several sessions of clear, advance-planning conversations are the solution.

Business Aspects of Consumer Photography

Pricing your weddings, or any of the consumer photography specialties, requires a delicate balance. You don't want to scare customers away with high prices—but don't underbid or you won't stay afloat. Create packages with a variety of options

so the customer can pick and choose. Knowing what they are getting in advance will help give the customer satisfaction. Then, if the results of the photography are good, you will get additional sales of prints, which in turn will add to the profitability of each event. Make sure there is enough mark-up on all the products and staff you add to the package or your profits will leak away due to the time it takes to manage them. You can find more about these terms and concepts in business books on photography. Simply stated, "mark-up" is a term that means you add a percentage, often 25%, to the cost of any item you provide and it's basic to any business. Again, the PPA is a valuable resource for the business details.

The customer base for weddings and events may seem to be made up of just one-time clients, but one satisfied customer can lead to other customers. The good reports spread by happy customers are excellent advertising. The established wedding photography studios boast about photographing the children and grandchildren of a family, demonstrating that building good will is building good business.

Digital Photography

In weddings, and all event photography, digital has changed the playing field in several ways.

Digital allows more certainty in results. It's reassuring to be able to check images instead of waiting to see film to be sure of what you have. So if Aunt Mary Jo didn't smile, you can check the images and reshoot right then. Most wedding photo buyers are mid to late twenties; they grew up on digital and expect it. Finally, digital allows you a marketing edge, since you can offer a bigger package of output products at the wedding to be ready by the end of the event.

Each year *PDN* (*Photo District News*) does an issue on wedding photography. Either online (*www.pdnonline.com*) or through a print version, check out their findings for the latest developments in the industry, especially the newest styles and digital breakthroughs. Below are several types of digital products featured in the recent wedding edition of *PDN*.

Digital Products

Variety is a key part of your package. Be prepared to offer the full range of cutting-edge digital goodies—whatever is available on the market. As of this writing, it's common to have digital-printing capacity on site at the wedding (or other event) to provide the bridal couple and guests with prints before they leave. You can even use digital capacity to create elegant traditional wedding albums. Take advantage of each new technology as it comes out—at least by experimenting to see if it works for your customers.

One enterprising wedding photographer, Jefferson Todd of Arizona, offers what he calls " iDo iPods." He gives the bride and groom each an iPod loaded with their wedding album. Take a look at the impressive presentation at *www.jeffersontodd.com*. Neal Clipper, of Abbey Photographers in New Jersey (*www.abbeyphotographers.com*), can provide a large projection screen at the wedding and quickly upload shots of the wedding during the wedding. Guests look up and see themselves in the moment. This dazzles everyone. Also, blending images with music is a specialty of Ed Zemba of Robert Charles photography in Massachusetts (*www.robertcharlesphoto.com*), who uses a dramatic mix of still photographs and music to create extraordinary DVDs. The company has had such success with their own audio visual presentations that they formed a company (*www.theslideshowcompany.net*) to prepare them for others. You provide the stills you shot from a wedding, and they will put together a DVD with motion and music for your client.

At the Wedding

This is where your ability to control chaos and think on your feet comes into play. You need to maintain an air of calm no matter what happens. Being completely prepared will help when things go wrong. Backups of all equipment, careful rehearsal of your staff and being alert to the emotions of the family are precautions to take at every wedding.

Dress Code

Find out what the guests are wearing and dress accordingly. Short of sling-back stiletto heels, do your best to dress to blend in. In the planning stage, ask if the wedding is a black-tie or a dark suit event—or if it is sandals on the beach at sunset. Even though you are working, you are part of a social event. It may be a job for you—but it's the participant's once-in-a-lifetime celebration. Your appearance and demeanor should enhance the event, not be an eyesore. Many wedding photographers find a tux as important a piece of equipment as the camera. Good referrals through word of mouth are critical to success in wedding photography—your dress, manner, and manners will be noticed.

Handling the Bride

There are many pitfalls in wedding photography. You have a brief opportunity and probably a tense bride. The bridal portrait is a critical image from the day. It has to be flattering as well as have an air of serenity, grace, and elegance. It's should look like a moment in time of unhurried loveliness. This is where your pre-planning kicks in. If you have checked the site beforehand, you'll know the good angles and lighting for the time of day you have available. It's also where your psychological

preparation will save the situation. Keeping a calm, friendly, and understanding manner will rub off on the bride and family. Humor with a delicate touch and at the right moment can diffuse difficult situations.

As a wedding photographer, how you handle people depends on your style. If you need to touch the bride or adjust her dress, how do you do it? Do you ask permission or just do it? Some photographers discuss these questions with the bride in the planning meetings when things are calm. Ask her what she prefers, so you are both comfortable when the moment comes.

PORTRAITS

A wedding may be the event of a lifetime—or is supposed to be. But other types of events, including portraits, fill the calendars of the consumer photographer. Many of the same tenets apply: love what you do and make the subjects feel comfortable.

Portraits depend on the rapport between the photographer and the subject. Everything else is a distant second. Lighting and technical ability become relatively unimportant if your well-lit, sharp portrait is stiff or doesn't represent the sitter's personality. Understand that most adults, unless they are professional performers, are uncomfortable, almost pathologically so, in front of the camera.

Before starting a portrait session, talk to the customer to learn the purpose of the portrait and what style they want—serious, professional, warm, friendly—or all of the above. Advise on clothing (simple designs, long sleeves, especially for older women) and color. Discuss background, environment (studio or exterior), and show the kinds of backdrops you have to offer. Get the subject talking and you've broken the ice.

Most of all make it clear that they don't need to "do" anything but relax if possible. Let them know that you will take enough extras that if they blink or make an awkward face it's no problem. I sometimes tell a subject that they look terrific and are doing a great job but I need to take extras just to get the "camera warmed up." It works especially well with children but adults are susceptible to a little reassuring as well. That's as true for a CEO as it is a plumber or sales clerk.

People need portraits for every reason from an engagement to a fiftieth wedding anniversary, a head shot for a real estate broker or an executive portrait for public relations use and, of course, to record each adorable stage of the new baby.

Competition? Go for the High Ground

You can't—and don't want to—compete with the low-end portrait studios in places like Sears and Wal-Mart. They are adept at providing a recognizable, sometimes pleasing, image fast and at an incredibly low price. They use mass-production

methods that don't allow for any real connection with the subject. The best approach for the professional photographer is to provide what the low-end people can't, which is an understanding of the subject. What you have to offer is a window to the essence of the person. If you can establish some rapport and capture the personality of the sitter, then you've accomplished something they can't get at Wal-Mart—something that's worth your price.

Head Shots

Another interesting variation to the normal portrait is the headshot needed by performers. These sitters, actors or musicians, are usually more than comfortable with the camera and able to provide a range of expressions. They want to know that you have skill in lighting and technical excellence to make them look good. This specialty is most needed in the larger metro areas or places with a strong presence of the performing arts. It's not just performers who need photos; models also need headshots as well as life-style portraits to show how they look in different wardrobe or settings. A model might want to be portrayed as a busy executive, a young mother, or a playful romantic partner to show on a "comp" card that a model agency requires.

Group Portraits

A big segment of the consumer market is in school portraits. Also included are the ancillary group photos of preschools, day care, summer camps, dance camps, etc. Success in this area requires efficiency, patience, and speed and among these being fast is the most critical as Joe Slayton explains later in this chapter.

More Family Events

In the boxed list earlier in this chapter, I mentioned a variety of other celebrations that people want to remember through images. Photography of these events is similar in approach to wedding photography. In a family, these are one-time events (or two-, or three-time events, depending on the number of children). So the pressure to record a onetime moment is intense. The photographer must be aware of, and sensitive to, the cultural and religious aspects of these events. Research beforehand or discuss with the families to understand the protocols specific to each celebration. A delicate touch and sense of dignity will go a long way to bringing repeat business.

THE WORLD OF EVENT PHOTOGRAPHY

Event photography that overlaps with topics covered earlier in the chapter might be categorized as "family occasion photography." Another type of event photography, which I'll call "Event" with a capital "E," is a less well known but expanding area

of consumer photography. It's arguably the fastest growing segment. Membership in the Society of Sports and Event Photographers (*www.sepsociety.com*) will give a helping hand when you are ready to pursue this avenue of photography.

To define event photography, you might say that anywhere or any time people gather together for an activity you have an event to be photographed. (See the profile later in this chapter on event photographer, Jim Roshan, who came up with this definition.)

The activity might be on an amateur level, such as a kid's soccer tournament, or on a professional level, such as a rodeo or jeep racing. Events include state or county fairs, medieval tournaments, theater group activities, and marching bands. There seems to be no limit, except to your imagination.

Corporate Motivation Events

Another very successful new wrinkle in the world of event photography is corporate motivation photography, which is used by many high-powered corporations to great success. One company, Photo-Tech in Sarasota Florida (*www.photo-tech.com*), is credited with creating a niche specialty that takes corporate-event photography to a new level. Using photography as a tool, this company and others like it offer a line of photo services to motivate and reward employees. This includes photos to commemorate trips to Hawaii, Puerto Rico, or the Far East given as awards to employees. An additional bonus for the employees is the album created from the photos recording memories of their trip. Having your own "personal" professional photographer assigned to cover your trip is reward indeed. A photographer looking to enter this special niche must have excellent people skills in addition to superior technical ability.

Self-Motivation

Unlike publication photography, where you usually have a client assigning the photographs and paying you a fee, event photography depends on your initiative. Here you can be a true entrepreneur. Sales ability is a big factor in successful event photography. The good photograph that doesn't sell a print won't increase your business. After taking good shots you must do the selling or work with a partner who likes to hustle. If the push and shove of aggressive selling bothers you, then this may not be your area of photography. But for the person who enjoys it, event photography seems to offer almost limitless possibilities.

Here are just a few of the extraordinary number of events out there to be covered:

• Sports (league teams, individual and competitions) including marathons, X-treme sports, cheerleading competitions, marching bands, racing, equestrian events

- Seasonal and holiday at the mall
- Amusement facilities and tourist attractions
- Parties: anniversaries, class reunions, bon voyage parties
- Theater: performances, group activities
- Fairs and festivals: medieval and Civil War reenactments
- Beauty pageants
- Corporate: trade shows, conferences, banquets (including celebrity guests to be photographed with attendees)
- Corporate incentive awards programs

MARKETING CONSUMER PHOTOGRAPHY

The avenues for consumer marketing are Web site, yellow pages (still), direct mail—and the old stand by, word of mouth.

Web Site

Replacing the yellow pages (though you still need a listing), your primary marketing vehicle in terms of impact will be your Web site. Once a customer has heard of you, then your Web site should give a thorough introduction to your talent, experience, and, in some cases, prices. Most of the best Web sites have music and extremely fast loading time.

There seems to be a demographic split among those who search on the Internet and those who research using print advertising. Younger people (twenties to forties) seem to have no hesitation to searching online for services or products. Then there is the retired segment of the population, sixty-five and over, who use the Internet. They have time available and spend a tremendous amount of time on the Internet. That leaves a gap in the middle with the folks who didn't grow up with the Internet and haven't spent the time to learn. These days, not too many people use the yellow pages to find a portrait or a wedding photographer. But to serve those people in the gap who are not searching the Internet, some advertising in local magazines or newspapers could be useful.

Database Marketing/Direct Mail

Consumer photographers now have access to an unparalleled type of database for their direct mail marketing. Database marketing has been made so specific that you can now buy mailing lists of people thinking about having their first child. Just

thinking about it. So you can market to them for baby portraits without wasting your mailing pieces on non-target potential customers.

In the marketing industry this information used to be called "psychographic data," but people didn't respond well to the term so it was changed to "behavioral data." These studies reveal how you as a consumer behave, where you shop, what you read, what you buy. It was the idea, about six years ago, of the Direct Marketing Association (*www.the-dma.org*).

Word of Mouth

As long as the words are good, word of mouth is still a significant way of getting business. Satisfied customers beget satisfied customers. And people trust their friends far more than what they see in an ad. This just underscores the value of handling each customer and each wedding with special attention—making the event as photographically perfect as it can be.

Products as Marketing Tools

These days, you need to offer wedding or event customers more than just prints. For inspiration, there's a company that provides all kinds of products to wedding and event photographers (*www.eventphotomarket.com*). Look over the list to see what might sell well in your market. The company is the brainchild of experienced event photographer Jim Roshan, who is profiled later in this chapter. It provides everything from mouse pads, calendars, posters, and buttons to a bobble-head doll, all of which you can customize with images of your customers.

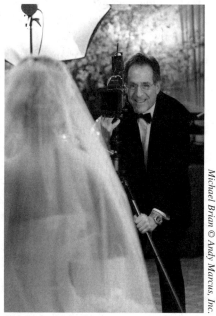

The best news of all is that many aspects of consumer photography are growing. Think seriously about the opportunities it offers.

PROFESSIONAL PROFILE
NAME: Andy Marcus
PROFESSION: wedding photographer and president, Fred Marcus Photography
WEB SITE: *www.fredmarcus.com*
HOME BASE: New York City

Andy Marcus at work.

Michael Brian © Andy Marcus, Inc.

What styles do you offer in your wedding photography?

Most studios shoot either traditional or reportage-style wedding photos. We do both. A truly complete coverage of any wedding should cover family portraits and fabulous candid, reportage-style photographs to capture the spirit of the day.

Why are the portraits important?

I feel very strongly that the portrait aspect of wedding is crucial to a complete story in a wedding album. A lot of photographers kind of pooh-pooh portraits as old-fashioned. My high-end brides order many, many portraits of themselves and their families and have always been a very important part of my wedding coverage.

We take the time and energy to find lovely settings and angles; we use soft, flattering lighting to enhance these images. We do not photograph line-ups of family groups but rather pose lovely portraits. Years from now, when these brides and grooms look back, your photographs will be invaluable keepsakes. You want to look at how your family was then. Family photographs—it's a must at every wedding.

How do you handle the bride who doesn't want portraits?

A combination of both styles is crucial. We have many brides who come in asking to have only reportage photography. I try to advise people when they come to see me that if you have both styles done at the wedding, then you can choose which style you want to predominate your album. But if you only have chosen one particular style, say the reportage, you can't go back and do portraits later. With all those proofs spread out on the table, you can pick and choose what you like. I find most brides wind up taking lots of the portraits in the final album.

What people display are the beautiful portraits of the bride and groom and of the family and bridal party. People will not order additional photographs of their "candid" images.

Beautiful portraits are priceless because you just can't go back. These are treasures because they let you remember how the family looked on that day. Just another cute shot of the back of the bride's dress is nice, but twenty years from now how important is it? It's nothing compared to having the family record as years go by.

Are you involved with the new trend of using digital to provide prints or other products to guests on the day of the event?

We do a very high-end business and I try not to get too jazzy with gimmicks. We have a dignified, traditional coverage of our weddings. For the most part the work is very classic and simple. Now at some events we do take beautiful

digital portraits of each couple and provide them a print in a 5 × 7 frame to take home at the end of the evening. It's all according to what the client wants.

Are you shooting film or digital?

I am still film-based and not a 100 percent believer in digital for weddings. Digital photography is in its infancy. In the beginning of any industry it takes time to develop the quality. Every few months you see tremendous strides in digital quality—the number of pixels—everything keeps growing and growing. Right now, digital photography works well if you are in a studio situation. If every thing is perfect and you can control all the lighting then digital photography is fabulous.

For weddings, where you are dealing with different light sources, the digital sensor on the camera is so sensitive that unless you have perfect light, which is never the case at a wedding, the skin tones just don't look real. That's why at this moment all the portrait work we do is film-based. A small percentage of digital photographs are taken of the overall décor, where color accuracy isn't so much an issue. To shoot digital throughout the wedding, with the mix of light, ambient light, window light, flash—all with different color temperatures—can result in some strange color shifts. If your client's skin tone or their lipstick color looks odd, then you're not going to have a happy customer.

Digital experts would argue that you can correct these color shifts easily in Photoshop.

I don't agree, not yet. Film is still more forgiving. Digital does not have the latitude. And even if the corrections could be made, you don't want to spend the time to do postproduction when you can get it right in film. Many people look at saving the cost of film and processing, but they don't take into account what their time or an assistant's time costs. I'm not saying that in a few years digital won't be equal in quality to film. But now there are still issues. If you want to give your customers the highest quality, then film is still your best avenue for achieving success.

For portraits in my studio, where we can control lighting, we shoot 100 percent digital. That's because I can control everything in my studio, something that I cannot accomplish on location. Most other photographers are digital, but we have our point of view on quality and how best to achieve it. I only want the best quality available for my customers, and I am not compromising for something "almost" as good.

Do you have advice to the photo student interested in becoming a wedding photographer?

The first point is that in wedding photography there's a tremendous responsibility. It's not like a portrait, where if the client doesn't like it he can come back the next day and you can redo the photograph. This is a profession where you must get it

right the first time. That's my number one priority. Number two, you have to be a really versatile photographer to be a wedding photographer because you have to know so many different types of photography: portrait photography, architectural photography, food photography, interiors—plus you have to be a psychologist to deal with the people. There are a lot of little hats you have to wear on the "day of." So, to go in not knowing the technical end is just a prescription for failure.

In addition to being a good photographer, I think you need to have some business skills and know how to handle money. Above all, to stay in business, you must manage your cash flow. All of a sudden you've got some money in the bank from a wedding and you spend it on equipment. When the clients come in to order their photographs you wind up with no money to pay for the prints or bookbinding. Balancing your cash flow can be a big problem for newcomers.

My advice to most people starting out in wedding photography is to begin by training as assistants. Connect with a high end or up-scale photographer—or the best wedding photographer you can hook in with. Stick with them for a few months, or it may take a year. Learn how they pose, learn how they light, learn how they speak to clients—improve your skills. It's not so much the "taking," it's the "watching." That's how I learned photography from my dad, who started the business sixty-five years ago, and my son, who is in business with me now, learned it from watching me. It also gives you the experience of working in the chaos of a wedding.

What's your philosophy about pricing?

As to how you charge, every area is different. You need to get a feeling of what other people are charging in your area. Then the question is, do you charge more, the same, or less. If you think your work is better than what's out there, certainly you might charge a bit more than the going rate—not double, but more. It's more about the quality of what you're producing and what it costs to produce that level of quality. Somebody shooting 2000 images at a wedding—which is ridiculous but they do it—obviously spends a lot more time, and if they're giving paper proofs it's going to cost them a lot more money than a photographer who shoots 300 images.

But the photographer who shoots 300 photographs may be doing a lot better job by being more selective in what he's shooting and capturing the moment. If you "nail it" in the first shot, then you don't have to overshoot.

What are your thoughts on dressing?

The way a photographer is dressed is crucial, since guests at a wedding notice everything. My photographers have to be dressed the way the guests are—in clean suits or tuxedos and nice shoes. People spend thousands of dollars on a beautiful wedding, so my people must look the part.

How many staff members do you have at a wedding?

It depends on the size of the wedding and what people are expecting. For some large weddings we'll have one or two color photographers and one shooting black-and-white photojournalism throughout the night. The color photographers all have assistants working with them. It's important because of the multiple lighting we use at the wedding—it's not just a light on the camera. There are several lights going—bounce strobes to light the backgrounds of my candids. For the portraits we use multiple lighting with umbrellas. Once we start shooting the candids those lights all come down. For the reportage we use portable lighting, but always more than one light so we can light backgrounds to give a three-dimensional look to the photographs. If you're just putting a light on a camera, you're just taking snapshots. That does not set you apart from your competition. All our lighting is radio controlled so we don't have a problem with the wedding guests and their digital snapshot camera flashes setting off our strobes or having our room flashes lighting their snapshots.

Do you pre-check or scout the space for good locations for your shots?

No, I usually wait until the day of the wedding. Our lighting system is well worked out, so we just see the layout once we get there. Most often things will change on the "day of." So if you go before hand it won't be what you expected. You'll come back on the wedding day and they've set up a buffet table in the spot where you wanted to place your portrait background. Then you've wasted your scouting time—so it's better to do it at the moment.

Any final advice to a newcomer?

You have to love people and enjoy being part of their special day. It gives me a lot of pleasure doing wedding photography, because you're dealing with families and creating relationships you'll have for years to come. I work with families that we have photographed for three generations. Maybe my father did the grandparent's photographs. It's nice to have people come back to you over and over again because they're pleased with the work.

How many staff photographers are in your studio?

There are a total of five photographers on staff then my son and myself. We do about 450 weddings or events a year. Other events include anniversary parties, bar mitzvahs, birthday parties, and corporate events.

What are the origins of your business?

My father started the business in 1941. I began as his assistant at age thirteen and have been doing it almost every weekend since. I still love it, it's just fun.

PROFESSIONAL PROFILE

NAME: Jim Roshan

PROFESSION: event photographer; founder, International Association of Professional Event Photographers/The Society of Sports and Event Photographers (*www.sepsociety.com*)

WEB SITE: *www.roshan.com*

HOME BASE: Kentucky

How would you define event photography?

You could say that anywhere or any time that people gather together for an activity you have an event to be photographed. Anywhere in the world, whether in an Inuit village in Alaska or on a riverbank in India you might find an event photographer. I know an Indian photographer who attends a religious ceremony every year where the adherents color themselves with a dye powder. He takes pictures to sell to the participants.

How do you distinguish event photography from an editorial coverage of an event?

There's a huge difference between the two. An editorial coverage of an event is basically that you're going to cover the story of the event. You're looking for a few shots for publication, maybe three or four photos. You might shoot 1,000 images to get those final shots. In the editorial world most of the time you are working for one client and one client only.

The event-photography business is completely the opposite. You are at that event, whether or not you are hired or contracted by the event management; you are there to shoot photographs for the attendees of the event. Most event photographers will bring systems with them to offer on-site printing of the images they shoot. They'll shoot 1000, 2000, up to 5000 images. They offer the attendees the option of picking out the images they want, print them, and buy them right there on the site.

An editorial photographer is making money from the publication client, but the event photographer makes money from sales of photos to the individual attendees.

Here's an example: if you have a Little League baseball tournament, you'll have three types of photographers there. One will be the editorial photographer shooting pictures for local newspaper to show the story of the game. Second, will be the mom or dad with their own point-and-shoot camera who is taking pictures of their kids. The third is the actual event photographer who is there to take as many individual photographs as possible of each of the kids and all the action to offer for sale to the parents. After the game is over, the parents can go to the event photographer's booth, look over the photographs on a monitor or

through proof sheets, and buy the shots they like. Then the photographer will print the pictures for them right there. Or the photographer might upload all the pictures from the event to a Web site. The parents can view the shots, put their orders in, and purchase them online.

Photographers have to publicize the pictures during the event. Depending on their system, an event photographer will either hand out cards saying: "We've taken great action shots of your kids in the game, swing by our booth and take a look at what we've got to offer."

Or they'll go through the crowd handing out cards saying, "Go to our Web site and choose your photos at your convenience." Most event photographers, even if they can print on site, will put the photos on a Web site for future reference and orders by the parents for Grandma in California who couldn't make it to the game.

Are there economic differences between an editorial and event photographer's coverage?

An editorial photographer will earn money with a fee of about $500 to $700 for the day's assignment. An event photographer will charge ten to twenty dollars per print working on volume sales. Depending on the event and his sales skills, he could make more than an editorial photographer.

The style is completely different as well. An editorial photographer is looking for a few defining moments of action in the game, not caring which kid made the great catch. The event photographer will be sure to get a shot of every kid on the field.

When there is good action, the editorial photographer will shoot the maximum number of frames possible on one play—about 8 frames per second. An event photographer needs to cover each kid, so is less likely to shoot multiple frames of any one play unless it's really outstanding. Even if the player isn't in the action, you'll shoot him standing alert at first base, do a few shots, full figure, medium close-up on the face, and then move to the short stop or the second baseman. This way each mom will have a good shot with a visible face even if her child doesn't make it in an action play. Once you've covered all the individuals then you look for action. The more variety of scenes you have the more likelihood of sales.

The editorial photographer has a guaranteed fee, plus the client is covering the expenses. Event photographers generally don't have costs reimbursed, so they must make it up in volume sales to be sure of a profit for the day.

How do corporate trade shows fit into the event photography world?

At a trade show, the goal of the company is to get people to stop at its booth and sign up to for literature about its product or services. One way to attract them is

to offer photographs, especially photographs of the attendee with a celebrity. This helps lure them in. I have a friend who shot at a trade show in St. Louis. A pharmaceutical company hired him to help get people to come to booth by having their photograph taken with a celebrity. They sign up to be on the company mailing list and take home their photograph with a celebrity such as a sports or entertainment figure, or a TV or movie actor. In this case the photographer is paid not by sale of prints, which are given free to the attendees, but by a fee from the company.

Are there other types of events?

Yes, there are many charity events where an event photographer is used. Usually there will be a corporate sponsor who pays the event photographer. Then the photos are given out as part of the fundraising for the charity. Events are wide ranging, from charity golf tournaments to an event called the mini Corvette grand prix.

What kinds of photo products do you market at an event?

Besides the pictures, of which 5 × 7 and 4 × 6 are the biggest sellers, we offer calendars, buttons, mouse pads, snow domes, or even a bobble head doll in which we insert a photo of the person's face. We started a company to provide these products to other event photographers (for a list of products go to *www.eventphotomarket.com*).

Do you see the event photography business growing?

Yes. Like a weed. The reason is that unlike portraits you don't have to be an artist. You don't need to be Ansel Adams. Good photo skills are needed but put your photo ego to one side. You have to be a businessperson first—a type-A personality. There are economic incentives for the photographer who is also a good sales person. At good events many of my colleagues report a one-day gross around $5,000 and weekend grosses of $15,000–$20,000 as not unusual. A week-long event can generate $60,000–$70,000 gross sales. Of course, there are staff and printing costs to be accounted for, but there is still a potential for very good net proceeds.

What advice do you have for someone interested in event photography?

Stay in your region. You don't have to be in Chicago, LA, or New York City. Every geographical region has a variety of events. Join the Society of Sports and Event Photographers for more information. If you have initiative and are self-motivated that's a good start. Use your imagination and drive to build a very good business.

PROFESSIONAL PROFILE
NAME: Joe Slayton, Slayton Studio
PROFESSION: photographer
HOME BASE: Monticello, NY

What's your current position in the photo industry?

I'm the owner of Slayton Studio, specialists in photography of children for preschools, day care centers, dance schools, and camps all over the Northeast.

Where did you begin?

It turns out I was good with babies. When an early job as a salesman didn't work out, I answered an ad for a photographer, "no experience necessary," in the *New York Times*. I applied for it since I had always been interested in photography, but more important I needed a job that didn't require experience. Back then, in the fifties, the baby-photo companies trained their own people. I bought my first camera to take pictures of girls at the beach, not real training for baby photography.

At that time Joseph Schneider was a big name in the field—his mural of a baby was hanging in Grand Central Station. When I saw an ad for his course in baby photography, I signed up. He taught me lighting, how to use different kinds of backdrops, plus the psychology of handling kids.

After that I decided to go out on my own. You can't imagine it today, but I went door to door. I would stop mothers with baby carriages in the street, show them sample pictures, and get commissions. This was in Brooklyn. Somehow or other I had a flair for baby photography and I got bookings.

I kept moving. First, I worked in the upstate New York Catskill resort area, later it was on to California, opening a studio in Culver City; but I went broke because I didn't understand the business.

Next, I bought an eighteen-foot house trailer, outfitted it with a darkroom, and pulled it across the country by an old Studebaker. I took off into the wilderness—left LA not knowing where I was going. I'd stop in a town, knock on doors, get appointments, take pictures, make proofs saying "I'll come back tonight with a proof," because I was broke and needed the money right away. I dragged that trailer through the mountains going from place to place, following the seasons, for fourteen months, ending up in Florida; then came back to New York, where I met my wife.

When did you start to be successful?

When we came back to the Catskill mountain resorts where I still had some contacts. People were happy I was back—after all, they had kept having babies

while I was gone. With the camps, day camps, and bungalows, it made for busy summers. So it was back to my roots canvassing. This time the studio I opened was longer lived. I became a small-town photographer, raised two sons, sending them to Harvard and Duke.

What is the long-term reason for your success?

I was always good at baby photography; I was able to get expressions and I could handle kids. At one point decided I needed a gimmick, so I used a clown suit to entertain the kids. I was Jo-Jo the Clown for many years.

After that it was expansion that made the difference. We expanded into camps outside of the region, mailed brochures, made phone calls, and eventually hired other photographers. Along the line, one of my camp customers called to ask if I'd come do his nursery school. My first thought was: what do I want to do that for? But I realized that if I didn't do it someone else would. I took the nursery school job and when I saw the sales I was amazed. I did in one day what I was doing at the studio in a month. And I had enjoyed myself.

Where is your business today?

We have ten staff photographers, each covering their territory in the Northeast. Our support staff, including the office and shipping, is around ten, plus those who run the lab.

What's your arrangement with your photographers?

The photographers are on staff and have their territories across the northeast. I hire and train them, supply camera equipment, medium format. They work on commission and we cover all expenses covered by the company and provide a pension plan and a health plan.

What are the changes you've seen in the business?

It's more hectic than ever. There's no time for costumes like my clown outfit. There are too many babies, so little time. Some days you feel lucky to escape with your life.

It's an assembly line. You've got to keep rolling—you have to get so many kids before lunch or nap time. It's frustrating, maybe you have twenty babies and seventeen toddlers crying and fidgeting, so you resort to every ploy and trick to get them with a good expression. You do miss an occasional shot, making a few unhappy mothers, but the good pictures bring in the income and we maintain high percentages. You get awfully good at working fast.

Service Photography

The area that we are calling service photography is sometimes included in discussions of consumer photography, and it can overlap with publication photography. However, it seems appropriate to separate them. The end user for consumer photography is usually an individual, whereas for publication it is a client. For the most part, service photography is done for an institution or a government entity. Some institutions might also publish the photographs, but primarily this is useful photography serving a primarily pragmatic purpose. Among the potential service photography are jobs in real estate, forensic, college and university, medical or scientific institutions, and museums and government.

Whether or not you agree with the way I've grouped them, the careers offered by service photography should be of interest. There are more potential staff photography jobs in this group. That will be appealing to anyone who doesn't want the hustle and push of freelance photography.

Of the specialty areas covered in this chapter, I must confess to giving more space to the discussion of forensic photography than the others. I think we can imagine fairly easily what's involved in doing photography for real estate purposes, or university or museum use. But when I started research for this book I knew nothing more about forensic photography than what we all see on television. My conversations with the experts in forensics were so fascinating that I hope you will find the extra coverage as interesting as I did.

REAL ESTATE DOCUMENTATION

There is certainly some overlap between this and the specialty of architectural photography in publication photography. Though similar skills are need, photos that serve the real estate market have their own special niche. In some ways, it's a specialized form

of advertising. The purpose of these photographs is to show—and to great advantage— homes, buildings, and all kinds of property that are for sale. The users of the photographs are usually real estate agencies or brokers.

Since the goal of the photographs is to make the property look beautiful and appealing, photographers wait to shoot until there is lovely light and also may bring props to dress up the property. The house must have what's known in the industry as "curb appeal." So potted plants or hanging flower baskets are placed judiciously around the house to create a pleasing look. The photographer may even work with the homeowner to clean up fallen leaves or clean up unsightly areas, like patchy spots in the grass, by retouching done later in the computer.

The need for real estate photography has grown as prospective buyers have become more Web savvy and want to see photos of the houses before going in person. This means that more room interiors are needed for real estates use. A common approach is to create a virtual reality tour of the interior, sometimes referred to as "360-degree photography." (I've even seen requests for this type of work on Craig's list.) Essentially this creates a panorama of the rooms. One technique is to stand in the middle of the room taking still shots, usually about twelve pictures, with an overlap of about 30 percent from one picture to the next. They are then linked through one of several programs, including Photoshop CS 2.

The real estate photos of property get a lot of exposure depending on the market. In Florida and other hot real estate markets, realtors send e-mails with photos of houses listed. They also blanket the area with post cards, print catalogs, use online catalogs and place ads in local magazines. In a few areas real estate brokers have a photographer on staff to handle the photographs of all their listings. One colleague of mine, Maria Lyle in Florida, has expanded her real estate shooting to include portraits of the real-estate agents.

FORENSIC PHOTOGRAPHY

"Forensic photography is giving the victim a voice. Your photographs may be the only way the victim's story is told." This eloquent description of forensic photography is from Drew Webb (see the professional profile of Drew Webb and Charlie Walsh, forensic photography instructors, later in this chapter). Forensic photography tells the story of a crime—helping to figure out what happened to whom and by whom.

Forensic photography is used for documenting a crime scene, so accuracy is of the utmost importance. It's interesting to note that the same high level of digital competence that we "standard" photographers must have to satisfy our clients is equally, if not more important, in forensic work. Forensic photography is just

like regular photography except for the subject matter (occasionally gruesome) and the purpose—to help catch criminals and document a scene for possible later use in court. Forensic photography will become more important in coming years, not less.

For an interesting glimpse at forensic photography procedure, see the box "Steps in shooting a crime scene." Also, a look at the course outline from the Web site of the Forensic Consulting Associates of New England will show the high level of photographic and digital skills needed along with the specifics unique to forensic experts, such as how to testify in court. The integrity of a forensic photograph taken in digital form must demonstrate a "chain of custody," showing that image has been safely handled all the way along the line. It is strictly analogous to the sign offs on the physical evidence bag used at a crime scene and thereafter.

As Drew Webb puts it, forensic photography can be absolutely fascinating. If you like solving puzzles, if you like applying your skills to finding an answer that's not readily apparent, and if you like deductive reasoning tied to photography, then you'll enjoy the field.

Steps in Shooting a Crime Scene

The order in which you shoot the photographs of a crime scene depends on local procedure. Usually the first person on the scene is the beat cop, then the detectives. These are closely followed by the brass and the press. There is a sequencing to the photos needed that is almost reminiscent of storyboard or layout.

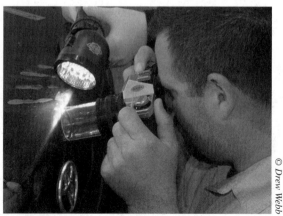

1. Prior to entering the scene, photograph the outside, the street signs, building number, and entry point.

2. The first photo of the crime scene should

Forensic photographer shooting fingerprint.

© Drew Webb

be from the point of first responder, the person who found the crime. Go into the scene the same way the first responder did.

3. Shoot the scene itself from the point of view of the first responder to give an overall map of what he saw entering the scene. Do this by shooting 360-degree overlapping views to stitch together (in Photoshop) for a panorama. Do not use wide angle lenses, which can cause exaggerated perspective. Use a 45–50 mm lens on a tripod, stitching undistorted images side by side to create the overall view.

4. Next, move in to take medium-range shots items of interest that you notice or as instructed by the officer on the scene.

5. When you move to shoot close-ups, include the evidence tag and a scale whenever possible. Photograph the item both with and without the scale.

6. Next move much closer, continuing the series of images. Shoot anything germane and or as the detective instructs. Some common close-up photos needed include: fingerprints, tool marks on pried doors and windows tools used to gain access, and ballistic comparisons. Then, on the victim, photograph wounds, body bruises, and position of the body. Take photos of weapons or any object that could be a weapon.

There are many other technical aspects critical to the documenting of a crime scene, but this is the basic approach.

—Drew Webb,
Chief Operating Associate,
Forensic Consulting Associates
of New England LLC

COLLEGE AND UNIVERSITY PHOTOGRAPHY

Photography for academic institutions is often a staff position, though some free-lancers are brought in for special projects. An advantage of being staff is certainly the security it offers. Also, life in a university setting can be most appealing. You wear many hats and have many bosses, often working for the faculty and administration and in some cases marketing and communications as well.

As a staff photographer for a university, you must be the generalist of all generalists, at one time or another recording every imaginable aspect of college activity. See Youngstown State University's (YSU) photographer Carl Leet's calendar, below, to give an idea of the variety of his assignments in just one month. University staff photographer Carl Leet. One month's assignments:

- A portrait of an artist who was about to retire. I had photographed his paintings previously (museum-style copy work) and done process shots—a series showing a painting starting with a blank canvas ending with the completed painting. I've done process paintings in other disciplines such as archaeology and chemistry.

- A glossy "view book" brochure for prospective students, featuring fifteen current students and faculty members looking friendly and appealing (environmental portraits).

- Tennis team group photos and action shots (sports).

- Baseball team group photos and action shots (sports).

- Helicopter rescue with a patient for emergency medical services (photojournalism).

- Ty Pennington's (television celebrity) appearance on campus (with the girl's softball team in pursuit).

- Virtual reality shots of interiors of dorm rooms (real estate).

- Building exteriors, forty-three buildings on campus in different seasons, for a poster (architectural photography).

MEDICAL AND SCIENTIFIC PHOTOGRAPHY

A variety of medical facilities and research labs use photography, and you'll also find hospitals making use of medical photography. Quite often, photographs showing patients with various medical conditions or trauma will be taken for teaching purposes. You might find yourself photographing rashes and other skin conditions for the dermatology department, detailed coverage of the wound-care unit, and documenting all kinds of surgery from transmyocardial revascularization to foot surgery or the Moh's surgery procedure for skin cancer. Sometimes there are new medical equipment or procedures that you will witness and photograph, such as a newly developed robotic arm doing a laparoscopic procedure. For this work, it helps if you're not squeamish.

There are special approaches to keep in mind when shooting for medical or scientific purposes. One is to avoid any distortion in the resulting photograph. The

color rendering of the skin pigmentation must be as accurate as possible. The choice of lens should not warp the appearance of a surgical procedure. Often you'll use a 50 mm lens to avoid distortion. In the cases where you can't work very close, you might work with a 105 mm macro. If the surgery is one where the patient is especially susceptible to infection, you may have to stay outside an established perimeter. In that case, a telephoto zoom lens will do the job. Scientific aspects of the work could also require photomicrography, or photography through a microscope. Hospitals and scientific institutions have needs similar to corporations for good exposure to the public. Therefore, happy patients and cheerful medical staff, from nursing assistants to doctors, also figure in medical photography. Enter advertising and public relations photography, which gives some creative outlets not present in the more scientific aspects of this work. Portraits of prominent clinicians round out the styles needed in the medical or hospital world.

MUSEUMS

Fine art, history, natural history—museums of all types—use photography to publicize their work and as an educational tool for the public. There is a need for straight documentation to record paintings, sculpture, and artifacts in a collection. Not just for inventory purposes but also for use in publications, catalogs, or postcards. If you have an interest in the arts, then you'll find what is essentially still life photography can be very appealing because so often you are photographing exquisite objects of art.

If you are on staff at a museum, you may also need to produce the grip-and-grin photos of guests at museum charity events. But the real appeal of this work is in your close proximity to the art and the atmosphere of a museum. I confess to finding it thrilling. On a freelance assignment to photograph a curator in the Egyptian collection of a museum, I was shooting in the back rooms where the curator was preparing one of the Tutankhamen masks for an upcoming loan display. At one moment he went out of the room and left me alone with King Tut. I photographed for a while, then stopped and just sat, absorbing the beauty. It was a memory for a lifetime. These are the moments in photography that wash away any of the day-to-day tedium in our work.

GOVERNMENT

Any career search in the ranks of government requires patience and fortitude. There are opportunities and needs for photographers in all branches of government. But only research will yield the information. There are staff jobs and freelance—the latter usually called "contract" or "project" jobs. If you are searching for stability and benefits, the government staff job fits the bill. Though the salaries are not

as high as in the private sector, there are good benefits. Staff jobs are not plentiful, but if that's your goal, keep searching to find the match for your skills and the government opening. The official job site of the federal government is *www.usajobs.opm.gov*. You can also try the Web site *www.fedjobs.com*, a service that lists jobs in the federal government.

The day I searched the federal Web site, there was an opening in the Division of Conservation, West Virginia, for the National Park Service; another for a position as visual information specialist for the army (this involved being in the army, possibly a combat zone); and another as visual information specialist at FBI headquarters in Washington, DC.

More common are the contract projects offered by various government departments. Just think about the various departments in the federal government and visualize the photography they might need. The Environmental Protection Agency, U.S. Fish and Wildlife Service, U.S. Forest Service, Bureau of Indian Affairs, Bureau of Land Management, and all the national monuments or tourist destinations run by the government—many of these are under the Department of the Interior, National Park Service. State and local governments also use photography to promote their activities. Getting government work takes perseverance, because the bureaucracy doesn't yield up its information easily. You must do diligent research to find employment opportunities. But there is a great variety of photographic jobs if you have the patience to explore.

PROFESSIONAL PROFILE
NAMES: Charlie Walsh, special agent, FBI (ret.) Drew Webb, chief operating associate, Forensic Consulting Associates of New England LLC
PROFESSION: forensic photography instructors
WEB SITE: *www.forensicconsulting.com*
HOME BASE: Massachusetts

How would you define forensic photography?

It's the use of photographs as documentation to support a conclusion in an impartial way. The forensic photographer is part of the team that answers the question "who speaks for the victim?" It's telling the story of a crime on behalf of the victim.

One place where photography becomes absolutely the most important tool we have is for lifting fingerprints. The general rule for getting hold of fingerprints to use as evidence is to dust them, eventually comparing the print you have on the object. The crime scenes person is going to lift that fingerprint on what we call a "tape lifter."

But there is a phenomenon known as "losing it in the lift," which means when you complete the lift of the fingerprint you get nothing or it gets gummed up. If you have not photographed that fingerprint beforehand, you don't have anything to use.

This shows the importance of photographic documentation of evidence in situ. It's not something you see often on the TV crime shows but you do see it in real life. I've walked into crime labs and heard the supervisor saying at the top of his lungs "You didn't photograph that?" It's a crucial part of the process.

The interesting thing about forensic photography is that it is the safety net for all evidence collecting. Also one of most important tools because it's the way you can demonstrate the kind of detail you see under a microscope. It's a crucial part of any crime solving.

What kind of training does a forensic photographer need?

They must have a solid working knowledge of technical aspects of photography. They need to understand photographic processes so they have a good understanding of lighting, have a basic understanding of optics also including digital capability. It's critical to understand the methods for keeping accurate logs for the photographs. When you are using photographic documentation as part of court testimony, having a documented and secure chain of custody for the photographs just as you do for other evidence is very important.

To be a forensic photographer you need a person who can completely submerge their own desires to interpret the scene and become a pure documentation photographer. You need someone who can provide the documentation that will support a conclusion in an unbiased way. The "best evidence rule" means that the evidence will be in its original condition. Your angle, position, and lighting must be used to avoid any alteration to the subject.

Are forensic photographers more often civilians or law enforcement officers?

Generally, it's a mix of both but the swing is toward using civilians as forensic photographers. The use of civilians releases sworn officers to concentrate more on law enforcement work instead of photography. Also, the move toward using civilian forensic photographs lends an additional air of impartiality to the work.

What lenses do you use or recommend for forensic photography?

Almost all lenses, especially macro lenses, will come into use, but in general we advise the use of 50 mm lens and not wide angles or any type of lens that would distort the location or object being documented.

Also we teach and advocate painting with light to add to the clarity of the scene. When you paint with light the shadows can be eliminated and every aspect can be seen. Straight flash can distort in its own way by lighting the foreground and leaving other details obscured in the shadows.

Are you teaching both film and digital?

The entire field is in a transition. Some would argue that photography has already gone digital. In the law enforcement business it depends who you ask. If you ask the chief of a police department, who doesn't like to see the recurring costs of film purchase and processing, he'll say it should be all digital and that's what he wants. If you ask the FBI they will tell you that you should be using at least a 35 mm film camera if not medium format, although they do have specifications and standard operating procedures for digital. But they will also tell you that if you go out to photograph a foot track or tire impression to get good detail, take out your 4 × 5 Speed Graphic.

There are a whole bunch of conflicting rules. There is a scientific group for imaging technology. The Scientific Working Group on Imaging Technology (SWGIT) was created by the Federal Bureau of Investigation to provide leadership to the law enforcement community by developing guidelines for good practices for the use of imaging technologies within the criminal justice system. SWIGIT has specifications as to what's recommended for optimal imaging—but some people read this information and go on with their previous methods.

Since digital files are used as evidence, how do you guard against manipulation of digital image and demonstrate that they are "pure"?

The standard is still that a photographer will testify in court that the image is a "true and fair representation of the scene as shown." But when working in digital we do need some underpinning support. We encourage the development of a series of standard operating procedures or SOPs. We start those SOPs by telling the student to make their initial digital captures in RAW format. Before the image is even opened, you bring it across to the computer desktop. Next create a file folder, labeled with date, time, evidence number, etc. Also, make a note of anybody who is observing the process. We usually recommend that you have someone observe the handling of the digital file. That person can then sign a form that goes into evidence that he observed your procedures.

Next, two CD-Rs are burned. One goes into the evidence locker along with the rest of the evidence that was collected. The digital files placed in the folders, now on the CD-Rs were *unopened, never touched, never viewed.* What you are doing is transferring the data file, moving it over to the computer in a format where it can't be manipulated easily, and putting it in the evidence locker. That is the equivalent of an unprocessed negative. At that point the data is the best, most virgin data available. It can always be brought forward along with subsequent the notes that are made once the photographer converts the RAW file and processes it for enhancement.

The second CD-R burned with the unopened RAW file is the master file. The process we recommend is to maintain a log of what settings they changed when they start to enhance the image. Ideally, if they're working in Photoshop CS 2, they save the xml file that's made by the history palette, the history of the actions. I believe you can also save that history file out of Photoshop Elements as a text file. But they should still make notes as they go along, which will back up either of the history files.

What you do in terms of enhancement are global changes only such as adjusting exposure (lighten or darken using levels or curves), sharpening (either using the unsharp mask or other sharpening tools) to improve the fine details of texture. This may allow you to see things like fibers on carpet. The key is to document and record, only doing things that are easy to explain. In testimony we can say that it's analogous to fiddling with the controls on your TV. You can say "I'm not changing the TV signal I'm simply making the signal easier to see." That's a strong position to make clear to the judge or jury that you didn't do anything to the image that would have an adverse effect on its accuracy.

We encourage photographers to do such things as photograph objects with and without scale so the "scale" doesn't obscure any part of the scene. But having some photos with scale enables you to set size so you can enlarge it to exact size. We suggest that they take at least one scene shot with a grey card or with a Macbeth color chart or Kodak color patch. Then they always have a scene reference for color.

This is all part of a general topic called "chain of custody." You are trying to demonstrate that image has been safely handled all the way through and not in any deleterious or prejudicial way. Chain of custody on a piece of physical evidence is a series of sign-offs on evidence bags or with an accompanying sheet, which lists who has had it, when and where they took it once they got it, and what they did to it once they put it where it was going. In our digital photography procedures we're strictly analogous to that.

PROFESSIONAL PROFILE
NAME: Carl Leet
PROFESSION: staff photographer, Youngstown State University
WEB SITE: *www.ysu.edu*
HOME BASE: Youngstown, Ohio

© Carl Leet

As a staff photographer at YSU what is your assignment?

My department, media and academic services, serves the faculty and

Celebrity Ty Pennington chased by the YSU women's champion softball team.

administration, so most of my photography is done in that context. There is another photographer who handles marketing and communications, press releases, and that sort of work.

Do you need to be a generalist in that position?

Yes, I have to do everything both in terms of subject matter and technical skill. And over the years I've been constantly learning new techniques.

Is there much variety in the job?

Just looking at my calendar I see how many different types of assignments there are. I do practically every kind of specialty that a freelancer might do.

You do absolutely everything; how does that feel?

I love all aspects of photography so I find it fascinating. If something comes along that I haven't done, I'm champing at the bit to try it. I'm a photography junkie, so the variety of work keeps me amused and entertained and challenged.

© Carl Leet

Crystalography lab, Youngstown State University.

What do you value most about your life as a university staff photographer?

What's really fun is the chance to get to know faculty and sometimes become friends with them. That's the bonus in my work. It's been an education in itself to be exposed to so many fine minds in different areas. I can hang out with a world-class musician, architect, mathematician, or philosopher. It's inspiring and like another level of education.

Second, of course, is the security. It's great to have a steady income and all the benefits for my family. My son is getting ready for college, which will be paid for by the university. That's a huge benefit.

What's the worst thing about being a staff photographer?

I suppose it's the lack of travel. I'm tied to one place, a 150-acre campus. So I try to travel on vacations.

Is it difficult to maintain your enthusiasm when you're on staff?

Sometimes it is hard to stay diligent and strive for excellence, especially if the faculty person "hiring" you limits you, when their expectations might be lower than yours. You can develop tunnel vision for your work if you're getting pats on the head when you know the work could be better. You must push yourself above the expectations placed on you, not limiting your own vision.

C H A P T E R

Fine Art Photography

Fine art photographs can be said to exist for their pure artistic merit. But the purpose of fine art photography, if any art can be said to have a purpose, comes from the point of view of the photographer. It can be beautiful, meaningful, express an intellectual concept, or make a graphic statement. Many in the fine art world believe that to be considered fine art a photograph simply needs to embody an authentic expression of the artist's unique vision. (See profiles of photographer Joyce Tenneson and curator Karen Amiel in this chapter.)

Fine art photography may be seen on a gallery wall, in a book, on display in corporate offices, in a museum or university exhibition, or on various Web sites. The physical manifestation, the print from the fine art image, is intended to be sold to collectors, whether individuals, galleries, museums, or corporations.

From almost the first moments in the development of photography, the debate began: was photography art, craft, or merely a technical device to record reality. That thinking has been laid to rest as photography has taken its place along with the other fine arts. The answer to the "Is photography art" question is: "It can be." Today serious collectors and curators buy and sell fine art photographs for extraordinarily high sums of money. There is recognition and praise from critics in both the photographic and art world.

STYLES IN FINE ART PHOTOGRAPHY

Where does fine art come from? From virtually every discipline and style within photography and the visual world. Some photographer artists create photographs with the sole intention of creating art. Often these photographs come from photographers acknowledged by critics and museum curators and collectors as being artists.

In addition to work driven by a photographer's fine art aesthetic, fine art can also emerge from documentary photography, photojournalism, and even from assignment or commercial work. In the past we saw photographers moving from photography into the fine arts. Now it's going the other direction as well. In recent years, fine artists trained as painters or sculptors have created works for which they chose photography as their medium. Boundaries are being pulled and stretched beyond recognition.

Of course, many photographs have authentic value and impact whether they are art or not. Commercial photography is made to be useful—to fill a need such as illustrating a magazine article or advertising a product. A photograph can be useful or beautiful or both. It can exist in its own right, or it can explain, illuminate, and inspire. Commercially created photographs intended merely to be utilitarian can rise to the level of art, while photos created to be art may be merely contrived or sentimental. Just as some paintings are never more than illustrations, lacking the stirring fire of art, some photographs are merely serviceable. But art can emerge in the most unlikely photographs, whether they were designed as fine art or not. Some assignment photographs that were not shot with that intention are reborn in their later life as fine art.

The recognition that art can be found in all areas of photography emerged with the work, among others, of Robert A. Sobieszek, director of the Department of Photographic Collections of the International Museum of Photography at the George Eastman House, Rochester, NY. In the book *The Art of Persuasion* he surveyed the history of advertising photography as a visual art.

The following year a collection was established called "The ASMP Archives at the International Museum of Photography at the George Eastman House." The opening exhibition was titled "Professional Vision: Photographs from the Archives of the American Society of Magazine Photographers." Helen Marcus, then president of ASMP, worked closely with curator Robert Sobieszek to bring the exhibition to fruition. This marked the first occasion when advertising photography was mentioned in the same breath as art.

W. EUGENE SMITH MEMORIAL FUND

Legendary photojournalist W. Eugene Smith was known for his passionate photographic essays for *Life* and other magazines and his idealistic pursuit of the truth in photography. After his death a fund was started to "seek out and encourage . . . independent voices in photography." Since that time, the W. Eugene Smith Grant in Humanistic Photography has been awarded to photographers who reflect Smith's compassionate dedication (*www.smithfund.org*). Some of the recipients are now

represented by major galleries and acknowledged as fine artists, including James Nachtwey (1993), Graciela Iturbide (1987), Donna Ferrato (1985), Gilles Peress (1984), Sebastiao Salgado (1982), and Eugene Richards (1981). Helen Marcus, current president of the W. Eugene Smith Memorial Fund board of trustees, says, "These works have enduring value as examples of humanistic photography in the spirit of Gene Smith as well as in their own right as fine art."

You will discover other fine artists emerging in unexpected places. A friend recently came across the Web site of a marvelous African photographer, Seydou Keita. His first New York show was a few years ago. It turns out he had been working in a vacuum, with virtually no influence from the outside, creating the most extraordinary portraits. His authenticity came from within and it was finally discovered (*www.zonezero.com/EXPOSICIONES/fotografos/keita/default.html*).

As a result of these pioneering efforts, the lines today between commercial and assignment and fine art are so blended as to be indistinguishable. A look at some of the prominent photography gallery Web sites will show that the photographers they represent are a mix of established assignment photographers with the traditional fine arts photographer. Works of fine art photography, perhaps originally defined as those intended to delight the eye and arouse the intellect, now include works that shed light on the human condition.

CROSSOVER: CAN YOU DO BOTH?

If you want to have a career in photography, most people would assume that you desire to make a living as a photographer. I believe that making money is compatible with creating art, but not everybody agrees with that premise. If you are one of those who love photography and can't bear altering your art to suit a client, you may need to pursue fine art and pay the rent through other means. There are allied careers in the photographic world that might suit this purpose.

Starting out as a fine artist, you have the challenge of first getting gallery representation, and then getting enough recognition to warrant a good price for your work. In the past, fine art photographers had to drive cabs or wait tables to support their art. Recently, however, there has been a dramatic increase in the number of purely fine art photographers whose work was picked up by the commercial world. There are many more opportunities to cross over without sacrificing your artistic standards. Some examples of photographers who have had success in both the commercial and fine art worlds are Joel Meyerowitz (*www.joelmeyerowitz.com*), Joyce Tenneson (*www.tenneson.com*), Mary Ellen Mark (*www.maryellenmark.com*), and Stephen Wilkes (*www.stephenwilkes.com*).

In the past, it was felt (and said) that art is rarified, exalted, refined, and completely separated from the taint of business and commerce. But looking at the work

of these people, you'll see that's not necessary and not so. So this is your goal: to find your own expression and stay true to it, whether working on assignment or as an artist.

HOW TO BE A FINE ARTIST

Be yourself. The age-old adage "To thine own self be true" is still sound advice. If your photograph does not represent your authentic vision, it won't resonate as art.

Where does fine art come from? From inside. Be ruthless and honest in looking at your work. In the profile of Joyce Tenneson, below, you'll read insightful words about finding the artist inside you. If you track the progress of her work you'll see she never wavered from her commitment to her artistic exploration. Her art evolved but has always been true to her inner self. As Tenneson puts it, a fine art photographer must "mine their inner territory."

WHAT MEDIA TO USE

When expressing your vision in fine art photography, your work can be film based, digital, and/or any combination of current or alternate photographic processes, including cyanotype, brownprint, palladium, gum bichromate, kallitype, ambrotype, anthotype, daguerreotype, and many more.

For information on these alternative photographic processes see the Web site *www.alternativephotography.com*. For example, not too long ago it would have been surprising to think of a daguerreotype artist such as Jerry Spagnoli being in the forefront of fine art photography.

Digital artists are at the other end of the spectrum of technological development. Look at the profile of fine art photographer Sanjay Kothari in chapter 9 to learn the views of a committed artist who uses digital extensively.

Printing has had a revolution as well. Some dealers believe that inkjet prints are now acceptable to collectors. Long-time art dealer Alex Novak markets fine art through his Pennsylvania gallery Vintage Works and on his Web sites *www.vintageworks.net* and *www.iphotocentral.com*.

FINDING A GALLERY

Before looking for a gallery for your own work, get to know the major galleries around the country and the level of work they represent (see the list at the end of this chapter). Not that you are trying to mimic the work you see there: that's fatal for a fine artist. But it will help you understand two things: first, the style a particular

gallery seems to represent; and second, the level of quality and innovative thinking exemplified by the artists represented.

Don't approach the major galleries until you are ready. First, try to get shows at a local level to see how you feel about your work when it's exhibited and gauge its reception. You can learn a great deal from the response from your peers and your professors. The critiques you receive can be helpful, not by suggesting that you change your style, because that must be your own authentic expression, but to see if you are actually communicating that vision to others.

How to Approach a Gallery

Be professional in the way you contact any gallery, large or small, national or local. Virtually all galleries will have submission guidelines. You can see these guidelines on the gallery's Web site. Follow them scrupulously. Here's the wording for submissions from one major gallery:

> Our gallery reviews photography portfolios on the first Thursday of every month. Drop off is anytime from 11am to 6pm on Thursday and MUST be retrieved the next day, Friday, during the same hours. You may submit no more than 20 photographs, no larger than 20 × 24 inches. NO TUBES AND NO CRATES. We make no exceptions to this policy, thank you for respecting our time and guidelines.

If you have been to some exhibitions at the gallery you're interested in, you'll have a sense of the type of work it exhibits. Don't waste your time or the gallery owner's time if your work is nowhere near what they show. For example, if a gallery shows only vintage work and you are doing alternative processes, you may not be a fit. The more shows you go to the better. You might find a friendly curator who could turn into a mentor—just don't be a pest. Learn to recognize when someone is offering help as opposed to merely making a polite comment. If you are able to make contact with a local gallery owner, invite them to any show you may have while in school.

MARKETING

It has not been in the tradition of fine art photography to use the word marketing in the same breath with fine art. However, artists energetically seek gallery representation and show their work with the hope of being recognized and rewarded (paid)

through sales of prints. They also seek the attention of curators or buyers of fine art photography for use in corporate collections.

That being the case, the idea of marketing and self-promotion for a fine art photographer should not be anathema, an abhorrence, an abomination—it's a reality if you are to earn a living as a fine artist. It's no less important for an artist to promote him or herself to galleries and curators than it is for an assignment photographer to do so to clients. The only difference is that the usage is exhibition instead of advertising or editorial. However, getting the attention of that corporate buyer—or gallery owner—is every bit as critical as it is for an assignment photographer. An interior designer or corporate curator buying 20 prints at $3500 each for a corporate headquarters is in the business of art. And it's a part of the business that you wouldn't turn down. So make yourself known and available to participate in the marketplace of art.

Your physical presentation of your fine art photography depends on the process you are using—to that aspect you will have devoted much time and energy. If you are fortunate enough to have a meeting with a gallery person, you can leave behind slides of your work (as has been done for decades) or CDs of your work. But added to that should be a Web site, an excellent first step in your promotion. A note of caution: unsolicited work is very rarely given serious consideration. Find ways through networking to get your work seen. Follow the advice of Karen Amiel in her profile later in this chapter.

The concept of marketing fine art is sufficiently well acknowledged that there is a new book on the subject just coming out. It is *How to Exhibit and Sell Fine Arts Photography*, by Maria Piscopo (Allworth Press).

You will also find over forty pages of gallery listings in the annual publication *Photographer's Market* (*www.writersmarket.com*). The magazine *Art In America* (*www.artinamericamagazine.com*) has an annual listing of galleries, including a section on photography galleries.

FINE ART PHOTOGRAPHERS

This list of fine art photographers has been included as an inspiration. A colleague and I compiled the list from the heart and based solely on our love and respect for the work of these artists. Their names are listed neither alphabetically nor chronologically but loosely and abstractly under broad categories to encompass their commonality.

There are surely major omissions, for which we apologize, and others which you may think don't belong, but all have been exhibited, collected, or acknowledged posthumously as fine artists. A look at their work should convince any observer that each brings something special to the understanding of art done through the medium of photography.

While many photographers listed in the late-twentieth-century group are still highly productive today, we tended to place them in the era when they first began to have an impact on the art scene.

It was fun putting it together. You can shuffle these names and create your own categories, or add names we have overlooked. Most important is that you can use this list as a jumping-off point to explore the visions of these extraordinary photographers.

FINE ART PHOTOGRAPHERS		
Early Art Photographers	Jacques Henri Lartigue	**Late Twentieth-Century Colorists**
Fox Talbot	Brassaï	
Louis Daguerre	William Klein	Ernst Haas
David Octavius Hill and Robert Adamson	Paul Caponigro	Jay Maisel
	Jerry Uelsmann	Elliot Porter
Peter Henry Emerson	Aaron Siskind	William Eggleston
Lewis Carroll	Harry Callahan	Steven Shore
Clarence White	Diane Arbus	Joel Meyerowitz
Eugene Atget		William Christenberry
Félix Nadar	**Late Twentieth-Century Art Photographers**	
Eadweard Muybridge		**Contemporary Art Photographers**
	Sally Mann	
Mid-Twentieth-Century Art Photographers	Chuck Close	Andreas Gursky
	Jerry Spagnoli	Thomas Struth
Alfred Stieglitz	Cindy Sherman	Gregory Crewdson
Edward Steichen	Sandy Skoglund	Richard Prince
Edward Weston	Hiroshi Sugimoto	Jeff Wall
Josef Sudek	Tina Barney	Andrew Moore
Imogen Cunningham	Nan Goldin	Robert Polidori
Man Ray	Joyce Tenneson	James Casebere
László Moholy-Nagy	Robert Park-Harrison	Nic Nicosia
Paul Outerbridge	Mike and Doug Starn	Wolfgang Tillmans
Harold Edgerton	David Hockney	Alec Soth
Minor White	Joel-Peter Witkin	Désirée Dolron
Bill Brandt	Duane Michals	Philip-Lorca diCorcia
Walker Evans	Bill Owens	Stephen Wilkes
Paul Strand	Nicholas Nixon	
Manuel Alvarez Bravo	Abelardo Morell	
André Kertesz	William Wegman	
Robert Doisneau		

Twentieth-Century Photo Documentarians	Portraits/People	
Henri Cartier-Bresson	George Platt Lynes	Michael Kenna
Helen Levitt	George Hurrell	Lynn Geesaman
Gordon Parks	Irving Penn	Robert Adams
Ralph Eugene Meatyard	Richard Avedon	Richard Misrach
Mary Ellen Mark	Norman Parkinson	Joel Sternfeld
Berenice Abbott	Deborah Turberville	**War**
Lee Friedlander	Sara Moon	Mathew Brady
Gary Winogrand	Helmut Newton	Timothy O'Sullivan
Elliot Erwitt	Guy Bourdin	Robert Capa
Robert Frank	David Bailey	David Douglas Duncan
Russell Lee	Steven Meisel	Larry Burrows
Bruce Davidson	Bruce Weber	Eddie Adams
Danny Lyon	Rodney Smith	James Nachtwey
Larry Clark	Albert Watson	**Architectural**
Concerned Photo Documentarians	**Portraits/People**	Margaret Bourke-White
Jacob Riis	Julia Margaret Cameron	Charles Sheeler
Lewis Hine	August Sanders	Julius Shulman
Dorthea Lange	Diane Arbus	Ezra Stoller
W. Eugene Smith	Yousuf Karsh	Bernd and Hilla Becher
Sebastião Salgado	Seydou Keïta	Norman McGrath
Eugene Richards	Arnold Newman	**Sports**
Fashion	Annie Leibovitz	George Silk
Horst P. Horst	**Landscape**	Robert Riger
George Hoyningen-Huene	Carlton Watkins	Walter Iooss
	William Henry Jackson	Neil Leifer
	Ansel Adams	

PROFESSIONAL PROFILE

NAME: Joyce Tenneson

PROFESSION: photographer, writer, author, educator

WEB SITE: *www.tenneson.com*

HOME BASE: New York City

Joyce Tenneson.

What you would say to students interested in pursuing a life in fine art photography?

Students must be realistic and understand that probably for the first ten years after they get out of school, they aren't going to be able to sell—or sell enough of their work to earn a living. So they really have to think about how they're going to support themselves—if they don't have a trust fund! I find many fine art students don't really understand that a few group gallery shows is not going to provide the income to pay for their apartment rent, food, and all of those living expenses. They need to have a realistic survival plan.

In school they have to minor in something like graphic design or business or something where they can find a job. They need to have other skills, beyond fine art photography to earn money while they pursue their art. Not enough schools give them this advice. Forewarned is forearmed.

In addition to having realistic expectations, what other qualities are needed?

Every fine art photographer that I've seen who has made it, has made it not just due to talent. That's just the beginning! They also have enormous dedication, vision, and perseverance. It's a long journey. They need time to develop their own unique voice.

The photo artists that have really done well are the ones that have a recognizable style, such as Sally Mann, Duane Michals, Irving Penn, Richard Avedon, or Diane Arbus. That doesn't happen over night.

Developing a style: how do they go about it?

That's part of their journey as an artist. Real artists do work that's

Joyce Tenneson interviewing woman featured in "Wise Woman."

true to themselves. They mine their inner territory, and the work that comes out has a real sense of authenticity.

If you had met Richard Avedon, you would know that his images looked and felt a lot like him: very psychologically intense. The same is true of Irving Penn—his work has an incredible European formalism and real elegance. That's the way Penn presents himself to the world.

So the work, when it has a signature style, somehow comes from deep within that person. Finding that style comes through working in the field for some time, continuing to hone your art until it is burnished like a fine jewel and is shining with your own authenticity and your own way of seeing the world.

Do some fine art photography students seem to try to be different for the sake of being different?
The really fine artist with a signature style does not force or push it. It requires perseverance to explore and find it, but the style comes from within—the art that rings true.

Years ago I was with Helmut Newton on a panel about this subject. Students were asking him about his signature style. Newton said: "Everyone who has a signature has an obsession." I think that's true. Your obsessions give you that distinct point of view.

Another example is Joel Peter Witkin. He certainly has a signature style and those are his obsessions. Just look at his work.

How realistic is it to try to convert from fine art into assignment work?
Lots of major shooters have always done some kind of assignment work as well as personal work. Think about Mary Ellen Mark. She does an enormous amount of assignment work, and a lot of those assignments have turned into book projects after the fact. Stephen Wilkes has done fine art photography and continues to do assignments for advertising and editorial.

Many photographers, such as Bruce Davidson and Duane Michals, have done annual reports and portrait commissions. During those assignments, Davidson took time for books such as his early work, *East 100th Street*, chronicling New York City's Spanish Harlem. The work is stunning fine art, yet he continued to earn a living on assignment. Annie Leibovitz has made her assignments for *Rolling Stone* and *Vanity Fair* into art that galleries are eager to carry.

The great thing about it is the assignments can pay for the personal work which often is undertaken with the photographer's own finances.

Is there a clear distinction between fine art and assignment work?
There is a blending of the fields, of the disciplines, which is the reality today. Go to galleries like Staley Wise gallery (*www.staleywise.com*) to see successful

work by all the top assignment shooters such as Herb Ritts, Sarah Moon, Steven Meisel, and lots of others. At the same time their work is being sold as art to major collections, so there's a blending.

Some art schools are behind the times. They keep the students in a kind of ivory tower, telling them that somehow to do assignment work is not as "pure." But in reality nowadays pretty much every photographer who really succeeds does both.

Not long ago, there was more of a division between assignment and fine art. Even if a photographer shot both, they called it personal work, not fine art.

They represent two equal parts of the person's ability. Both can be fine photography. Witness the huge stable of assignment photographers at Staley Wise.

You are known as having shot only on film and without any manipulation.

I still do that. However, for the past two years, I have been shooting digital. I love being able to see my results right away. I love the digital capture because I don't have to scan. It eliminates that step. It has nothing to do with manipulation.

Recently I had to archive my entire forty-year career for a retrospective book coming out in 2007. We are sending out DVDs and CDs everyday, so digital is the norm.

Are students getting the digital background they need?

In the next few years most schools will have made the transfer to digital. But right now some of schools still haven't been converted because they haven't had the money for digital studios. So some students aren't getting the training they need. That's really a shame because those kids are coming out unprepared. In terms of digital: if you're not there, you're not really working these days.

What approach should students take toward getting a gallery representation?

They should participate in group shows as early as they can. Representation comes later. Major galleries have to represent photographers who command thousands of dollars a print, but until you get to that stage, take any exposure you can find.

What is the most important thought you can leave with students?

Have the courage to believe in yourself and persevere. Everyone has some special uniqueness within. The artist's job is to make work that they are passionate about and that is authentic to who they are. It's important to study the history of photography, and to understand where your work fits in this history. There is no quick route to becoming a success. If you have the drive and are willing to put in the hard work, it can be a wonderful journey!

PROFESSIONAL PROFILE
NAME: Karen Amiel
PROFESSION: art dealer, advisor, curator
HOME BASE: New York City

Karen Amiel, curator (right) with fine art photographer, Cynthia Matthews, viewing Robert Polidori's "Central Park, Autumn, 2003" in the FSA Collection.

Do you see a change in today's fine art students?

Students are focused on their careers at such an early age today. When I was in art school, none of us thought about a future career or considered that we were going to earn money right away from making art. In fact it was rather looked down upon, as making art was considered a purer activity divorced from commerce. We knew we might have to earn a living besides making art. But it was felt that first you had to live life and have some subject matter to express. The idea that you need to have to something to say through your art, based on a full life experience, seems to have faded somewhat. The schools are actively pushing students toward careers—it's all very workplace oriented.

Do you differentiate between photography and art?

The issue for me is about being an artist. The fact that someone is an artist using photography as a medium is somewhat irrelevant to the discussion, because I deal with artists who make works of art. Some of them are sculptors, some are painters or collage artists, for instance, and some are photographers. To me, the fact that someone is a photographer is really no different than if is someone is a painter. The medium is simply a means to an end. Others may distinguish between commercial work and fine art photography. But from my perspective it's all the same—I make no distinction. To me they are artists or they are not.

How do you know if a photographer is an artist?

Really, the question is what makes a photographer a fine art photographer as opposed to a commercial photographer. To me it has to do with a special vision that the photographer/artist has. It's something that makes their work individual, so that you're conscious of the content of the work unique to that artist, as opposed to the fact that it is simply a photograph. Really, what's interesting to

the art world is the content, the meaning, the message. It's irrelevant that it is a photograph.

However, what photography has done in the fine art world is to bring fine art to a wider public—simply, I think, because photography is much more digestible, easier to relate to, more easily identifiable. Photography is a recognizable form for most people. Even the person least familiar with, or least trained, in the world of art can relate to a photograph. They are used to looking at photography in newspapers and magazines, in advertising, in family snap shots—everywhere. Artists using photography as a medium have reached a broad public, bringing with it a tremendous amount of enthusiasm, as it isn't necessary to have a huge backlog of information about why and how a piece of art is made.

What are some of the ways photography artists are expressing their messages?

A lot of the photographs done by artists are manipulated photography. That is, photography that has been enhanced, changed in the computer, with maybe one part dropped out and something else replaced or staged. Photography is simply another medium. It doesn't make any difference to me how it's done. That's the big distinction.

When did you observe a changing attitude toward photography as art?

In the early seventies, I was curator of the Arts Council of Great Britain. Though I was in charge of a department of painting, drawing, and sculpture primarily, I started to buy contemporary video and photography. I saw that, all of a sudden, there was a new breed of artist emerging who was making art in film, sound, and photography.

I remember having to make a case to my chairman that I wanted to buy photographs by artists, despite the fact that we had a photography department quite separate from the main collection. In that department, photographs were being collected made by photographers, not trained painters and sculptors who were using photography and showing in the most avant-garde galleries. A Bill Brandt photograph wasn't considered in the same league, to most people, as a Francis Bacon painting. In other words, these artists didn't cross paths in the same gallery space, nor did they cross paths within the same institutions.

What was the next change you saw?

Until the early 1980s, the auction houses had highlighted this distinction between fine art and photography. There were photography sales and there were fine art sales—always separate. The artist who crossed the line—I believe the first who was able to cross that line—was Cindy Sherman.

Cindy Sherman is an artist who happens to use photography as her medium. But she didn't want to be known as a photographer per se; she wanted to be known as an artist. She began by studying painting and later gave it up to study photography.

Another influence came from teacher–artists like John Baldessari at Cal Arts in Southern California, also a conceptual artist who uses photography. He taught an entire generation of students who introduced photography into their work. This is a group of artists who are making setups, sculptural mock-ups of their content and photographing them. The work is shown in the same galleries that show paintings and drawings.

So not only have the gallery and museum worlds embraced it, but the auction world has embraced it as well. But they have embraced it to the extent that a certain group of artists who use photography are really considered part of the painting and drawing world as opposed to the photography world. There are many examples of this: Cindy Sherman, James Casebere, Thomas Struth, Philip Lorca di Corcia, Sandy Skoglund, Thomas Demand, Candida Hofer, and Vic Munoz.

Many of these artists are selling for huge amounts of money—in the hundreds of thousand of dollars. There are few examples where a vintage photograph sells for that kind of money. In certain isolated cases, vintage works by Man Ray or select historical giants have sold for close to one million.

What do you mean when you say fabricated photography?

A fabricated photograph means that the artist has created a set. They build their reality and photograph it. They are not going out into the real world with their camera and taking photojournalistic or landscape photographs. They create sculptural models. Sometimes there's a scene, there's a narrative, some kind of a story happening in these photographs. There are many examples where the scene has been set up physically, where everything is made of cardboard and paper or clay. The artist has constructed the entire set, and then he has photographed it. Alternatively, someone might create the scene in a set that's very small and the photograph is blown up to six feet.

Are there works of photography that have the conceptual underpinning to be fine art but are created in a more traditional way?

Richard Misrach is one example. What he's dealing with when he takes a close-up of the landscape is with form and line and light. He's still handling most of the same considerations as a photographer does in taking a landscape shot. It's just that he's come up really close on it, so you don't perceive what it is at first. You think it's something else. Or you're not sure what it is—it is a

design, a pattern. But when you move back you realize, wow, that's a close-up of the ocean or the sand. There's a conceptual basis to his landscape images in my mind.

Then you take someone like Japanese artist Yasumasa Morimura, who dresses up as other people. He's doing what Cindy Sherman is doing. The photography is recognizable but he's creating a narrative around a persona. He's taking on the persona of somebody else. He's the photographer but he's also the subject.

Generally, I see really very clear distinctions between the fine art side of photography and the photojournalistic side. However, the line gets a little blurred when you start dealing with someone like Larry Clark. And Larry Clark makes me think of Nan Goldin, and you have another type of photography taking place, which is slightly set up, but it's really more about sociological relationships. This kind of work has more in common with Diane Arbus than Richard Misrach or Gilbert George. In other words, these artists are looking at groups of people and how they perform in a given environment. Somewhat like cinema verité.

Where are photographers like Gene Richards in all of this?

It gets very blurred. That's why you'll start to see lots of photographers who used to only be shown only in photography galleries being shown in fine art galleries, because the line is getting fuzzy. And their work, though representational, embodies a universal humanistic quality that takes it to the level of fine art rather than commercial photography.

For photo students who want to be artists, is there any special temperament needed?

My criteria, what I look for in somebody who has talent, and I can tell it almost instantly, is the person that has a pure vision. I don't know how they get it—or where they get it from—but it's a uniqueness in delivering information. It's the kind of work where you say, wow, that person's showing a new or fresh way of looking at something.

They are not drawing off an earlier generation's work. But if I see people who are ripping off Duchamp and ripping off Andy Warhol, I ask myself why. What is the point of doing that? Those artists did it—brilliantly—nobody else had done that kind of work before Duchamp did. He has a uniqueness of vision and an individuality that hadn't existed before. He made everyone look at art in a new way, and became art historically significant for all time. Now, I'm not saying everyone who comes along can make that kind of contribution, they're clearly not going to—but to start your career copying someone else, to me is a disaster.

How do they find this artist's vision that you've spoken of?

You have to really dig deep. My advice would be to really try to understand who you are as a person. What is it you want to communicate? It has to be something unique and it's got to come from inside.

To use an extreme example, if I go to see an exhibition by Van Gogh, I know that it didn't matter to him what was going on anywhere else on the planet except in his head, in his studio, or between his brain and hands. That was all that really mattered to him. It was a very honest relationship he had to his work. And many other artists were the same. These are people who had no choice in what they did.

For the most part you can tell somebody who's the real thing. If you can go to an exhibition and think, "I really felt the power of that artist, I felt they really had something to say. I might not even have liked it, but it rang true"—those are the artists worthy of respect.

Is this an easy process?

No, certainly not. They have to have courage—courage is a really big issue. Courage to do this work year in and year out against all odds and against the possibility of total failure. If they don't make any money the first year, and the second year, and the tenth year, then they must find jobs waiting on tables, working in bookstores, installing other people exhibitions, or teaching if they are talented and lucky. They must be prepared to do whatever it takes.

How do you suggest approaching a gallery owner or curator?

Unfortunately, more often than not, it's who you know. The chance to have your slides seen and taken seriously enough to lead to representation is close to non-existent. Anything unsolicited is problematic. Everybody needs an inside track one way or another.

What can a student do?

What's valuable is getting involved in shows and certain exhibitions that are open to students or young and emerging artists or having an exhibition in your college or graduate school. Let's say you have a graduate exhibition, then you should make sure that all the gallery directors get a notice, do blast e-mails, do anything you can to make people aware of the show. Dealers are looking for new, young talent and are watching the graduate exhibitions.

Another route to become seen is submitting your work to the Public Art Fund, a non-profit arts organization that presents the work of contemporary artists in New York's public spaces. You might find ways to get on the Web, or have your own Web site affiliated with one of the Internet sites dedicated to contemporary art.

The truth is I never saw any unsolicited work that I valued. But if a friend calls me and says, "I met this artist at a cocktail party the other night. I went to their studio and the work's really interesting, you should go take a look," I'll go. So mingling and getting out there and socializing is important—which some artists don't understand.

Sometimes artists, if they are interesting, have been recommended by other artists. Let's say you're an assistant to a well-known artist, often that artist will come forward to their dealer or will call me and say, "You should take a look at the work of my studio assistant." That's how I first heard about Christopher Wool in the early eighties. He was Joel Shapiro's studio assistant. I included him in an exhibition I did.

Try the magazines. The magazines will often do articles or feature stories on who the hot young artists are or artists seen to have potential. You could send your work to some of the magazines such as *Vogue* or *Elle Décor, House and Garden, Metropolitan Home*, the *New York Times Magazine*, or *Dwell*. They do features on young artists. Or you may get a painting or photograph placed in a room in one of their feature stories.

Can you suggest a good source of information about galleries?

Art In America has a yearly guide with a list of galleries according to specialty all over the country. *Artnet.com* is a good Web site, with a good search engine to look up photography galleries.

For reaching corporate art buyers, who are usually termed "art advisors," there is an organization called the International Association for Professional Art Advisors (*www.iapaa.org*) There are many books on specific corporate collections, which will tell you who's in charge of buying art. All the big corporations have collections—IBM, Citibank, Prudential, Paine Weber, Duetchebank, Seagrams, Chase, and lots more. One of many books on corporate collecting is Margory Jacobson's *Art for Work*.

Auction catalogs are good sources of information of what's going on at the moment—to learn what's cutting edge contemporary photography. Between looking at Sotheby's, Christie's, and Phillips, which is distinguishing itself as a house dealing with contemporary photography, you'll learn a great deal.

Do you have a final word for fine art photography students?

They must be dedicated to it. They must believe it's what they do—that they have to do it—that they have no choice. It has to be at that level of dedication and commitment. When I said that the message has to come from deep inside the artist, I meant that there's no way to make that information resonate with anyone unless it's genuine. It comes from a place that's very personal.

Stock Photography

When considering a career in photography you may want to include stock photography in your thinking and planning. Stock photography is intertwined in almost all aspects of the photographic world, both for photographers and especially in lots of careers for picture professionals.

DEFINITION OF STOCK

What is a stock photograph? The definition is straightforward: a stock photograph is an existing photograph that is available in a photographer's files or on a stock photo agency Web site to be loaned (licensed) for reproduction use to a wide variety of clients. Stock photographs are different from assignment photographs, which a photographer is commissioned by a client to create. Stock already exists, whereas assignment is potential or proposed photography. Ownership is the key issue. If you took it, it's yours (with only a few exceptions, as you'll see in the copyright chapter). And, it's important to remember that you are NOT "selling" photos, though that's the easy term and commonly in use. You are actually licensing limited rights to use the photo.

Why the Word "Stock"?

The word can cause confusion for those searching the Web, since *stock* to the general public refers to company shares traded on a stock exchange. (I have a few photographer friends with the word *stock* in the name of their Web site. They get hits from people seeking financial information.) But the term stock with reference to a photograph means it's available, it's "stock on the shelf."

Where Does Stock Come From?

Stock comes from five sources:

1. From a photographer's personal shooting—that is, work derived from independent projects, photographs on which you hold the copyright (see chapter 17).

2. From photographs created specifically with stock in mind—that is, photographs based on the photographer's sense of market needs or at the suggestion of a stock agent.

3. From assignment outtakes—these are photographs available after an assignment has been completed and after any time restriction has expired on the film or digital files you provided.

4. From stock productions done with agency participation—joint ventures. Cooperation between photographers and agencies in financing the production of stock is available to a select group of photographers who have proven their value to an agency.

5. Royalty-free. This form of stock was called by the derogatory term "clip art" when it first appeared. Royalty-free shooting occurs when the photographer accepts a fee for shooting stock and turns over all rights to the company selling the images.

DIGITAL STOCK

All stock today is digital stock. What's important to understand is that every aspect of stock—except the original idea, which still begins in our imagination—is being done in a digital format. That includes the marketing methods for licensing pictures, delivery systems, and, of course, the creation of images. Virtually all agencies are accepting only digital files—either film images that you have scanned or digital captures.

CAREERS IN STOCK PHOTOGRAPHY

If you haven't had experience with stock photography, it's important to be familiar with the opportunities available to you and the realities of that part of the business. In many ways stock photography is a microcosm of the larger world of photography. Many of the same career possibilities available in the wider world of photography exist in stock. There are photographers who shoot specifically for stock, and others who make stock an adjunct to their assignment careers. A few of the larger stock agencies actually have photographers on staff.

Stock Agency Photo Editors

A key role is played by the photo editors, who contribute in large part to the success of a stock agency. All images that come in from member photographers must be reviewed for both quality and content; decisions are made on which to keep on file. This is a very satisfying job, because you are helping to shape a photographer's career as well as adding to the economic health of your agency.

Producing Stock

More and more stock agencies are collaborating with their photographers on photo shoots. A representative of the agency sometimes helps shape and direct the shoot to ensure that the images make the best, most saleable stock. Stock photography projects require production managers and stylists. The stock agency staff might fill these positions or they may hire freelancers. There are also times when individual photographers producing their own stock will hire producers and stylists.

Account Executives for Stock Sales

A more recent development in the larger stock photography agencies is the role of an account executive. This person handles a client base, assigns a researcher, and negotiates rights and pricing.

Researchers

The next step in the life of a stock image is in the hands of researchers who answer requests from clients. Many clients search a photo agency Web site on their own for the photos they need by simply putting in key words, and then later license the approved images with the account rep. But other clients rely on a team of photo researchers working for the agency, who collect images from all parts of the Web site of the agency's files and post them to a Web-based "light box" for client viewing. These days, all major agencies have their collections in digital form. Some smaller agencies continue to scan older "classic" film images from their collections, to complete the conversion to digital, but it's a dwindling number.

Naturally, digital experts of all stripes are in great demand—there is a need for everything from key-wording the images to be filed within the agency to managing the Web sites, and everything in between.

Film Images as Stock

In most cases, agencies are accepting only digital images for new contributions. But they routinely scan the best (most timeless) of film images in their files to make

them available for the Web sites and for digital transmission to buyers. If you have film images that are good enough for stock agency use, you can either provide scans (doing them yourself to agency specifications or using a reputable scanning source), or you can have the agency scan your accepted images for a fee.

HOW IS STOCK PHOTOGRAPHY MARKETED?

There are a number of ways to market stock photography: through a stock photo agency, through a portal agency, or through your own Web site.

While some photographers market their own work to stock buyers, using Web sites for the purpose (though in the explosion on the Internet individual Web sites are in danger of getting lost in the shuffle), others leave that aspect of the business to one or more of the many stock photo agencies in the United States and abroad. In addition to handling archiving, billing, and licensing of reproduction rights to clients for a percentage of the reproduction fee, many agencies spend time and money researching and opening new markets for the use of stock photography with capabilities way beyond the average individual. In the United States, the Picture Agency Council of America (PACA) is a trade association that represents the interests of member photo agencies (*www.pacaoffice.org*). This is a good starting place if you hope to find an agency to represent your work. However, it's important to remember that this will not be likely to happen early in your career. You'll need an excellent body of work to show an agent.

The Giants

In competition for the billions of dollars spent each year for stock photography, two mega-photo agencies have taken over a huge share of the marketplace: Getty Images (started with the lucre from the Getty Oil family) and Corbis (Bill Gates's baby under the Microsoft Corporate umbrella). You'll see later as the story unfolds that Jupiter Media is nipping at the heels of the giants. More on Jupiter when we get to the section below on royalty-free images.

These two "giants," Getty and Corbis, have swallowed up dozens of large to mid-size stock agencies, amassing huge files of varying topics and styles. Searching for photos at either of these agencies, a client can find everything from sports to life style, from underwater to photojournalism. The goal of these two entities seemed parallel—to corner the market on stock photography. They propose to offer clients one-stop shopping for stock photography. Heavily discounted prices are available to clients who enter into a volume purchase contract. This will benefit the agency but usually shortchanges the individual photographers, who may only have a few photos in the volume sale.

After the Giants

What's left after the lions have had their feast? There are a diminishing number of agencies to live off the scraps. But a relative handful of boutique and mid-sized agencies are still functioning very well by giving clients some variety as an antidote to the sameness of what the big fellows have to offer. The emphasis in the mega agencies is toward advertising and what is often called the commercial market. Agencies that specialize in editorial, particularly in textbooks, seem to be holding their own.

RIGHTS-MANAGED VERSUS ROYALTY-FREE

When a photographer retains the ownership of his images and is able to license them for usage fees, these photographs are termed "rights-managed" photographs (R-M). The terms came about as a way to distinguish those pictures from royalty-free (R-F) photographs. In most cases, royalty-free photos are sold, not licensed. This is a reversal of everything most photographers fought for since the 1950s—managing their own images and getting paid each time they were used.

The Beginning of the Change

A dark cloud appeared on the stock photography horizon about twenty years ago, when some entrepreneurs started a company based on marketing "free" photos. They hired photographers to shoot photos especially for the company, which would own all the rights. The photographers got a one-time payment for the shoot without any prospect for residual income, and in most cases they were required to sign away all their rights. The company also bought rights to certain existing photos, and in this way built collections of wholly owned photographs. Under this system, a client/photo buyer could purchase a CD of images, any and all of which they could use, over and over again, at any size and for any usage—from advertising to place mats—and never pay any additional fee beyond the cost of the CD, which was a few hundred dollars. The purchasing patterns for royalty free have become more complex in recent years, but this was the initial method. Regarded by photographers as another form of clip art, royalty free was decried by many as short-sighted at best, and at worst, an abomination that could mean death to the traditional stock business. Some photographers chose immediate compensation in exchange for the rights to their photos. Perhaps the promise of immediate payment outweighed the possibility of future residual income from stock.

Impact of Royalty Free

It turned out to be detrimental to some of the photographers who sold off their rights, thereby limiting any future income from those photographs. And it did make a dent

in sales of stock photography, especially among the low-end client who didn't need or want to pay for the most creative images. But when the euphoria wore off, some clients realized that when they searched their collections of disks of royalty-free photos, they found that these images didn't always measure up and they certainly weren't fresh. So the clients found themselves returning to search among the "rights-managed" images (stock photographs owned by the photographer).

Enter Jupiter Media

Since the beginning of the royalty-free era, the concept grew until, unfortunately but inevitably, royalty-free companies proliferated. They had found a product the market wanted. Then a new company, Jupiter Media, in quite a phenomenal business increase since 2001 now ranks third in gross revenues behind Getty and Corbis. (See the profile on Jim Pickerell in this chapter. He keeps tabs on changes in the industry.)

PORTALS

Many photographers found themselves stranded when the midsized agencies with which they'd had a productive and lucrative relationship disappeared—chewed up and swallowed by the giants. Some photographers left the new entities into which their agency had been merged because they didn't agree with the pricing policies; some photographers weren't prolific enough to suit the new agency so their contracts weren't renewed.

The response to the dilemma created by these mergers was that enterprising stock photographers and agents created a new entity known as a "portal." Most photo buyers want to go to Web sites that have hundreds of thousands of images to choose from, in order to see as much as possible in one place. Unfortunately, most photographers and mid-size agencies can't offer enough images on their individual Web sites to attract these clients. The portal provides an ingenious solution.

Essentially, the portal is a gateway to give the photo buyer access to a large group of agencies and individual photographers in one location. The benefit for the client who has not found what they need at Corbis or Getty is that *instead of being limited to the style or tone that comes with images chosen by the two "giants,"* they can see a large collection within the portal. For the photographer, portals are like being in a good mid-sized agency, but the artists often handle their own price negotiations (historically an agency function). Among the better-known portals are Alamy (*www.alamy.com*), Fotosearch (*www.fotosearch.com*), and IPNstock (*www.ipnstock.com*).

Businesses Spawned

A variety of other businesses have come on the scene to serve individual photographers who aren't represented by the mega-agencies. Digital asset management is the photographic "elephant in the room," and in the early transitional days of digital, nobody talked about the need for managing digital files. It's a huge, burdensome part of the digital photo business. There are companies who offer to take it off your hands—for a price. Unless you enjoy and know digital technology, you might be better off doing more shooting and leaving asset management to the experts. There are new companies entering the field every month, or so it seems. Look at Digital Railroad (*www.digitalrailroad.net*) and Spitfirephoto (*www.spitfirephoto.com*) for a sense of what this new breed of company can offer.

THE NEW ECONOMICS OF STOCK

The proliferation of royalty-free images coupled with fewer outlets for rights-managed images means that the income stream for stock photographers has been sharply affected. The economic reality is that the newcomer to the field must keep costs in line for any production of stock and balance the costs of photo production versus the projected income that might be generated.

WHAT IS YOUR PLACE IN STOCK?

Having looked at the economic realities, it's clear that stock is only for the determined, the dedicated, and the ingenious photographer. You'll need to use imagination and flexibility to create stock that you can afford to market in the mega-agency or portal climate.

Now that you have the overview of the industry—and you aren't dismayed—how do you begin to build your stock photogrpahy? Base your stock production on assignment outtakes, personal work, and portfolio shoots. If you have to shoot for your portfolio, then do it with saleable stock in mind. Do your best to plan shoots that are manageable in costs. Use your ingenuity to produce excellence that doesn't cost a fortune. Work with topics or locations you have at hand. Mine the fields in your area. Finally, research until you understand the style and concepts needed.

History of Style in Stock

Over the years the style of stock has changed many times. It started as generic, idealized photographs, made a swing to a softer, more humanistic style, then to a

variation of gritty realism. Now, to all that, add offbeat angles, severe (almost odd) cropping, and images with a sense of pace—fast-moving people in a fast-moving world are the norm. It's all driven by what the advertisers think the consumer relates to.

Setting Your Style in Stock

Your best bet is to study the current style trends in photos you see in ads and in magazine stories. Analyze the color tonality, style of model's clothing, the type of gestures, and use of body language. Pay careful attention to propping, models, locations, set decoration—these are essential to any setup shooting you do for stock.

Whether you are marketing through an agency or on your own, you can learn a lot by looking at the Web sites of major agencies. BUT—do not copy any of those images, since you will be violating the federal law on copyright. Use them only as a bellwether for the level of creativity you need to reach in order to compete.

Concepts in Stock

Most important are the concepts behind a stock photograph. It's been said by successful stock agents that they are not just looking for good photographers—they are looking for good photographers with brains. Stock photos are icons and are used by clients who want to sell a product or service by first selling a concept. Concepts can include "permanence, stability" and "dependability or traditional values" (Greek columns, stone walls, fences), or "warmth, nurturing togetherness" (family photos), or "cooperation" (barn raising, teams).

With the help of your agency or through your own your research, try to pinpoint what's needed and what's requested. If you have a stock photography Web site, keep track of what topics or concepts may be requested that you didn't happen to have. Use those as your shooting list.

If you are having trouble getting organized or thinking of topics, you may find help in my previous book *How to Shoot Stock Photos That Sell* from Allworth Press, which contains thirty-five assignments and more detailed coverage of the stock industry. Also, go to the Web sites of some of the major stock agencies to see what categories they use. Take a look at *www.pro.corbis.com*, *www.gettyimages.com*, *www.jupiterimages.com*, and *www.masterfile.com*.

Diversity

If you have an interest in shooting for stock, be alert to multiculturalism. Advertisers realize that cultural and ethnic diversity and the subtleties of expressing not just the color of a face, but the foods, flavors, and textures of a culture must resonate in

a photo. Photographers who shoot stock keep an eye on the demographics to see the fastest growing ethnic populations in the United States.

In-Depth Coverage

You can use your interest in breaking into stock as an adjunct to building your portfolio for assignment work. The best way to start is by planning a stock project. Assignment clients, stock agents, and other buyers want to see coverage in depth. That means various executions of the same concept or area of interest.

For example, if you are building a file of photographs of family scenes, you will want to accumulate eight to ten family scenes covering five different concept executions for each family, plus horizontal/vertical and wide/close-up pictures— that's in-depth coverage. Just to make clear what's really required, do the math: ten photo scenes times five concepts for each family scene is fifty photos. Then if each concept is done in horizontal, vertical wide and close-up angles, that's four times the fifty, giving you two hundred. Remember this number includes only the select photos good enough to send an agency. To get this yield of two hundred select photos you will have shot hundreds more that are rejects never to be seen by an agency or client. It's a lot of work but indicates a goal for what you need to build a credible stock file.

GETTING AN AGENCY TO REPRESENT YOU

Can you get into an agency? How difficult is it to gain representation? To all of these questions I say: though it's more difficult to find representation in a traditional stock agency, it is possible. Every agency is on the lookout for the next new talent. Just understand the challenges and go armed with perseverance. Even in the depths of the depression of the 1930s, new businesses were started. New faces and new visions will always be needed.

Research is your best tool for finding an agency. Explore all possibilities: understand the function of a stock agency, assess what you have to offer, and search until you find the right match. As you go through the process, remember that your search may lead you to believe you'd rather handle the business yourself.

What's Your Relationship with an Agency?

A stock photo agency is a marketing arm for photographers and a photo source for buyers. An agency provides buyers with quick access to a wide variety of excellent images. For most photographers, agencies can open markets far beyond the scope of what might be achieved by individuals. Agencies license rights to photographs on your behalf; you provide the photographs that keep them in business. You are partners.

How Are You Paid?

Agencies negotiate the fees that accompany photographic usage. The agency simply charges whatever fee is appropriate to a client's usage—and a fee as high as they can negotiate, though client volume contracts with stock agencies will affect the prices, bringing them down. It's an extremely competitive world.

The photographic reproduction fee paid to an agency by a client is then split between agency and photographer. The percentage paid to a photographer varies with the agency. Traditionally it was 50/50, a percentage that lasted for many years, but then it evolved to 60 (agency) 40 (photographer). Some sub-agencies or portals each take a cut, so the percentage can go down accordingly. In addition, there can be fees for preparing your photos for file (scanning, key-wording), so be sure to investigate these when considering an agency. These cost needs to be evaluated based on the amount of sales you're getting through the agency. However, it's important to remember that when your agency does well, you do well. If that's the case, then the preparation costs may not be a burden. No aspect of stock is an instant bonanza. If you approach agency representation with realistic expectations, your chance for success will be greater.

Finding an Agency

As pointed out earlier, an excellent source of information is PACA, the Picture Agency Council of America, which publishes on their Web site a directory of its member agencies, including their specialties (*www.stockindustry.org.*) A listing of agencies is found also in *Photographer's Market*, published by Writer's Digest Books (*www.writersdigest.com*). Talk to other photographers.

Based on what you've learned from visiting their Web sites, match yourself with an agency. Be realistic about what you have to offer. Generally you'll need a few years of professional experience under your belt to have value to an agency. But that doesn't mean waiting to organize stock. Think stock, shoot stock—and then, when you have an impressive collection, make an approach.

Generally an agency's Web site will list the way they want to be approached and give submission guidelines. Many agencies today have a fact sheet they send out describing exactly how they wish photographers to contact them and submit work for consideration.

If you start a relationship in a professional manner, it has a much better chance of success. Follow their guidelines to the letter. Include electronic and printed samples, and biographical information, including the areas of photography you are interested in pursuing. An agency is as interested in the person—the brain behind the camera—as they are in the photographs they see.

Concluding a Deal

If you and the agency are ready to work together, they will offer you a contract. Read it carefully. Decide if there are any provisions you find difficult to live with—consult other photographers. Next, have the contract reviewed by a lawyer who is knowledgeable in photographic matters. Your work will be tied up by this contract for a considerable time. Be aware of what it means.

PLAN FOR THE LONG TERM

When your decision is made to go with a specific agency, commit yourself whole-heartedly. Contribute photographs regularly, listen to agency advice, and shoot what you do best within their requests. It will take at least two or three years to have a clear view of how well you and the agency are doing with your work. The more pictures you have on file (well edited by an agency that knows its market), the greater your chances for sales.

USING A PORTAL TO MARKET STOCK

Much of what is said about preparing yourself and your work for a stock agency holds true for working through one or more portals. You will benefit most from having carefully produced, carefully edited images. Some portals have a policy of reviewing work before accepting. Others will accept most of what is submitted—within normal professional parameters. It's in your best interest to edit stringently—if you have to pay for key-wording or other services, make sure to submit only your very best images.

Here's good advice given by one portal company: "Before contacting us, we invite you to view work by other members of the network and judge whether your photography stands up against the quality presented. Please note that we prefer to work with digitally savvy photographers who can scan, transmit, and caption images electronically."

MARKETING YOUR OWN WORK

You might make a well-thought-out decision to set up your own business selling your stock. Or, like some photographers, you will stumble into the selling of stock without having made a conscious decision to do so. It just happens—a few phone calls, a few requests, and you are selling stock. However, to build a successful, long-term

stock business after an initial (accidental) foray, you must be aware of the pitfalls you face and the need for the professional planning.

There are some real benefits to selling your own stock, at least for a brief time early in your stock career. Handling your own work gives you the experience to understand what kind of time and skills are needed and helps you to gain an appreciation of what a good agency or portal relationship would do on your behalf.

Here are some good reasons to market yourself:

• Profit. You set your own prices and do your own negotiating.

• Productivity. You usually know your own photo files better than an agency can. You should be able to do a more accurate pull from the files, which could result in a higher yield of sales per request.

• Opportunity. You may have a lead-in to assignments. By having direct contact with the stock buyer, you may convert a stock request into an assignment.

• Marketing. When handling your own sales, you have some direct contact with buyers. You can learn the specific needs of their market—and sometimes find out about their future projects. You can then plan your stock shooting with their needs in mind.

• Control over the business. You run the whole shebang. It's your show in every detail. Some photographers find this complete control very appealing.

The main reasons for not selling your own stock and for going with an agency are:

• Loss of shooting time. Running the business cuts into your creative time.

• Overhead. Many photographers don't acknowledge the real costs of selling their own stock.

• Limited marketing capacity. You can't be in touch with as wide a range of buyers as a photo agency can.

It boils down to two questions: First, what are your expectations for finding an agency? Is that route open to you at this stage in your career? Second, are you temperamentally suited to running a stock business? You may enjoy handling the business details yourself; some people do. On the other hand—you may enjoy the photography exclusively and work better without the clutter of extra work.

Keep in mind that being a photographer is a full-time occupation. Being a photo agent is also a full-time job. Either you add a person to your staff or you divide yourself in half. If you decide to handle both functions, photographer and agent, understand that you will be spreading yourself thin.

The good news is that many of the paperwork burdens of pre-digital business—like, tons of paperwork—have been removed. The less cheerful outlook is the much greater

investment needed in technology. In addition to your digital camera equipment and lighting, at a bare minimum you'll need two computers: a laptop to take on the shoot and a desktop computer with calibrated monitor, scanners, and external hard drives for storage. That's before preparing images for the Web site and setting up a system for Web-site management.

As with the rest of the photographic world, there is a niche in stock for the dedicated person. Your success in selling your stock is in direct proportion to the commitment you bring.

PROFESSIONAL PROFILE

NAME: John Kieffer

PROFESSION: photographer, stock agent, writer

WEB SITE: *www.KiefferNatureStock.com*

HOME BASE: Boulder, CO

Nature photography has wide appeal. Did you start out wanting to be in the field?

I've always been a nature lover and dreamed of having a job outdoors. I liked backpacking, hiking—everything about the outdoors. In college I still dreamed of being a naturalist, so my counselors advised zoology. I ended up with a master's degree in entomology.

Afterwards, I found a good job in marketing for a company making scientific equipment, but I really hated it. After seven years, I was a casualty of the 1980s downsizing. I took this as an opportunity to change professions and used savings to give photography a try. I got a view camera because I loved the work of Ansel Adams and David Muench.

One of the most life-changing moments was when the Sinar view-camera rep said to me: "John, you should be a photographer's assistant." Thus I was born. I had been a devoted amateur but the minute I started working with pros, I realized just how little I knew. Suddenly I was working with successful photographers, stylists, lighting with strobe, testing with Polaroid, the works—it's so different from taking a snapshot. The wonderful thing I found out about assisting was that I could work with great photographers, learning while being paid. I still believe that is the very best way to learn. I even went on to write *The Photographer's Assistant*, a book about assisting.

How important was your business background in sales and marketing as preparation for a photographic career?

I would have been completely incapable of doing any of this if I hadn't been forced to learn some basic business.

Now I have my own stock business, and I look at photography as a product line. That may seem a little crass and uncreative, but the fact is in order to succeed, photographers must learn who has the budget in the photo world, then produce the imagery photo buyers need.

In my stock business I'm besieged by people who want me to rep them. A lot of them are good nature photographers, but their biggest flaw is they don't shoot what people want to buy. What buyers want are shots that convey something immediately—icons that relay a message.

What kinds, and how many, photographers do you have in your stock agency?

I represent about thirty-five photographers—most shoot some type of nature or people experiencing the great outdoors. People photography is the most valuable imagery, while wildlife is the most difficult to sell.

How are you expanding your agency?

Nature photography has always been a tough business, so we began by building a strong base of Colorado imagery and clients. We diversified by adding photos like hiking, skiing, rafting. Ideally, these images have universal appeal. Now it's the most profitable part of Kieffer Nature Stock.

Where does the Web fit in to the marketing of your stock agency?

We're a niche stock agency doing what I love and know. When we started in business, all marketing was done in print: we advertised in sourcebooks, sent out postcards. Very little of our marketing was wasted, because our message could go to a targeted audience of photo buyers. But today everything is on the Web—everything is keyworded. And there may be a million Web sites with nature as part of the name.

Searching for new talent was feasible for a photo buyer back in the days when they received print advertising. Now, when they do a Web search they reach countless nature sites. The images may be quite good, but how can they separate the professionals from the wannabes? For example, the photographer may not return e-mails immediately or can't send properly prepared digital files. There are many pitfalls for the buyer. In some ways the Internet has forced buyers to go back to the major agencies like Corbis and Getty because they can be sure of dealing with professionals.

When designing your Web site, add phrases that instill confidence—even using the word "we" instead of "I" helps. Indicate you understand the photo business and possess a level of digital capability. Photo buyers now expect to download a digital file almost immediately. Don't list your usage fees on your site. Contact with real photo buyers can be a valuable learning experience. And add copyright notice or watermark on each image.

What is the best thing about your profession?

Photography allows the individual to be creative and have an impact. Today, so many people are just a brick in the wall. For instance, last year a publisher commissioned me to do photo books of both Boulder and Denver. Where else can one have such freedom, to take a project from beginning to end following your creative vision?

What is the worst thing about your profession?

I dislike the multitasking. Besides being a good photographer, I have to keep up with many technologies, market the stock agency, bookkeeping—it saps your energy.

Is the fantasy of nature photography as a way of making a living realistic?

Yes, if you're dedicated, determined and realize it's a business. I've condensed my twenty years of professional experience in my Allworth Press book *Mastering Nature Photography—Shooting & Selling in the Digital Age.*

PROFESSIONAL PROFILE
NAME: Jim Pickerell
PROFESSION: photographer, writer, stock photography agent
WEB SITE, SELLING STOCK NEWSLETTER: *www.pickphoto.com*
WEB SITE, STOCK CONNECTION PHOTO AGENCY: *www.scphotos.com*
HOME BASE: Rockville, MD

You have been involved with many aspects of the stock business over the years. What are your current activities?

I publish an online newsletter called "Selling Stock," updated at least weekly with breaking stories of news and analysis of the stock-photography industry. Every two months I send out a sixteen-page printed version of the best stories published online in the previous two months. Subscribers can choose either format. In addition, with my daughter Cheryl Pickerell DiFrank, I run a stock agency called Stock Connection. Cheryl and I publish the book *Negotiating Stock Photo Prices*, now in its fifth edition.

How do you get information for your newsletter?

All the stock agencies give out periodic information particularly through their Web sites. Getty provides information to investment analysts once a quarter and provides a lot more operational detail than most other public companies. Given their dominance in the industry, this information provides an important perspec-

tive on what is likely to happen in the whole industry. I also get information from talking to photographers, agents, doing surveys, and visiting the Web sites of the major agencies.

Who are the power players in the stock agency business right now?

As most everybody knows, Getty and Corbis are the two majors, with Jupitermedia moving up fast. I estimate that Getty controls about 60 to 65 percent of the commercial side of the business (advertising and collateral; not including editorial sales). With that much dominance what they do has tremendous impact on everybody else. Corbis is next in size with about 12 percent of the total market. Jupitermedia is growing rapidly and will probably generate over $100 million in stock photo sales in 2006. They've been very aggressive in acquiring companies and content.

After these three stock agencies what do you have?

There's nobody else even close to the size of these three. The next largest are probably Amana in Japan, *Alamy.com*, and Masterfile.

Where did Jupiter come from?

Jupitermedia basically started as an Internet company with no involvement in photography. Then they purchased *art.com* and *photos.com* and saw the potential to grow the photo side of the business, particularly if they wholly owned the imagery. That division is now called Jupiterimages. They started with four divisions but sold off two so they could invest more in the photo part of the business. What makes Jupiter different from other agencies is that they came into the industry aiming at the low-end mass market and providing cheap photos by subscription. This is opposite to Getty Images and most other image suppliers who aim for the high end—like the advertising market—and seek to maximize sales at higher price points rather than going after the largest possible number of buyers regardless of price. Jupiter has some business in the high end but most of their business is royalty free and subscription-type royalty free.

What is the balance of the market outside the big three?

There are still a number of smaller "niche" agencies that are doing well. These are the agencies with special topics or expertise such as those handling stock photographs of medical, underwater, animals, or regions like Latin America or China and many other specialty topics. Actually if you look at the list of stock agencies in PACA (Picture Archive Council of America) it has been growing. Though almost all stock agencies are selling both royalty-free and rights-managed—very few are still only rights-managed.

What are the changes in fee arrangements with clients?

A growing trend in the marketing of stock is in offering subscriptions that give the user access to hundreds of thousands of stock images for a flat per-month or per-year fee. Subscriptions can range from $100 per month to $300–$400 per month or even $10,000 per year for unlimited access to sets of images that range in the hundreds of thousands and cover all subject categories. The higher priced subscriptions give clients access to a better selection and higher quality images. By making images available to these buyers it is expected that there will be a dramatic increase in the number of stock photos licensed.

Will photographers share in this expansion? Is there enough money in this market to divide with photographers?

It seems clear that subscriptions and low payments will bring a significantly larger number of people into the market for stock photography, but given the extremely low prices I question whether these sales will actually grow worldwide stock photo revenue. I am concerned that the availability of these low-priced options will begin to cannibalize traditional royalty-free and to some extent rights-managed sales. If buyers can find $1 to $5 images that serve their needs, as well as ones that costs $250, it is highly unlikely that they will buy the more expensive image. It doesn't take many such sales to bring the total revenue for the industry down.

In addition, as the market has changed the image producers tend to get a much lower share of the total revenue collected than was the case ten to fifteen years ago.

It's hard to see how the current emphasis on maximizing the number of units licensed will greatly benefit professional photographers. In order to sell at these low prices, Jupiter has focused on wholly owning imagery and thus is buying out photography collections from many photographers. In addition the trend at companies like iStockphoto.com is to get many of their photos from amateurs who have no serious interest in making a living from photography. Professionals will now be competing against thousands of serious amateurs who occasionally produce some excellent photographs. *Wired Magazine* calls this trend *crowdsourcing*, and the stock photography business is a prime candidate to be impacted by the crowd.

How does stock agency size affect photographers and client?

Though clients generally want the comprehensive coverage big agencies can offer, some buyers actually prefer a slightly smaller stock photo portal or stock agency. If you go to Getty and look for couples on the beach, you might find 10,000 images. Nobody is going to look through all 10,000 pictures. You may

have a great image, but if it is number 5,000 in the search return, no one is ever going to see it. If your image is with one of the smaller agencies or portals, it might be much higher up the search-return order and therefore have a better chance of being seen.

Where do Portals come into play?

It depends on how you define a portal. In one sense Getty is a portal, in that they represent seventy other stock agencies, i.e., third-party suppliers, in addition to their own stable of photographers and their own wholly owned imagery. But the majority of portals are like Alamy, which only represents other agencies and other photographers. They don't own any content (photographs) themselves. Then there are other distributors, like *Fotosearch.com*, which made its reputation as a royalty-free distributor and is now handling rights-managed photos from some suppliers as well.

Most royalty-fee producers have placed their images with one hundred to two hundred distributors around the world. Each of these distributors is a portal because they have a Web site where they put together images from a number of different sources and handle the marketing side of the business.

It used to be that agencies accepted images on consignment from photographers and handled the marketing and collecting of fees for uses as well. Now, to a great extent, the marketing side of the business is separate from the production and preparation side. Many smaller agencies are focused on collecting images from a group of photographers and preparing these images for marketing. Then they turn the digital files and metadata over to a distributor or portal to do most of the actual marketing. Distributors like this system because they don't have to deal directly with individual photographers and have no cost or risk in producing and getting the images ready for market.

One ironic side to this acquisition fever is that photographers have had their agencies swallowed up by Getty or Corbis. Then they go to another agency, for example, to Zefa, and Corbis swallows up that agency too. You can't escape the big fish.

Is there any area where rights-managed is still viable?

It makes sense in the totally editorial side of the business, selling to books or special interest magazines. They usually need something very subject specific and often can't find what they need in royalty free.

What is open to individual photographers?

They have to provide scans and provide their own keywording, but individual photographers can get connected with a portal like Alamy, which has over five

million images. At this point Alamy represents over 300 stock agencies and over 5,000 individual photographers. Though it is unlikely that they will ever catch up with any of the big three in terms of gross revenue, they are growing and have a very viable business. Photographers like the idea that they get 65 percent of gross sales from Alamy. The problem is that with so many images, the chance that a photographer will make many sales is slim, because Alamy has such a huge number of images on every subject. The odds are that no photographer will make as many sales in the Internet environment as was possible in the days of stock-agency print catalogs, when there were only twenty to thirty images on each subject in a catalog. That kind of market is gone.

With portals like Alamy, I'd say the average return per image per year is in the range of $10 per image. Last year the average gross sale for a rights-managed image on the Getty site was about $400. Everybody might want to be represented by Getty, but Getty is very picky about who they will accept. Many photographers can't get images on Getty at all, and those that can are usually only able to get a small fraction of their total production accepted.

On Alamy, for example, it is not too difficult to post ten times the number of images that you could get accepted by Getty, and if the averages hold up that's not too bad a comparison. When I say ten times it's not ten slightly different frames of the same situation, as some photographers do to try to increase their volume. It is ten different situations. At most photographers should post no more than two or three different frames of any given situation. Since the arrangement on Alamy is totally non-exclusive, you can also equalize the disparity of low prices by putting the same images on sites of other distributors. Then you may be in the ballpark of making some reasonable money.

How are buyers affected by seeing the same images from many sources?

Most image buyers are not worried about seeing the same image used by many different customers. The only people concerned about not seeing the pictures everywhere are those producing major advertising campaigns. I estimate that less that one percent of all images licensed are for fees higher than $3,000, the kind of uses where exclusivity might be important. The gross revenue such sales represent is no more than 7 percent of the total revenue for the industry. Many photographers never get a single sale in this category and still can earn a decent living. The major part of the market is for non-exclusive images that sell over and over for fees ranging from $100 to $1,000. Most photographers should focus their efforts on this segment of the market.

Photo agencies around the world are less concerned than they used to be about exclusivity and more interested in having a broad selection of imagery to offer to their customers.

What do you see as the biggest change in stock photography?

The biggest change has been the affect the Internet has had on the business. When you think about it, the Internet has changed a lot of businesses, not just photography. There used to be a need for travel agents, but now with the Internet most of them have disappeared. With the availability of so many good images through the Internet, many of them produced by amateurs, it's tougher for any individual to make a volume of stock sales.

The way I see survival, for an agency or individual photographer, is by finding a niche as an expert in a particular subject matter. I also recommend trying to get some training in video as well. As the use of print products declines, you'll be well positioned to move into video when the demand really takes off.

Because the Internet exists, there are many amateurs, or people for which the prime motivator is not earning revenue, getting into producing and selling stock photos. Sites that focus on building community among art directors and picture buyers by also supplying stories and tips will take an increasing share of the market for stock photo sales. Places like iStockphoto (*iStockphoto.com*), which calls itself the "original $1 Community Photo Site," is one of these. Such sites will skim some share of the market, because the image producers don't care about price and don't want a career. They are happy with other benefits, such as what they can get by bartering or sharing pictures.

Does producing stock make sense?

It is very risky for stock photographer to shoot on spec or afford huge, costly production shoots any more. The volume of sales isn't there to support the outlay. Agencies and other middlemen can survive and be economically viable if managed carefully, but for most individual photographers, the potential revenue is too low to balance the cost of stock production. The alternative is to shoot with a very frugal budget on specialty topics such as those needed in editorial. There is such an oversupply of imagery on the side of the market focused toward advertising that it hardly makes sense for any individual to try to compete in this area.

Digital Photography

It's safe to say that the use of digital techniques, in all aspects of the medium of photography—from shooting and manipulation of images to portfolio presentation and archival photo storage—are now, and will continue to be, central to photography. We don't know what innovations are around the corner, but they will take our digital use forward, further away from film. You can't exist in the world of photography without a high level of digital expertise—the higher the better.

SPEED OF CHANGE

We all acknowledge that, in many ways, the conversion to digital has happened faster than predicted. For those of us who have been in the business more than twenty years, the shock of these changes takes an adjustment. But it's sometimes the homey little examples that carry the most impact.

Not long ago I was doing some casting at a preschool for a book project. Instead of using my digital camera to take headshots of each child, I had pulled out my old Polaroid. It seemed efficient to have instant prints that the teachers could label with child's name and telephone number. Also, I thought to save time by avoiding downloading the images, then making prints. The kids were amazed and dazzled by these instant prints. It took a moment for me to realize that none of the children (ages three to five) had ever seen a Polaroid camera or a Polaroid print. Presumably the reason was because their parents used only digital cameras. The children were fascinated by the technology, new to them but already deeply retro in our world. I was reminded once again of the rapid change in the technology. The college-age readers of this book will not consider the speed of change worth remarking. But veterans of the business world, including those considering a switch from other fields into photography, will need to prepare for the reality that digital is integrated in every part of the photo world—and not standing still.

DIGITAL VERSUS FILM

This heading, "Digital versus Film," won't exist in the next edition of this book. There may be some who say it shouldn't be included even now. At a time when there are hundreds of books on the subject of digital photography, just having a separate chapter may seem out of place. All of photography is digital. But perhaps in this era of late transition from film to digital, and while some people somewhere are still using film, it provides a bridge.

Where does that leave film? Will film survive beyond five years? There are divergent opinions, as you'll see in the interviews. I had expected the conversion among professionals by now to be complete, or at least up to 80 percent, but that's not so. There are a number of photographers that shoot both digital and film, depending on the nature of the assignment or their personal work. Some photographers love the texture and feel of images obtained from film and are determined to use it for the foreseeable future. Others shoot film, then scan the select photos and send the digital files to clients for printing or for gallery use.

The lab I've used for twenty-five years for black-and-white printing tells me that current use is divided 60/40 between printing from digital and printing from film.

Digital in Photography Schools

At this moment photo schools seem to be divided in their approach to teaching film and digital. Some schools teach only digital in the recognition that it's what today's students will need. They want to help the student get a grasp of the contemporary photography techniques as speedily as possible—arguing that they save students money by avoiding teaching the arcane and unnecessary film process

Others teach the principles of photography using film as part of an introduction to the concepts. They follow with courses on digital shooting, including photo manipulation in Photoshop and other postproduction skills. These educators hold strong views as to the value of the experience with film in the teaching framework. They argue that film gives a greater understanding of the technical aspects of photography such as exposure, sharpness, etc. They say that the involvement with film translates into a deeper awareness of the tools you learn later working in Photoshop. Having the hands-on experience in the dark room of dodging or burning adds a visceral understanding, which is invaluable when using the digital tools for those same techniques. Not only are the basic principles and terminology of film helpful for understanding digital, but there is also the sheer joy of the experience not to be discounted. I'd encourage everyone starting in photography to try at least one basic course in film and darkroom. The thrill of seeing a print emerge from that tray of chemical solution in the darkroom is unequaled. In my opinion, it's a moment of delight and magic. I wonder if photographers brought up on digital will find it so.

In addition, when you see how demanding—in terms of time, chemicals, and paper—it is to print from a less-than-perfect negative, you'll have appreciation for the ease as well as the difficulty of digital printing. Really, to process and print well digitally is equally as demanding (but less smelly) as printing from film—the only difference is where you spend your time.

THE CLIENT'S VIEW ON DIGITAL

My experience over the past few years is that all clients want delivery of a digital file. For some clients, whether it's from a scan of film or a digital capture doesn't matter, provided the final delivery is in digital form. Other clients are keen on the use of digital from the beginning, starting at the shoot with digital capture. They appreciate being able to review the images during the shoot. As a photographer I find it enormously helpful to get a reaction while I am still shooting.

I had assumed, starting the research for this book, that digital would be universally embraced by clients. However, I'm told that some photographers continue to shoot and deliver film because their clients can't handle digital. That was information that caught me napping! I was surprised to say the least. Certainly this will pass, as those clients are dragged into getting the equipment and expertise needed to use digital files. The majority of photographers believe that digital is the answer for professional work and that most clients agree. As the pool of photographers offering both film and digital capability becomes smaller, the companies will have to bite the bullet and flow with the tidal wave to digital. And the printing companies require digital files at the end of the process, so the conversion is inevitable across the board. There is a certain irony that some companies are technologically behind the photographers. The reluctance is found in smaller companies and nonprofit organizations that haven't been able to make the investment for conversion to digital equipment. But also there is a dragging of feet on the part of some photo buyers.

Client Skill Level

Whether they are established or entry-level picture professionals, photo buyers must be digitally savvy. First, buyers must be able to communicate with the photographer in the language of digital, so they can know what's available in creative terms and make clear what they want. Second, buyers should be able to communicate specifications for their type of publication to a production department or printer.

Many picture professionals are going back to school—attending classes in the full range of digital workflow. After all, the buyer or art director is the bridge between the photographer and the printing company—a vital position.

GETTING A HANDLE ON WORKFLOW

The very word "workflow" once struck terror into the hearts of converts to digital photography. Many of them, myself included, thought, "It's enough to learn the camera; now I have to learn another language?" Workflow simply means not making it more work than it needs to be to process digital files. Hmmm, process files? There's more work to this process than I thought. In the old days of film, after a shoot there was a respite when the film was at the lab. You took the pictures; they did the work. Of course photographers who did their own black-and-white printing weren't spared, but the majority of professionals shooting color had the processing handled by others. Not so anymore. Not all professional photographers do their own digital processing; they often rely on assistants for that. The degree of the photographer's participation post-shoot often depends on his or her inclination toward or away from technology.

The enormity of the work needed to go from digital capture to the final image ready to print (or send to production) is almost incalculable. And before doing the work, you have to learn how to do it! For us seasoned pros it seemed like adding insult to injury to learn so many new techniques. But the rewards are great. Digital is powerful and worth the effort. It opens doors that bring back the first creative thrill of photography. But it takes time to get there. Photographers and clients alike are exploring a new type of education designed for the working professional. There are classes and workshops trying to bridge the gap between film and digital by starting at an advanced photographic level but with a basic level of digital instruction.

If you live within in a reasonable radius of Manhattan, I heartily recommend workflow classes given by Maria Ferrari (*http://mariaferrari.com/classes*). She has a variety of classes, but the workflow class is a series of four nights, one per week for a month, and is jam-packed with essential information.

Maria's approach is simple but handles a lot of complex issues. She gives you procedures for adjusting and enhancing images. You learn color management, color-correction adjustment layers, layer masks, channels, sharpening, and preparation for printing. It's designed to complete the process in the most efficient way possible. If you are not near Manhattan, try to find a class in your area. It will greatly enhance (pun intended) your digital experience. Classes of this sort are invaluable for picture professionals as much as photographers. Check the schools listed in the appendix for classes in your area on digital workflow.

SMALL BUSINESS DIGITAL

The use of digital in the photography world has given rise to many new small businesses. There are career opportunities for picture professionals with good technical skills and some creative openings for photographers who have a penchant for the inventiveness of photo manipulation.

The number of new businesses offering digital retouching is legion. Many offer consumer products like restoration of family photographs and gift items made from your photographs in various styles, including collages/montages, pop art, portrait effects, and vignettes. They may handle all the necessary skills for professional-photography clients needing portrait retouching, including skin smoothing, glare reduction, and correcting teeth and aging issues. Scanning is the mainstay of many of these businesses who handle *not only* high-quality scanning and retouching, but also complex image manipulation for stock agencies and photographers RAW file conversion. Some companies also provide key-wording and captioning service.

THE ART OF DIGITAL PHOTOGRAPHY

Most of this chapter is concerned with the technical capabilities of digital. The artistic advantages offered through use of the digital tools are finally becoming accepted. But still, the attitude so many bring to the discussion is that digital is merely a convenient, sophisticated toy. If you believe that *digital* should be integrated to where it belongs as part of the evolution of an art form, instead of merely a technical side issue, then you'll enjoy the profile of Sanjay Kothari in this chapter.

To my mind, his is the best expression I've heard of the implications of the medium expressed in terms that are articulate as well as heartfelt and intellectually sound.

Another thought on the artistic aspects of digital photography is from Chuck Delaney, who says: "Digital is seductive. In digital photography it's easy to be good. But it's a long step from good to great. To get to be great takes a long time. In film it was harder to be even good. Unlike being an opera singer or a painter, which takes a long time to be good, digital gets you there almost too quickly." So beware that you aren't deceived by the ease of the medium. Hold yourself to the same high standards you did with film, so that the digital tools become a means to push your creativity, not sidetrack it.

IMAGING SOFTWARE

The two main software providers to the photography and graphic arts industry are Adobe (*www.adobe.com*) and Corel (*www.corel.com*).

Photoshop is, and undoubtedly will continue to be, the imaging software of choice. It's as ubiquitous with digital photographers as was transparency film. Photoshop CS 2 is the most recent version in use as I write, but the next version is expected out before the publication of this book. Check to get the latest version. Though pricey, it's another piece of essential equipment.

Apple has entered the market of digital file management with Aperture for Mac users. It's not intended to compete with Photoshop, but to be used as an extra

tool for organizing pictures, handling RAW files, etc. It is somewhat comparable to Adobe Bridge, part of Photoshop Creative Suite 2 (CS 2), which is used for processing and organizing RAW files. There are dozens of other programs for drawing and design on the Web sites for Adobe and Corel; these may be of interest to graphics professionals.

DIGITAL PHOTOGRAPHY BOOKS

In the Appendix, you'll find some useful books for further research into the digital world. But keep in mind that books on digital topics go out of date fast. Be sure you get the latest edition of a book that covers the newest version of the software you have. Intersperse your book reading with magazine articles on the latest changes in technology and software.

PROFESSIONAL PROFILE
NAME: Sanjay Kothari
PROFESSION: photographer, digital artist
WEB SITE: *www.sanjaykothari.com*
HOME BASE: New York City

You've done a considerable amount of conceptualizing about photography. What is your philosophy about the medium?

My philosophy is that photography has its shooting capabilities, lighting capabilities, optical capabilities, and we have the choices of film, Polaroid, gum bichromate, or photogravure . . . as well as digital. All of these can be used—should be used—if and when they are needed to make a more meaningful picture.

But also it is important to acknowledge that photography has limits. The desire to manipulate the image stems from the desire to transcend those limits and transform an image. That desire has been around since shortly after photography was invented (look up Hill and Adamson's work in the 1840s). Further, I reject the way that our history and institutions have always shunned the "transformed" photograph.

What is the affect of digital in your approach to the medium?

Digital what? Digital capture or digital transformation? Digital capture hasn't made much difference. It's cheaper, gives me immediate feedback, etc., and while these are important aspects, they don't make a fundamental difference—my pictures would have looked more or less the same. However, transformation, whether

analog or digital, is what can distinguish your picture. Transformation is because of you, not because of a camera body or the kind of emulsion you used. With digital transformation the boundaries between different disciplines have collapsed. Designers, retouchers, photographers all use Photoshop. Simultaneously, a lot of people have lost their phobia of photography and are increasingly confident at doing the picture-taking themselves. While this is a troublesome trend for our profession, it's certainly a positive trend for the medium.

What are the most important elements in the artistic process?

For me there are three things. First is immediacy, that you have an immediate relationship with your work. When I discovered collage in 1984, my work changed dramatically, opening me up to much more. Then I started photographing with the *intention* of collaging the image. The end result was so far beyond anything I'd done before that I realized how much the medium affects your work. It has to. And that the limits of the medium you work within affects the work. The moment those limits change, your work changes. For example, when you get your first wide-angle lens, you suddenly have a new set of possibilities that you didn't before, and so your work is going to show that. In the same way, the moment I started collage, it drastically changed my work. It allowed me to make far more imaginative images. The immediacy of the process allowed me to make lots of decisions—it wasn't one decision, there were many, many, many decisions at many stages.

The second element in the artistic process is that the process has to be reversible. The image needs a way to evolve—back and forth and back and forth. Reversibility allows the image to evolve. Every other medium, sculpture, painting, music, writing, and film, allows editing. If you can go back and forth, it allows you to develop a dialogue with your pictures.

The third is selectivity. When you burn and dodge, you selectively darken and lighten areas. That control is crucial. Well, let's take it further and selectively control color contrast, scale, proportion, form, placement . . . and we end up with collage in Photoshop. Instead of the entire picture being affected globally, we can affect it selectively. Selective adjustments are the signature of the individual's hand, whether the adjustments are made by analog or digital means.

Photography has always been a medium of subjective choices within objective limits. For example, if you wish to photograph a chair, that chair has to exist. Not only must it exist, but it must be exist in front of your camera at the moment you press the shutter.

That also dictates the chair's light and shadow, scale, etc., which are all aspects that are governed by reality. However, by using Photoshop or collage,

I could mix the shadow from one image with a picture of the chair from another image, and be able to overcome nature's limits.

Where do you see your future in imaging?

I am exploring software other than Photoshop, such as 3-D software. That opens up another enormous world of possibilities.

What trends do you see in photographic digital imaging?

Basically where we are going and where medium is going is toward filmmaking. It doesn't mean that we have to go into motion—the "still" image is still what you want to create, but that's the direction in the sense of working in a collaborative way as they do in films. The software After Effects is the filmmaker's equivalent of Photoshop, and photographers are likely to incorporate the software Maya or 3-D programs into their process in the next few years. Maya has been part of film making for quite some time already.

At least for high-end images, the workflow will become increasingly like that of film. There's a photographer, a Photoshop artist, and there'll be a 3-D artist. If the client needs that type of powerful picture, they'll deem it sensible to take advantage of the various artists who are needed to work together. It depends on the visual concept.

So if collaboration is possible in film, it is possible in stills. The medium is becoming too complex for one person, and it will be rare to find all the components needed in one practitioner. Already it has become a two-person team in many cases, photographer and so-called re-toucher, a title that denies that person's creative contribution. There will be additional team members depending on the visual.

What led you to this approach to the medium?

Early on I was drawn to the more imaginative interpretations of photography like the work of Jerry Uelsmann and Duane Michals. But then I discovered the inspiration for both of them was René Magritte. Understanding Magritte's work is essential for anyone interested in photographic transformation. I have experimented with multiple exposure, multiple printing, etc., but I found them not immediate enough. It was my accidental discovery of collage that brought me to this approach.

What is your advice to a student wanting to be a photographic digital artist?

First of all, find a school that has an integrated approach towards photography and Photoshop. Second, make sure that school has an approach that relates photography to other artistic disciplines, such as graphic design and film, and not a

purist approach. Plan on doing a master's in an area such as film-making or graphic design, depending on where your work takes you—and finally, experiment, experiment, experiment with your medium.

Photo production specialist Jessica Oyanagi, The Seattle Times.

PROFESSIONAL PROFILE

NAME: Jessica Oyanagi

PROFESSION: photographer, photo production specialist, the *Seattle Times*

WEB SITE: *www.seattletimes.nwsource.com*

HOME BASE: Seattle, WA

What's your role as Photo Production Specialist at the Seattle Times?

Simply put, I take photos approved by the photo editor of the paper and prepare them for press and publication in the newspaper. The process starts with our photographers shooting assignment photos. Then they transmit them to an ftp site, which funnels their images into our digital archive "media grid." Next, a photo editor and page designer choose which photos will go in the paper. The designer will then "order up" the selected photos, and that's where I come in. The request for photos comes into my digital inbox. I pull them into Photoshop—and make them look beautiful. Of course I don't mean changing the photograph through any manipulation. To me making them *beautiful* is to process the digital file so that they are as technically perfect as I can make them.

Exactly what do you do to make the photo "perfect"?

Well, the original image from each assignment stays in the archive so we always have the "RAW" format version, which is the original, safely on file. It should come to me untouched, but sometimes we get material in varying formats from other sources, like the AP, freelancers, and other agencies. Those photos could be TIFFs or JPEGs, color corrected or not—some people work on them, some people don't—it's mystery meat. But ideally we start with a RAW photo.

When the designer orders an assignment photo from the archive it comes to us as a copy. We make three global corrections. We color correct, and we adjust the levels to make sure it's light enough, because once the images hit the paper—between the ink and the grey paper it can go really dark, so we want to

make sure that it's light enough for news print. And third, most of the time we would also sharpen the pictures to make them a little crisper.

We actually work up two versions of each photo, one for our Web site that is always in color, and another for press, which might be black and white or color, depending on the section of the paper where it's being used.

Do you make any other changes?

No, just those three basic corrections. As you look at each original image, you work it using your instincts to see if any technical corrections are needed. But you're trying to maintain the integrity of the photo. You don't want to manipulate it in *any* way. You enhance to the best of what's in the image but you do not change it at all—because this is journalism.

Do you get responses from readers about photos?

Now that everything is digital, viewers are quick to look for a reason to say we've done something wrong. They are more suspicious than ever before. Readers will call in to say "this photos looks odd, you must have manipulated it." You say, "No, they were using a wide-angle lens which caused that look," or try to answer them, explaining why an image looks as it does.

We're the vulnerable spot, the place where manipulation *could* happen. So we are very careful that nothing is changed that affects the content of the photo. We do only the basic technical corrections of color balance, exposure and sharpness. Though we may be the last people to work on an image, we're definitely not the last people to see it. After my work, the editors and designers often double-check the picture. They are making prints, making sure it looks good—and at that stage they'd catch anything that isn't right – anything that wasn't in the original image.

What's your next step in getting ready for the printer?

When the image is ready, we use RGB for the Web version but for press we convert to CMYK. One interesting thing is that our monitors and color workspaces (or computers with more reliably calibrated monitors) in Photoshop are so much better than they used to be. Even just a few years ago, it was more difficult because you'd be working on a picture, and it looked one way on your monitor but then you'd send it off to the presses, and the next day in the paper it'd look totally different. It was so frustrating when you worked so hard to make it look so good and it didn't show up that way. That was a period of time when the technology hadn't quite synchronized with the presses, but now it's phenomenally better—so what you see on the screen is very close to what shows up in the paper.

How many photographs do you handle in an average day?

Lots. We process at least 50 to 100 images every day between print and the Web, where we have galleries with multiple photographs.

Do you learn from the photos you process?

It's another of level of learning, being exposed to pictures from different countries all over the world. We see lots of photos that never appear in the paper. Sometimes it can be pretty intense, especially when there are war scenes, but we get a fascinating, behind-the-scenes view of the world.

What's your ultimate goal?

I'd like to be a photo editor. That would be the natural progression from my position now. Over the long term, that would be more creative than my current job. I might also want to be a teacher.

Part III
Picture Professionals: Careers without a Camera

One very heartening thought, as you approach the field of photography, is to realize how very many places photographs are used—even some you may never have considered—and, along with that, how many different types of careers involve working with photographs. If you aren't quite sure what's best for you, consider the ways to work with photographs that you'll see in the next three chapters. It's possible to blend and to mix and match a variety of these professions to find a satisfying career.

C H A P T E R

10

Buyers, Sellers, and Dealers

The careers for picture professionals are varied and intriguing. They include the photo buyers, who are the people who search out, find, and decide on the photographs to be used for everything from magazine covers to mugs. Those who sell and/or provide photographs can be stock agents, photographic reps, or dealers in fine art. Each has a vital role to play in the business of photography.

OVERVIEW OF PHOTOGRAPHY USES AND USERS

Different companies and various parts of the industry have their own names for the people who find and select the photographs. To see the variety and number of photographs that are needed on a daily, weekly, and monthly basis, look at the box "Photography Uses."

PHOTOGRAPHY USES	PHOTOGRAPHY BUYERS
Advertising	**Photo Buyers/Picture Professionals**
Magazines—Consumer Local Regional National	Art Director
Magazines—Trade Local Regional National	Creative Director (if a small ad agency)
Newspapers	Art Buyer
	Graphic Designer
Billboard, Kiosk, Transit Display	Media Buyer
Television: Stills for Commercials	Photo Researcher
Advertorial	

Corporate	Photo Buyers/Picture Professionals
Annual Report	Corporate Communication
Brochures	Marketing Communications
House Publications—Internal: For Employees	Photo Researcher
	Internet/Intranet Content Managers
House Publications—External: Public Relations or Advertising	Graphic Designers
Prints: Display In Lobbies, Trade Shows, etc.	Editorial Marketing Staff
Slide Show: In-House for Employees, Sales Staff	
Trade: Public Relations, Advertising	
Annual Reports	
Audiovisual (in-house use only) Trade Slide Show (for promotion)	
Calendar	
House Publication—external (promotional/public relations)	
House Publication—Internal (employees only)	
Posters	
Recording—Promotional	

Editorial Books: Consumer & Trade	Photo Buyers/Picture Professionals
Consumer/Trade (Books to the General Public)	Photo Researcher/Photo Editor
Author Head Shot	Author (especially in educational)
Educational: Textbook & Encyclopedia	Editor
	Designer
Editorial Magazines: Editorial Content/ Stories/Features	Creative Director
Consumer (to the General Public)	
Trade Circulation	
Editorial Newspapers: News and General Feature, Daily Sunday	
Supplements/Magazines	
Newspapers	

	Photo Buyers/Picture Professionals
CD-Rom Disk	
Display Prints (public locations—business, stores)	
Exhibit/Decorative Fine Prints Exhibit Fee	
Multimedia/Audiovisual Stills in Filmstrips/Video	
Misc	**Photo Buyers/Picture Professionals**
Calendar	Graphic Designer
Cards—Greeting Cards & Postcards Retail Sale	Package Designer
Greeting Cards & Postcards Advertising or Promotional Use	Photo Researcher
Posters—Retail	Editor (some book publishers publish calendars)
CD-ROM—Consumer (retail sale)	
Display Prints Murals	
Products	**Photo Buyers/Picture Professionals**
Apparel—Shirts, Bags	Package Designer
Background—Movies, TV	Photo Researcher
Bank Checks	
Credit Cards	
Life-Size Personalities	
Logo (corporate)	
Phone Book Covers	
Place Mats	
Plates—Mugs, etc.	
Playing Cards	
Puzzles	
Stamps	
Stationery	

THE WORLD OF THE PHOTO BUYER

There are many professions, interesting and rewarding, where it's your job to acquire or buy (or license rights to) a photograph. There are two basic ways to acquire a photograph. The first is to assign or commission new photography from a photographer. The other is by searching in stock-photo files. These two ways to attain images—assignment and stock—have been written about extensively in Part II of this book.

As it relates to the picture professional, the advantage to assignment photography is that you will get fresh pictures, never seen before. But there are no guarantees, and there is always the risk that something could go wrong. The advantage to using stock is that it exists. No unpleasant surprises, no disappointments, no pig in a poke—you know what you're getting.

One of the more interesting aspects of being a photo buyer is the interaction with colleagues. It's quite common for a group of professionals (possibly art director, creative director, art buyer, and photo researcher) to confer to come up with the best approach to a photo solution.

WHO BUYS PHOTOGRAPHS?

Photography buyers work in many industries with a variety of titles. Many photo buyers, but not all, have art-school educations with training in the graphic arts, design, and photography. An interesting place to see the involvement of different creative professionals in a photograph is in the *PDN* (*Photo District News*) annual issue "Best of the Year's Photos" which covers advertising, books, stock, and Web photography. The photos are shown along the concept or a description of the assignment and the name of the client. Credit is given to the photographer and all the key people who worked on the project. You'll see that sometimes mention is made or credit given to the photo buyer, to the creative director, to the art director, or a photo editor. Each may have a slightly different cast of people who collaborated on the photographic project. This attribution gives an interesting mini history of a photograph's evolution into publication. Under their various titles, the work of acquiring photos can be done by:

- Creative director
- Art director
- Art buyer
- Graphic designer
- Corporate communications director

- Photo editor
- Photo researcher
- Internet/Intranet content managers
- Editorial marketing staff
- Book authors

Creative Director

A *creative director* at a smaller advertising agency may be involved with photo assignments along with other responsibilities. But this would be much less likely for a creative director in a large agency.

Art Director

An *art director* is quite commonly involved in the selection of a photographer and in developing the concept for the photographic style in an ad campaign. He often works very closely with the photographer and may be on location for the shoot.

Art Buyer

An *art buyer* for an ad agency can have widely differing levels of responsibility. In some cases art buyers review portfolios and have significant influence in the final decision of which photographer to use. In other agencies the art buyer's role is limited to bringing in samples of those photographers selected for review.

Graphic Designer

A *graphic designer* in a design firm, or perhaps an assistant designer, will choose a photographer and work out the concept for a shoot. Graphic design firms are known for working on corporate annual reports and brochures. Recently they are emerging as a part of the ad agency scene, as some advertising agencies are buying up small design firms. In addition, some corporations are acquiring design firms to form part of their in-house advertising capabilities.

Corporate Communications Directors

Corporate communications directors or *corporate marketing directors* are responsible for the look of the publications that represent their company to the world and to their stockholders. They will work closely with a graphic designer but often have significant involvement in the selection of a photographer and in following through on the shoot.

Photo Editor

A *photo editor* can be found working for a newspaper, magazine, or book publisher, often in a staff position. The term can mean different things in different companies. The job will include making the final selections from assignment photographs for use in the publication. Photo editors may do their own photo research, or they may choose which stock photos to publish from the selection provided by a photo researcher.

Photo Researcher

A *photo researcher* works for and with virtually all other types of buyers and clients including ad agencies, design firms, publishers of books, magazines, newspapers, encyclopedias, and content developers sometimes known as book packagers. The services they provide include photo research, not only of contemporary photography but also of historical photographs, prints, drawings, and other fine art works. The photo researcher or their assistant will also handle rights and permissions for the visuals researched, gathering the digital file needed by the client, and may also handle image and archive management.

There are staff positions in photo research, particularly in the larger book publishers, but many photo researchers are independent professionals working as freelancers. Others have started small businesses to provide greater depth of service for their clients. One example is the photo research firm of Feldman & Associates, Inc. (*www.feldmans.net*).

Early in my career, before I became a photographer, I worked as an art and photo editor for a publishing company, with photo research as one of my responsibilities. I fell in love with it. Just imagine looking through the archives of individual photographers, news organizations, stock agencies representing every imaginable style and subject matter, as well as digging into art museum and historical-society files. If it's visual, then at some stage a photo researcher will most likely have to find it. Photo research becomes an education unto itself, as photo requests can lead down paths to some unusual and even arcane subjects. (During my photo research work in historical archives, I became enamored of early photography.)

A good background for a photo researcher is a mixture of photography and graphics arts or art history. But a thorough liberal arts education gives the breadth of knowledge that's useful for a researcher.

Photo research was also a great training for my future work as a photographer in that it allowed me to see the work of the "best of the best" among photographers. You learn very quickly to push for the highest standards when you've

been exposed to that level of quality. Simply good work isn't good enough. Researching in the work of the top photographers gives you a measure to use against your own progress.

Net Content Managers

Internet/Intranet content managers are the people that post information and updates to Web sites as well as keep them running. (An Intranet is an internal Web site for companies. It's usually different from the external site and may have information of more interest to employees.)

Content managers make sure that the site's links and downloads are all functioning. They often have to find images to correspond to information that will relate on the site. Or they may have to seek out artwork to help illustrate pages. For instance, Web sites like *nbc.com* or *cbs.com* need still images, as opposed to the video shown on TV. So they need someone to get those on the sites. The content managers might research the images and get the image files, but they also have to work with the images to make them work for the Web—resizing, working with the color, making sure the image works with all the text and fits in with the look of the site.

Editorial Marketing Staff

In many large corporations, the marketing department is huge and includes an *editorial marketing staff.* These people are members of the marketing team responsible for the editorial work on all the marketing brochures and documents they give to clients. In this context they may buy (license rights to) a lot of photos to go with the text. This could be a job given to a photo researcher, whether staff or freelance but as the need is usually for only a few images a week, the job is often handled by the marketing staff.

Book Authors

Book authors, particularly textbooks authors, don't technically buy (or license rights to) images but they often do preliminary research and initiate the photo list that a researcher might follow. They are constantly researching clippings, cartoons—all sorts of visuals—to illustrate their books. In addition some have assistants who do this type of visual research.

Acquiring and working with photographs is a satisfying way to build a career or to blend with your life as a photographer—there is real symbiosis in the mutual benefit.

THE WORLD OF THE PHOTO SELLER

Photography sellers are those who make images available for sale or licensing. They actively seek out buyers/clients to provide the service of assignment photography or to present selections of stock photos. The people selling and providing photos are:

- Photographer
- Representative ("rep")
- Stock agent
- Fine art galleries and curators

PHOTOGRAPHER

We can't forget that selling is an important element in a photographer's life—though they, and we, usually think of the photographer primarily in the role of creator.

Unless he or she has a partner, spouse, or rep to handle business, some selling will be necessary, as is covered in detail in the marketing chapter 16.

REPRESENTATIVE/MARKETING COORDINATOR/ CREATIVE MANAGEMENT

Just running a photography business, however large or small, is an all-consuming undertaking. The photographer has enough to do—planning and executing shoots, processing and manipulating images—without adding another task. So imagine the relief if someone else would handle the "business" end of the business. Not many photographers have someone to do that work unless they have a partner or spouse in the business. Otherwise the photographer has to add to the load by doing marketing, searching out new clients, and negotiating jobs. In addition to the serious difficulty of finding time for these tasks, there is a reluctance by many photographers to represent themselves to clients. The process can make them uneasy, sometimes resulting in a less-than-favorable impression.

Enter the photographer's representative or the creative manager. The commonly used term is "rep," which is useful shorthand. However, career people who represent photographers often prefer more dignified terms such as "manager" or "creative management." The feeling has been that the term "rep" meant just dragging around a portfolio and doing the drop-offs and pickups. A serious "rep" handles a complex number of tasks that vary with the needs of each of the photographers they represent. If you want an interesting, challenging career then

being in creative management might be a strong possibility. You become the voice of the photographer. Often you can present them and their work in a better light than they themselves can.

A representative or creative manager will do many things, including advise a photographer on the content and presentation of a portfolio, search for new clients, assist in estimating the job and negotiating fees, be present on the shoot to hand-hold the client, and virtually anything else that will help the photographer prosper.

A good representative is like an advocate, someone on the photographer's side who reduces stress and removes the energy-draining aspects of the business. The worth of a manager is in the subtle ways it frees the photographer to be creative. Managers build confidence because the photographer doesn't have to face a possible lukewarm reception or even outright rejection.

Opportunities and Qualifications

At this stage there is actually a shortage of people to represent or market other photographers, as you'll see in Maria Piscopo's profile in chapter 16. There are probably enough representatives to handle the established, high-end photographers but there is a need for young people to start in the business, first as an assistant to an established rep, and then branching out to represent mid-career and entry-level photographers. To be creative about this process, some photographers are forming a type of cooperative studio setting in which they share space and duties. They are being imaginative in searching out a person to work with them to do the marketing.

One way to start is by looking around among your colleagues in photography school. Put together a group of like-minded aspiring professionals with different and complementary strengths. For example, a newly established rep with a stable of newly established picture professionals—all new, all in it together, sharing expenses—could make it work. You might have a combination of two or three photographers, one rep, one stylist. The group could include anyone with mutual interests and mutual professional needs. Several factors make the idea viable. Since there is less need for leg work in the current marketing arena, a lot can be accomplished through direct mail, e-mail, Web site, and drop off of a portfolio or a mini-portfolio used as a travel portfolio.

Figuring out the money is tricky, but with imagination and a good business sense you could create a viable arrangement. The classic arrangement of a rep receiving a percentage of the photographer's fees doesn't work when there are no (or few) fees. Consider working out a balance of hourly rate plus commission. For example, each photographer in the group could invest in a certain number of hours

(at an hourly rate) to cover the marketing coordinator's efforts. Then an additional payment would come as a percentage of work brought in. It would be a modest percentage until the photographer is established at a higher earning level.

In the early stages, it is frugal going, but that's true for many entry-level creative people. As the photographer's progress and fees go up, it's viable. This process is worth starting even in college or photography school.

Some photography students are drawn to the being out front, talking to people. They have the people skills and confidence needed to approach clients and show portfolios. It's always easier to be enthusiastic about someone else's work, where there is less danger of a bruised ego. So, examine your strengths and passions. Maybe you'd be dynamite as a marketing coordinator representing photographers.

If you have a serious interest in representing photographers consider membership in The Society of Photographers and Artists Representatives (SPAR) (*www. spar.org*).

STOCK PHOTO AGENT

There have been dramatic changes in recent years in the way stock photography is sold—and in the careers that support the stock industry. The classic stock agent was a person who built a relationship with a photographer and fostered his or her productivity to the benefit of both. There was a bond of trust and a common goal. In the best of stock photo agencies it became a partnership—and not uncommonly a friendship. Those same qualities are important today, but the close contact is less intimate than in the past. The success of your work as a member of a stock agency still depends on your in almost equal parts people skills and critical eye for photography.

Careers in a Stock Agency

It takes many people to run a good stock agency:

Stock agents will review portfolios to identify photographers with talent and ability to produce saleable stock. They will negotiate a contract. Depending on the size of the agency, the stock agent may be the agent/owner or an upper-level management person.

Stock agency editors will review the photo submissions of member photographers, deciding which to keep on file. This is one of the most rewarding jobs in the stock business because it's the hub of the creative part of the business. In working with the photographer, there is a considerable exchange of information leading to better stock. Though the agency editor is not technically a seller, since they are more

involved in nurturing a relationship with the photographer, they are nevertheless getting material prepared to be sold (licensed).

Marketing and sales representatives carry out an important function, especially since the emergence of the mega agencies described in chapter 8. In these agencies, each client who uses the stock agency will be assigned a marketing "rep" to provide customer service and to act as liaison with the agency researcher. Often these reps work on a combination of salary and commission, so good service to a major client will pay benefits.

Stock agency researchers will search the agency files for images to match the client's photo requests and post them to a digital light box for review by the client buyer. The days are long gone when a client would physically go to an agency and review pieces of film through a loupe on an actual light box. With the conversion of stock agency film archives to digital files, the relationship of the researcher within a stock agency has changed. Now, since virtually all photos are available electronically (or will be scanned quickly to fill a request), there can be direct access by the client to the files on the agency's Web site. So a client can use a researcher's help to search the files—or they can do it themselves.

Still, a common scenario is that a professional researcher/buyer will submit a photo-research request list to an agency's marketing rep. This request is turned over to a photo-agency staff researcher, who will "pull" a selection of topics or concepts to fit the request. (Lest this become confusing, remember that we have two types of researchers here. One is working for the client finding photographs, the other is working inside the stock agency finding material from agency files to show to the client researcher.) Next the stock agency researcher will post them on a digital light-box on the agency's Web site. Sometimes there will be e-mail exchanges between the agency researcher and the client researcher (or even phone calls) to clarify what's needed. The thinking behind this approach is that the agency researcher knows her own file and key-wording system better than the client researcher and can be more efficient in gathering a good selection for the buyer. If the right material doesn't show up, the buyer researcher has the option of searching on the Web site himself.

However some client researchers prefer to search the agency Web site themselves using key words to navigate the system, thus bypassing the need for a person within the agency to help with the research. This is the method typically chosen by either an exceptionally knowledgeable client/researcher or sometimes the exceptionally uninformed one.

The latter group consists of clients who misguidedly hope to save money by having a secretary or assistant go directly to photo agency Web sites. Most clients have the sense to conduct their search for photos by using experienced photo researchers.

The *director of photography* will consult with the stock agent (or owners) and sales reps to identify photo topics needed in the files. He will direct agency staff producers

or freelance producers hired for a project to schedule and budget photo shoots. They will consult in selecting which agency photographer is to be assigned to the shoot.

Stock-photo producers in a larger agency will work under the guidance of the director of photography who will decide what topics and concepts are needed. In a smaller agency, photo producers will handle the decisions and production for the agency and work with member photographers to obtain specific styles and concepts in stock photos needed to round out the agency's files.

As never before, *technology specialists* are essential to the running of a stock agency. Web site management is a full-time process at the heart of the photo agency. In addition, people who know stock photography content and the underlying concepts are valuable for the key wording of images. Photographers are requested to furnish some keywords when they submit an image, and pinpointing the right keywords for concepts can increase sales.

FINE ART GALLERIES AND CURATORS

Having come into its own in recent decades, fine art photography has provided a flourishing business in buying and selling prints. Though the fine art photography establishment tends to hold itself aloof from the commerce associated with assignment photography, the fact is that fine art photography is big business. Prices have risen sharply to levels not even imagined ten years ago.

Collectors buy vintage prints of established artists as well as from emerging contemporary photographic artists. Some collect out of love for the work, others because it's an investment strategy.

Gallery Owner/Manager

Galleries display fine art photography for sale. Gallery owners manage the business of finding and selling fine art photography.

Gallery owners are constantly searching for genuine new expressions, a unique voice in visual form. Part of their search involves looking at the portfolios of many hopeful fine art photographers. The search is exhaustive and not many are chosen. Since space and time to present an exhibition are limited, gallery owners must judge the impact and likely staying power of a new artist. There is a massive amount of work in handling this and the installation of new shows, publicity for a show, arrangements for an opening reception and then the sales of prints. Frequently a gallery assistant helps with these tasks—being an assistant in a gallery is a promising way to learn the insides of collecting. (A little-known side use of stock photography comes about when fine art gallery owners and artists license stock photography to aid in the installation of shows; for instance, as backdrops to the paintings or sculpture. This is separate from fine art photography.)

Historical Photographs

Confederate soldier Pvt. Edwin Francis Jenson, 2nd Louisianan Cavalry. © Library of Congress

Civil War. The ruins of Richmond, Va. © Library of Congress

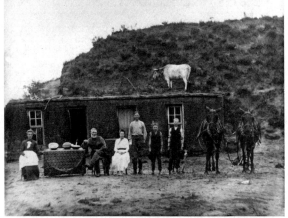

Sod hut on the Nebraska frontier. Rawding family, 1886. © Solomon D. Butcher Collection, Nebraska State Historical Society.

Gold rush. Prospectors heading to the Yukon from Juneau, Alaska, 1896. © Library of Congress

Tom Torlino in traditional Navajo clothing. © The Smithsonian Institute

Tom Torlino after entering school run by whites. © The Smithsonian Institute

Hampton Institute was set up by the Freedman's Bureau for the education of emancipated slaves. © Library of Congress

The billboard, "Next Time Try the Train, Relax," confronts Depression-era hobos. © Library of Congress

Photography Dealer

Working with gallery owners or individual collectors, a photography dealer buys and sells photographic fine art prints. Web sites are a major source for the dealer to present their work to the collector.

Art Advisor/Curator/Consultant

Known by many names but expert in one thing—the fine arts—an art advisor or curator provides services frequently sought by individual collectors or institutions.

For the fine art photography student, a career as a curator in photography may be an excellent way to blend an interest in the gallery world with a pursuit of his or her own photography. There are many academic programs for curators. One particularly well-regarded program at the University of New Mexico in Albuquerque turns out major number of curators. Building a collection is fascinating work, as you'll learn from the eloquent words of Karen Amiel, art advisor. For more information about curators and art dealersthere is an organization called Art Dealers Association of America (ADAA), *www.artdealers.org.*

In addition to selecting the photography to add to a collection, a museum photo curator or photo-department head assigns photographers to take photographs of works of art, installations, and museum activities. Museum photo departments may also license photographs in their collection for editorial use—and in rare cases for advertising use.

Historical Photo Archivist

In historical societies and libraries across the country, there are photo collections that are preserved and documented by archivists or curators. In addition to those preserving the collections there are photo departments in these historical societies and libraries that make prints available to the public for reproduction in books and magazines. There are photo departments in institutions across the country including state as well as county historical societies, regional and nationally known museums. Major organizations such as the Library of Congress and National Archives are just the beginning.

These photo archives contain treasures, some well known and widely shown, others quietly resting in backroom files. Working with these icons of fine photography and artifacts of our past would be a rich and rewarding career. I confess to a special love for historical photography, and to some degree, I'm indulging myself by presenting a selection of my favorite historical photographs here for you. It was difficult to limit myself to the few shown here. I hope you enjoy them and that they may whet your appetite to explore further in the magical recesses of historical archives.

PROFESSIONAL PROFILE

NAME: Angela Gottschalk

PROFESSION: photo editor, the *Seattle Times*

WEB SITE: *www.seattletimes. nwsource.com*

HOME BASE: Seattle, WA

Director of photography Barry Fitzsimmons, photo production specialist Jessica Oyanagi, and photography editor Angela Gottschalk review pictures together in the Seattle Times *newsroom.*

What in the photographic world attracts or appeals to you most?

I suppose the adrenalin, that's so much a part of newspaper work both as a shooter and as a photo editor, really appeals to me. You have deadlines constantly—it keeps you on your toes.

The ability to provide readers with compelling images, those that enlighten or engage them, is very important to me as well.

You are currently a photo editor at the Seattle Times. How did that come about?

After several years of working a split position as photojournalist and photo editor at the paper, I realized that I was a good photographer but maybe I wasn't a *great* photographer. But I loved working with the photos, so I took on a full-time job as a photo editor.

What is your role as a photo editor on a newspaper?

I am one of four picture editors for the paper. Right now I work as the sports-photo editor as well as the wire-photo editor for both national and international photos. Checking the wires each day is my window on the world. I may view thousands of photos each day that come over the wire from AP, Getty Images, and other sources. I can go around the world and back again in one day—from Haiti to Russia to Italy. It's never dull. I supervise four sports photographers—edit their photos and review their submissions—plus a production team of three photo techs who prepare the selected photos for publication.

How are decisions made on what photos to use?

We have a very collaborative working environment at the *Seattle Times*. It's an atmosphere where we have joint discussions, usually between the news or sports editor and me; the designer joins in as well. My opinion, or any photo editor's opinion on the choice of photos, will carry weight once we have earned

the credibility of the news editor. There are always some moments of frustration with too many people weighing in; but, in all, it's a healthy process.

What makes your job as photo editor special?

It gives me great pleasure to show inspiring and thought-provoking photos to the readers of our paper. My goal as a photo editor is to give informational pictures, which in addition to inspiring them will surprise and delight the reader—photos which view things in a way they might not see, take them places they won't go, and provide an outlook on life they won't see on TV. Of course we have the meat-and-potatoes photos that we must show just as a record or to document an event. But the thrill is in finding the special photos for each story. Stand alone photos—which our newspaper refers to as "lines only" photos—can be a fun and interesting diversion. We don't want to overuse them or become dependent on them, but they serve the purpose of providing a little slice of life for the reader.

In our technological age when photo manipulation has become more common, how important is ethics in photojournalism?

At the *Seattle Times* we have no tolerance for any breach in credibility. We have a photo-manipulation policy which we take very seriously.

Also, our photojournalists must write accurate and complete photo captions for their images. We established a set of photo caption guidelines for photographers, which has helped them improve their caption-writing skills. We still have room for improvement, though. We have fewer problems than we used to, but it's still an issue. We constantly push to improve accuracy and therefore our credibility. Our photographers go the extra mile to provide that accuracy.

As to the integrity of the image, they provide, without question, absolutely un-manipulated images. Anyone found to have manipulated a photo—one that is not shot for the purpose of a photo illustration, such as for a news features page or special section cover—will likely not be working here any longer.

What's your advice to newcomers; what type of background would you advise?

A degree. If you have interest in photojournalism, whether as a shooter or a photo editor, find the strongest university program you can in journalism, especially with a good photojournalism component. Then get as much experience as you can in the newspaper business as an intern. There are possibilities of "job shadows," where you are allowed to follow a professional and watch how they work. Not by assisting them, not shooting—just watching how they handle the difficulties of getting a good shot in the midst of confusion and complications that come up on every assignment. I think, too, that determination and flexibility are great assets to have.

Even if you don't have a degree, or can only attend a school that doesn't have a great photojournalism program, it's important to create your own opportunities by seeking out talented professionals to be a mentor and being willing to take whatever constructive criticism they offer regarding your work.

How does someone find work?

When applying for a job at a paper let them know you have more than a strong portfolio of pictures. Because even the most fabulous photo portfolio or having just one awesome skill won't necessarily get you the job. In the next twenty years the jobs will often go to the people who have a varied skill set, to people who have a full understanding of the technology both Mac and PC and all levels of Photoshop. An understanding of digital photography and digital transmission of photographs is imperative. The Web has also become a medium for photographic expression. All major newspaper have Web sites. One way to follow the work of photojournalists is to constantly be checking out the Web sites of news organizations.

PROFESSIONAL PROFILE
NAME: Jennifer LaFond
PROFESSION: creative management
WEB SITE: *www.jenniferlafond.com*
HOME BASE: Dallas, TX

What's your description of your profession?

Though it's commonly called being a photographer's rep, I prefer the term manager, since the work is creative management. That term better reflects the complexity and depth of what a good rep will do. Being a rep can mean simply dragging around a portfolio.

In your view, what's the role of a manager or rep?

A major aspect of my job is simply managing everything to remove the stress of business from the artist. I handle the logistics so the photographer can focus on creativity and work as a team with the creative folks to create amazing work, instead of thinking about how much this model's going to cost today. I'm more hands-on than most reps, who say "Here, you've booked the job, now have fun." I take a more client service approach.

Then, when seeking new work, at least 50 percent of my time is spent "planting the seed." Getting work, quality work, is certainly the ultimate goal of a manager, but most people aren't aware of how much advance effort is needed before you land a good assignment for your photographer.

How do you go about it? How do you find new clients?

I spend 70 to 80 percent of my time getting new business—finding where the accounts are going and chasing down those accounts that are the best accounts for my photographers. For example, say I have an automotive shooter, I'm going after this agency because they manage *x* amount of accounts in automotive. Also I'm continually reading trade publications, so if I've got a food shooter I'll check the food trade journals to learn what's new; where is the influx of money coming from; does this company have a new product. Then I try to find the point person that has the decision making power on the photography.

How do you become successful as a rep?

Success comes from relationships. I have clients who will say to me, "Jenn, you always go above and beyond what we ask for." Those people will always return my calls, look at samples of new work, and give us a crack at any work that matches my photographer's style. It's what ensures continuing flow of work. I never waste their time but always check in to see how I can help. Service is a delicate balance.

What's your method for showing portfolios?

We customize our presentations to each client. And it varies on whether you are pitching a specific job or marketing to a new client. But we usually start with a digital sample.

If there is a specific assignment, you learn—in as much detail as possible—what the client needs and tailor a presentation to that project. We will create a custom mini-portfolio of work that exactly matches what the client described, then send it as an online portfolio through the Web or as a PDF file. Say it's a hotel client—they want to see hotel interiors. I'll pull work from one of my photographers who shoot hotel interiors. If they need a fuller portfolio we provide it. In the case of a new client, when they express interest in the custom file, I'll follow with a sample packet in the mail or FedEx a portfolio. If I can, I'll get in front of them to do a traditional portfolio showing. If you're dealing with a VP of marketing he'll have five minutes for you—if you're very lucky. So your spiel can't be overdone. It must be professional. Most of the time I'm just planting seeds. They'll say: "We're happy with our photographer." I counter with: "OK great, but what happens when he's unavailable or breaks his leg? Or if you're looking for a new style." I also do traditional showings where I go to an advertising agency and show to a group—art directors and creative directors if they are available. But this most often occurs if the agencies have worked with me, then they'll give me the time.

How involved are you in estimating and negotiating?

That depends on the photographer. Some like to handle it themselves. Others are happy when I do a rough estimate for them to review. I'll work it up and say:

"Hey, does this look good?" I try to work with the photographer to help make sure that everything is covered in the bid—I ask my photographer questions: will you need special lenses, special rental equipment, or a set builder? If it is an out-of-town job, or out of the country, I often work with the producer we hire in that city to match their estimate with ours. It's important to know the going rates in another location so you don't get caught unaware—and to make sure that producer knows our budget limitations, so they don't get grandiose.

Do you go to many of the shoots and what's your role?

"What can I do to make the photographer's job easier?" That's what guides me on the set. First and foremost it's client liaison, keeping the client happy with everything from conversation to snacks—"making nice" helps keep the atmosphere calm. Also, it can be a good time to work on the relationship with the client. But I've been known to steam clothes when a stylist was overwhelmed, or download cards into the computer when the assistants were handling other problems. I do whatever it takes on my part for the shoot to be successful.

How many photographers do you represent and are they in different specialties?

I represent four photographers. That's just about the limit if I want to give proper attention to each, because I'm involved in all aspects of developing their careers. Also, as I'm only one person, I like to give hands-on service to the client, so that also limits the number of photographers I can represent.

There is some overlap with my photographers, but their styles are different enough that we don't often find them applicable to the same job. There is one who shoots product still life only, another who shoots product and people, and the other two are primarily people but with a different styles. One of my "people" photographers shoots families, children, and lifestyle in a soft and pretty style, while the other is more hard edge and urban in style.

But when I am going for new work, I match the account to the skills of the photographer.

Do any of the photographers you represent still shoot film? Do any client's still request film?

Yes, it's interesting, because you'd expect that all jobs would be digital, and certainly all photographers *must* be competent in digital—but film is still used.

In our market there are two areas where film is still required. One is when the client needs utmost confidentiality. For example, in the automotive industry, we are required to sign a nondisclosure agreement. The agreement governs what we talk about as well as how all of the visuals we produce are protected. After all, GM doesn't want Ford seeing their newest models when they are still in test mode. They insist on film, often 8 × 10 film. Film limits the number of copies, so the image distribution can be controlled. With digital the control is more difficult.

Another group of clients who need film are those who haven't invested in the technology or trained personnel to handle digital files. I have a list of maybe fifty questions I ask a client before we advise if the shoot should be digital or film. We ask about their digital capacity, especially the file-management skills of their staff. We deal with a lot of small companies who simply haven't made the investment to handle digital. We find they can't handle digital postproduction or CMYK conversion or even know where to get it done.

Will you represent a young, new photographer?

It's unlikely because a new photographer simply won't have enough experience to give me a track record to market. Usually they don't have the income level to support investing about $30,000 in digital so they are fully functional for high-paying assignments. It's unfair to take a slim portfolio to a client when that person can't demonstrate that they are ready to handle complex assignments. And it goes to my credibility. It's better for them to build up solid samples over a few years before seeking a rep. Though there are reps that will simply trot a portfolio around for you, but if there is no backup experience to the portfolio a newcomer might blow a big opportunity by not being ready.

Is there a suitable background for management?

My master's degree was in art history, which trained my eye and indicated a love of the visual. But there is no real training for a rep—except possibly being an intern or an assistant in a management agency: if you decide your career goal is the management of photographers, that would be a good path but it seldom happens. In my case I worked at a talent agency doing casting and saw the opportunity in management. Having done some small amount of shooting gives you understanding to help you bridge the knowledge of the client to the photographer.

PROFESSIONAL PROFILE

NAME: Chrissy McIntyre

PROFESSION: Proprietor of Image Research, Inc.

WEB SITE: *www.imageresearch.com*

HOME BASE: New York metropolitan area

You have your own photo researcher company. What do you find most satisfying about the work?

One of the best things about my job is that I get to look at pictures all day. That beats spreadsheets and PowerPoint presentations any day of the week! Being a part of a project pleases me. I do a lot of research for books, children's books,

all books, which I like because books have permanence. It's something you can hold. When you work on project you can help create ideas about spreads. You get to be a part of the process and have real influence. I like the interaction with editors and writers and the photography team.

Where did you start in the industry?

I took a job with Corbis Photo Agency. When I was first there it was the beginning of their big Web conversion. They went from traditional marketing of images to showing photos online only. I was part of the team that chose which photos would make it online and which wouldn't. That was exciting, fun, and very interesting. Essentially we were in a lot of meetings where we fought over what photographs would make it on the Web.

For a while the Corbis researchers had to send out both transparencies as well as to prepare digital light boxes for clients. Once the clients realized how easy it was to work with the digital light boxes, that's all they wanted. They were much happier not having to send back transparencies and it was so much quicker.

In choosing what was to go on the Web, it became the classic fight of the art person versus the tech people—and they don't understand each other. We'd argue that we needed, say, six images of some celebrity, because all the images were good and each represented a different aspect of the person's life or their contribution to the world. I'd say: "Why don't you understand this—these are important images, why don't you understand that we need to have them." I wanted to say: "Don't question me, I know what clients want." It was a struggle, but it was interesting because it was about pictures.

Unfortunately then I moved into a position as a sales assistant. I learned that I hated sales. There's tremendous pressure to get your numbers up. You have an Excel spread sheet with your monthly sales goal. You'd work toward that goal, build up to your sales, and then at the end of the month it all went back to zero. That was the worst day. I had wanted to be a part of a project, and in sales I felt completely out of the process of research. So I up and quit and started my own business.

What I learned in the process is that there's no art involved in sales. I was naïve when I started in sales thinking I could really make a difference to the artistic part of a project. However, if I hadn't been at Corbis I wouldn't have found my way into photo research.

What do you find most pleasing about running your own business?

I like being more directly involved with clients and I like the teamwork of working on books. Also, it's more interesting to make a wider search using other

sources beyond Corbis. There's a challenge in finding the right styles for each level of book, from the need for historical photos, pictures for children's books.

Another good part of this type of research is that you have an end point in your project. There's a time it's finished, completed, and there's a tangible result like a book to hold onto and put on your shelf. It's something that people want, and buy, and use. That's very satisfying.

What are some of the worst things about your work?

It's frustrating when a client doesn't like the photographs you brought in. It's not fun when you thought they had the perfect shot but they are lukewarm about it. At that point I wonder if I didn't get their point at all. That's why it's important to ask questions at the outset in order to be clear about what's desired.

What's really dull is doing the photo logs and all the billing and data-entry work but any job has some of that tedium so you just grit your teeth and get through it.

Do you work with Photoshop?

Well I have to know how to convert from hi res to low and back again as needed, but I don't change pictures. I never manipulate a photo, but I do need to know what's possible so I can explain that to a client. Naturally that may involve getting permission from the photographer to make a change. Often it's nothing more than a layout problem, adding more sky or grass to fit a layout.

Do you have any advice for someone interested in becoming a researcher?

There is almost a dichotomy in what's required. A researcher needs to be artistic and have a creative eye as well as a tolerance for detail and good organizational ability. So you are both intuitive and linear.

Another tricky aspect of the work is negotiating fees so you stay in budget. Some companies don't have much money and they want as many free sources as possible. Free sources can take more time, which has to be part of the equation.

In the end you must do all things: find dynamic beautiful pictures and do it quickly. Slow and methodical doesn't get it because in the digital world everyone wants things fast. So being speedy with a smile—a freelancer must be pleasant—will bring repeat clients. Above all you need to enjoy being a detective, searching, finding photos

How does someone find work?

Now I get most of my work by word of mouth. But it really starts with one client, and for me that just ballooned into other work. I took on a job organizing about four hundred photos for a client who needed someone to edit and

organize the material. Next I was helping out a researcher who was swamped; that led to being assigned to other books in that series. So through friends and connections you build a business

Some people start by working in photo agencies. Then when they branch out on their own they have some contacts to fall back on. It can help to belong to organizations like ASPP—the American Society of Picture Professionals—as a way of networking.

Taking on the drudgery tasks of organizing or permissions can be an entry. If you love photography and know enough to judge quality and composition, know the sources then all you need is one break to show a client what you can do.

PROFESSIONAL PROFILE

NAME: Karen Amiel
PROFESSION: art advisor, curator, private dealer
HOME BASE: New York City

How do you approach building a corporate collection?

The first step when you build a corporate collection is to understand what the clients want and need for themselves and the corporation. My usual approach is to ask a series of questions of the CEO. What the desire for the collection is, what thoughts he or she has in mind, does he or she have any specific vision? Sometimes people have an idea in mind, but they may not know how to express it. This is true whether I'm collecting for a corporation, or for a personal collection. It is very important to listen to what the client is saying all the time because they are giving out clues that are important to consider.

So, the main thing is to try to get a read on what people are interested in, especially if they are new to art. Often times you want to find out what they dislike as much as what they like. If I have a client who has a desire to collect but is not sure what interests them, I'll take them to the Museum of Modern Art. Usually in one hour I can sum up what their interests are. We'll see a picture and I'll say, "What do you think about that?" Let's say it's an abstract painting. They'll say "Abstraction

Hallway, FSA collection, curated by Karen Amiel. Tokihiro Sato "# 389 Kamaiso, 1999."

Reception area. FSA collection, curated by Karen Amiel.

makes me nervous." Now that's not something someone would have said had I asked what are you interested, or *not* interested, in. They wouldn't know to say that. But the feelings that art elicits are very important to know about.

One person said to me "I can't stand orange, can't be around anything orange." I was astounded. I wouldn't have known that nor would I have thought to ask if any color disturbs them. Or somebody may say "I love photography," and then you know the best kind of collection for that client. So the beginning stage, whether for a corporate or personal collection, is to find out what turns that person on—what rings true for them.

Are there special challenges to a corporate collection?

The challenge is to build a collection that considers what the company's core business is. Employees who work in an artistically interesting and meaningful environment are generally happier and more productive.

With a recent collection I put together for a financial corporation, the FSA collection, they already owned some art, so we decided to try to build on what they already had. The works were mostly about landscape. Secondly, the company's core business dealt with infrastructure, both urban and rural—building roads, schools, bridges, power plants, etc. We felt it was plausible to find photography—in order to be mindful of shareholder's money—that addressed rural and urban infrastructure. This approach would have meaning to the company. The fact that people were coming to the offices from all over the country indicated that the collection should represent both urban and rural landscape from across the United States and areas in Europe, where FSA has offices as well.

The company moved to a new building this year, where the architect created some larger spaces, so I was able to introduce larger scale works of photography than we were able to use before. At that stage, I also suggested to the CEO

FSA collection, curated by Karen Amiel. Mike and Doug Starn.
"Structure of Thought #17, 2001–2005."

that the collection needed an edge. Having too much pleasant landscape pho-
tography could become boring the same way too many photographs of New
York City bridges can become boring after a while. What we needed to do was
add photographs that still related to infrastructure issues, but that moved into the
area of art photography that took a more conceptual approach.

Does the public's response to works of art change?

When I was at the Arts Council of Great Britain, I had to find homes for some
of the larger, mostly abstract, paintings that we had in storage in the Hayward
Gallery. I ran a loan program where we'd place paintings in universities and
government buildings around England. One time I loaned a great big pink
splash of a painting by John Walker, which was hung in a hallway in the science
department of a university. The response was immediate and vocal: "It's ugly,
I hate that painting, it's horrible, take it away." I'd always say to the employees,
give it some time. You need to give it a chance because then you'll begin to see
things in it, over time. Art education is a process. I'd go on to explain: "Once
you go through that phase you'll begin to understand things in it the painting."
But they were still kicking and screaming.

The loan lasted for two years. When two years came to an end it was time
to take away the painting. You should have heard the screaming and yelling
then: "Where's my painting, where's my beautiful pink painting, the one that
was in the hallway, where did it go?" Human nature is really funny.

Do the workers in a corporation influence your collecting?

Yes, you have to appeal to a great number of people in a working environment.
And the nature of landscape photography is fairly amenable to most people, and
it was compatible with the FSA corporate vision.

It's a challenge to strike the right balance. When you do something for a
corporation you have a large employee population with, perhaps, not much art
education. The wrong collection for that group of people might be confusing or
threatening.

The experience with the FSA collection was amazing, because it threatened
no one and there was a lot for people to take away from it. Most of the early
purchases were easy viewing for most people. Then by introducing more intel-
lectually challenging works, it elevated the viewer to another level without their
really knowing it. And they always had the other work to fall back on—all the
totally recognizable, easy-to-understand landscape or cityscape photography.
They were able to view the more difficult work because it had a relationship
to what they already understood. They actually got very excited by what they
found in the collection.

How important is the installation—the hanging of the collection?

Where art lives is very important. The way in which you install art is important. There is always a message to be had. It's what happens when curators curate shows. What they're really doing is making connections between things that the viewer might not understand if the work were hung randomly. The viewer is not going to understand the messages, the inherent links between things, unless you make them physically proximate.

There are relationships that are made. As the viewer, you start to look and say to yourself: "I'm looking at this picture. But how does this picture relate to that picture over there? And if I'm standing at that doorway, what does my eye read when I see through the doorway to that wall? And now through another doorway?" So in hanging a collection you're always making the brain try to understand one thing in relationship with another by making a visual link, even if it isn't obvious at first to the viewer.

How you hang the art creates the link. It's a link in terms of color or it's a link in terms of content or it's a link in terms of format—and, of course, a link in terms of scale. When you come to scale some pictures are more powerful together than they would be separately. Or if you have larger than life size works positioned at two ends of a hallway, like book ends, they relate in a stronger way than if they were hung unrelated to one another.

The physical relationship of the art gives the viewer another level of understanding of the message and the power inherent in the works. How you influence the viewer depends upon how you install a collection.

Location and Support Services

All photographers depend on help from assistants, technicians, and retailers. In this chapter we'll look at the support-system careers that are needed during the actual shoot time, as well as the ongoing services provided by retail stores and manufacturers.

Some photographers work alone much of the time—photojournalists, documentary photographers, or nature photographers may not need much more to create their fine photographs than the equipment they carry.

However, a photographer shooting production assignments for a client counts on the help of a team of specialists, which can vary from one assistant on a standard shoot to a full-scale production with six, eight, or more professionals doing their parts. There is a lot of electricity when a creative group gathers together on the day of a shoot. Each person performs a valued, even essential, function. It may not be quite as hectic or time sensitive as it is, say, for the pit crew of a NASCAR race, but the contribution of the specialists assisting on a photographic production is critical nonetheless. It can be a great deal of fun to be part of the team. Also, these are career opportunities that are well suited to a career blended with your own fine art or personal photography.

Some of the team members work long in advance doing preparation for the photography; others are needed only for the shoot day.

PHOTOGRAPHER'S ASSISTANT

Being an assistant is still an almost essential part of becoming a photographer. Working as an assistant gives you direct knowledge of the realities of a photographic assignment from lighting and all equipment formats to the delicate art of client handling. It teaches on-the-job subtleties that cannot be learned in school. This is true for publication, consumer, and service photography.

Watching the way a photographer handles sticky situations teaches a lot—from the client's unreasonable demands for a complicated lunch order to handling a breakdown in equipment. Some photographers allow (or create) a stressful environment during the shoot, whereas others maintain a calm demeanor in the midst of mini-disasters. You can see which approach is more effective and how the photographer's behavior either diminishes or benefits the productivity on a shoot. The answer is obvious on paper, but when you see it happening you'll get a gut reaction that instills a valuable lesson.

A good assistant will anticipate what the photographer's needs, almost before the photographer has thought of it. In a way, if a photographer has to ask you for something, you might almost say you've let him or her down. Assisting is a critical job and requires someone who takes charge and doesn't sit back to wait for instructions.

Time

A requirement I have with all assistants is they must be where we are supposed to be, on schedule, without fail. As most photographers will tell you, being "on time" means being "early." Even if you can prove that King Kong closed the highway for thirty minutes, you would still be better off allowing extra time for the unforeseen by leaving home thirty minutes ahead of schedule.

This "on-time-means-early" business isn't just uptight behavior on the part of the photographer. Precious minutes wasted early in the day can compound problems later in the day that actually *are* out of your control. For example, a model may not arrive "hair ready" and unexpectedly needs an extra fifteen minutes. If you have squandered time earlier, you can start slipping seriously behind schedule. Allow for mishaps, traffic, train delays—anything, so you'll be waiting when the photographer or client arrives ready to start the day focused and relaxed. Even if the photographer tends to slip in a little late, if you can be counted on to arrive when you should, it will be points in your favor.

Getting Experience as an Assistant

Photographic skills and a high level of computer capability are essential—and the more experience as an assistant the better. Experience is taken as a given by any photographer considering hiring an assistant. Enter the old conundrum: "You must show you have experience, but how do you get experience if no one will hire you without experience?"

Internships

Even during summers, while you're still in school, internships are an especially good way to get a jump on the experience issue. Usually an internship is an unpaid

job (or at a very low wage), but consider it an investment in your future. Take into account the photographer's plight. If they should hire you without experience then they will have to spend a lot of time teaching you—that is a financial loss of their time. So if the intern learns something and the photographer is generous in teaching you, that's your payment and it's a fair bargain. Occasionally there are photographers who abuse the concept of internship—in which their part of the bargain for your free work is to pay you with professional training. They should take time to explain how and why they are doing things, not just give orders and use you as a pack mule for equipment. If they don't, then do your best to pick up whatever information you can from observation and turn to a more honorable person the next time. (You can find that person by checking references with other assistants in your area, whom you can meet by going to local meetings of organizations such as ASMP, APA, PPA, and ASPP.)

Finding Work

Whether you're looking for work as an intern or are an assistant with experience to offer, approach photographers by e-mail or by letter but *not* by phone. Send a resume, which should include: education and training; technical skill level in all photographic formats, lighting, film, and digital skills; the names of any photographers you've already worked for; your Web site address, driver's license, passport, additional languages spoken and level of fluency—any other special skills.

The key to finding work as an assistant (discussed again in chapter 14) is following up on your mailing in a polite and non-intrusive way. Once you've sent an e-mail or a letter, you can follow up by phone as long as you don't pester. Use networking, connections from anyone you know, and (here it comes again) contacts made by participating in organizations such as ASMP, APA, ASPP, and PPA.

Full-Time Professional Assistants

Although most assistants use their experience to further their goal of becoming a photographer by learning what's needed to become full-time professional shooter, there are a handful that make a full-time career of assisting. And it's not a bad life. Usually they are excellent at the work and often capable of doing the photographer's job if they chose to do so. They know the lighting, can rig most anything you can think of, have the ability to improvise at a moment's notice, and anticipate everything you need. I once had a professional assistant in Florida who could estimate the time it would take for the sun to come out from under the clouds. So while the models and I were fidgeting and wondering how fast the clouds would move, he'd study the skies through double sunglasses and report: four minutes to sun, or twelve minutes—or on less fortunate occasions state "that's it for today." He was uncannily accurate.

One reason for staying as an assistant is that you can participate in the creative work of photography but still avoid pressures from a client. You're not out front for the praise or the blame. You don't have to go out and market yourself—since the word gets around and an excellent assistant is never idle, giving you have the satisfaction of being much sought after. Travel is another perk for the full-time professional assistant. When photographers have the budget to take an assistant on a location shoot here or overseas, they inevitably opt for the top person available— the professional assistant.

Sam Willard gives lots of cogent advice later in this chapter on how to be an assistant; there is also plenty of great information in John Kieffer's excellent book *The Photographer's Assistant* (Allworth Press).

Digital Assistant

These days, depending on the size and budget of the photo production, photographers will have one photo assistant to handle lighting and other traditional assisting duties and an additional person to do the computer work. This person will download cards into the laptop, organize them into folders by shot name, and begin making sure the digital images are ready for the photographer to review when there is a break in the shoot. (Whether you are working on location or in the studio, you need to keep up with the shoot by downloading digital files as you go.)

On small shoots one person may do both traditional assisting and handle the downloading, so digital expertise is an essential component in what you have to offer when you look for assisting work. If you are very skilled, you may be hired by the photographer to do the postproduction workflow at the end of the day or in the days after the shoot. I've done this repeatedly—found an assistant adept at both location assisting and computer work. When they turned out to have real skill, I hired them for extra days to help out on postproduction.

PRODUCTION

On a large-scale shoot the producer is the hub of everything. Working sometimes weeks before a shoot begins, the producer is the person who makes sure everything happens when, where, and how it's supposed to.

A producer must be incredibly detail oriented, able to schedule and budget accurately and juggle a lot of things at one time, while still appearing calm. The producer instills a sense of confidence in the photographer and client by making sure all details are planned out in advance and by being able to come up with instant solutions when things go awry—and with so many details, things do go awry. As a producer, it helps if you have some knowledge of photography, since ultimately the

person you are solving problems for is the photographer. You might need to know what types of fabric photograph well, what colors are good with certain skin tones, and be able to notice reflective backgrounds that will cause problems in a location. You are always thinking for the photographer.

In the words of Catherine DeMaria, a producer whose interview appears later in this chapter: "The producer does the who, what, when, and where of making a photo shoot happen, based on a layout from the art director or photographer. In production the buck stops here. If anything is messed up, it's the producer's fault." Look at the list below to see the complexity of the job.

The role of the producer is to:

1. Visualize the job from start to finish to plan for what is needed and to estimate the cost of the job.

2. Estimate in collaboration with the photographer and/or rep.

3. Decipher from the layout what is needed to execute the shoot, including: crew needed—production assistant, location scout, casting talent, hair, make-up, prop and wardrobe stylists, and special people—baby wranglers, pyrotechnics experts, set builders, animal handlers, etc.

4. Interview and hire the crew, including making referrals to the photographer for assistants, digital techs, labs, and equipment rental houses.

5. Get all permits required for location shoots.

6. Coordinate the shoot day. Plan for comfort and commodities for the client (coffee, snacks, water).

7. Assign someone to get model and property releases and handle unexpected crises.

8. Handle all finances related to the shoot

9. Negotiate shoot site details and pay for locations and staff.

10. Make sure the job stays within schedule and on budget.

THE CREW

After a photographer chooses an assistant, a digital assistant, and a producer, there are still lots more jobs to be filled, collectively known as the crew. On a large production, as is common with advertising photography, you might need six or eight specialists. On smaller productions, one stylist may handle several roles. Though there is a lot of responsibility and the work can be pressured, these jobs are a lot of fun—working with other professionals to bring a creative vision to life is quite a

treat. To get experience in all these specialties, you usually start as an assistant to a producer to learn the ropes. The following sections describe various other members of the team.

Crew members can be provided by a producer, who should be able to schedule them so that things are done on time. The producer will also manage the budget for all these activities. Working on a big production may not be for everyone, but it's exciting to see a scene come to life when the crew does their work.

Location Scout

A *location scout* works with the photographer to clarify the style of location needed, taking reference photos of potential locations and checking permission requirements or location fees. The scout indicates on all scouting photos the time of day it was shot and the direction (N, S, E, W), to give an idea of the sun position at a given time. The scout also describes any reflective surfaces on interiors or any impediments to placing lighting equipment. The location scout will usually handle permissions from the location or property, finding out about any fees, and get a property release signed.

Props and Wardrobe

Prop buyers or *wardrobe buyers* do just that: buy what's needed on the list from the photographer. You'll need to know the exact time period, style, and general look for the items or clothes you're getting. Your creative input is important in getting the right style and color to complement the scene envisioned. It will help if you can see a layout. You might find yourself haunting prop houses (in larger metro areas), regular stores, flea markets, and thrift shops. The less exciting part is returning props after the production. Since some props will be rented, they will be returned to the rental house. Other times, props are purchased and not used so they must be returned to the store for credit. Before long, you know where to get anything and everything. One time I was on a shoot in Paris when the editorial content was changed last minute. We suddenly needed an American cowboy hat—imagine, in France! Our French stylist had it on location in two hours. Knowing your turf and how to find things will make you very valuable. It's not bad getting paid to shop.

Casting Professionals

Finding the right models can be critical to the success of certain types of photographs. A *casting professional* often known as the casting director, knows a full range of model agencies, those specializing in glitzy folks, real people, theatrical people, children, and even animals. The person in charge of casting gathers headshots or composite cards from a variety of model agencies. Usually the photographer will

want to follow up with one or more auditions to make a selection. At the casting call, the casting director may take her own reference shots at. In addition to the potential model's appearance, you can get an idea about attitude and physical attributes—are they stiff or loose, pleasant and easy to work with, or tiresome and whiny. All this comes through, and the casting director can save a photographer from headaches by weeding out potentially difficult talent.

Stylists

Hair stylists and *makeup stylists* are specialties widely used on photo shoots. They learn their skills from assisting a stylist or by working in theater. *Food stylists* know where to get the freshest looking fruit and vegetables and the most photogenic meats, often cut to their specifications. Perhaps the food has to fit on a certain size plate and still look appetizing. You won't get that in the grocery store cooler. Food stylists often prepare "stand-in" meals to be used for lighting and tests. Then, when everything is technically correct, they cook another meal with the same ingredients to be shot the minute it's ready, while it's still fresh looking.

Baby Wranglers and Animal Handlers

Aren't these great job titles? It's often said that the most difficult shoot you can arrange is one with toddlers or animals. Boiled down to basics, the *baby wrangler* does what the mother only hopes to do in real life. Keep the baby happy, calm, and quiet until needed on the set. A baby wrangler comes armed with a variety of toys and noisemakers used advantageously when the photographer is ready for a good expression. *Animal handlers* do much the same thing but with different toys. Don't get lured into using an untrained animal. If they aren't trained it could cost a bundle in time and money. Even with animals, go for the professional handler and a trained animal.

Set Builders

Set builders provide anything from basic carpentry to a sophisticated ability to create interiors quickly and with credible look.

SERVICES OFF THE SET

At first glance it may not seem glamorous to work in a lab or sell in a retail camera store or represent a manufacturer, but the fact is that all of these people work with photography and photographers. They fill essential roles. Often they have to be skilled in several areas of photography.

The major service areas are described in the following sections.

Retail Sales

Much of the retail business has moved from personal contact in a store to online buying. The price advantages are significant but something has been lost. The advice of a knowledgeable retailer has value. There is still a place, as you'll see in the profile of Victor Frey, for a supplier who goes beyond quoting price to help the photographer with analysis and information gleaned from working with other professionals. In some geographic areas, there are still customers who prefer to walk into a store, pick up equipment and feel it, heft it in the hand, and get a sense of the controls. Would you buy a car without a test drive? Finally, it's a good day job while trying to break in as a photographer, as you'll see in Maria Lyle's profile in chapter 14. She made working in a retail store into a stepping-stone to other parts of photography.

Custom Photo Labs

Custom labs are alive and well, but not all of them are thriving. Film labs have been hurt by digital, but almost all have responded by establishing digital departments to take up the slack. Some photographers who have always done their own darkroom printing will continue to do so. Many are able to do more of their own printing more easily with the new breed of professional-grade inkjet printers designed to handle digital files. Many photographers have their printing done by professional printers, either because they haven't developed the expertise or don't want to take the time. Lab work, whether in a wet or dry (digital) darkroom, is exacting and creative. There is artistry in making a fine print.

Retoucher or Digital Artist

For the person with superb skills in Photoshop, there are numerous career opportunities, from basic retouching to complex photo compositions. We sometimes do a great disservice to people who work manipulating digital-photographic files. We tend to lump them under the rubric "retoucher." That's fine for someone taking wires out of a sky or wrinkles from a CEO's jacket. But the contribution of a digital artist can be on a par with that of a photographer. A digital artist has not just skill but a delicate touch in bring to reality an imaginary concept by the photographer. If you have the skills, and it's obvious what's needed is superlative ability in Photoshop, then you could be highly sought after in this area.

Manufacturer's Representative

Quite often, companies who make equipment designed for use by photographers will hire photographers to market it, or to be their *manufacturer's rep, also called customer-relations representative.* This is a career to investigate if you want a regular income

with benefits and still be involved with photography. All photographers need the help and advice, and as a representative for a manufacturer you're in a unique spot. You can help answer a photographer's questions and pass on problems, complaints, or design suggestions to your company from the photographers you contact. And in some companies, your role might be to try out new equipment or demonstrate it at professional meetings. If you are working for a manufacturer, an interesting part of your job is to get feedback from working pros. If you are a photographer with a question, you can get in touch with a manufacturer's rep by attending meetings they sponsor for organizations such as ASMP, APA, ASPP, or PPA. If an event is sponsored by Nikon, Canon, or Fuji, surely the rep will be there; you can make personal contact and get a phone number for future questions. If you are working for a manufacturer an interesting part of your job is to get feedback from working pros.

All of these areas of support are crucial to the making of photographs. They can be very interesting creative and careers.

PROFESSIONAL PROFILE
NAME: Catherine DeMaria
PROFESSION: producer, photographer, photo editor
HOME BASE: Magdalena, NM, and New York City

What's the role of a producer?
Simply put, it's the person who gets it done. The producer does the who, what, when, and where of making a photo shoot happen, usually based on a layout from the art director or photographer. In production the buck stops here. If anything goes wrong, it's the producer's fault.

The responsibilities of a producer include planning, estimating, and executing everything from start to finish on a job. Finally, making sure the job stays with in the schedule of the allotted time and budget. Whatever you think might need to be done for a shoot, the producer does it.

What characteristics are most important for an assistant or producer?
The ability to anticipate the photographer's needs is key. You must be alert every second to foresee what he or she will need.

I often use a tennis analogy to explain my thoughts on assisting. As an assistant, or an assistant producer, you are like a ball boy at a tennis match; poised to run the minute the tennis ball is hit. You have to be there on call and ready for the moment the photographer puts down the camera or asks for something. You have to anticipate what is going to happen next. You have to be there at every

moment—there's no reading a newspaper or looking off into space. The tennis analogy works because the attention you have to have on the ball all the time is the kind of attention you have to have on the photographer. You even have to know the direction the photographer is going at all times. Through this you learn how to think, how to be attentive, and how to focus your attention on someone else.

This is true not just on the day of the shoot. If you are on staff in a studio, you should help predict what might be needed even the week before a shoot, the day before a shoot, as well as the hour of the shoot. You don't sit back and wait for instructions but participate as if it were your own photograph. Your purpose is to make the photographer's job easier and the results more successful.

Attitude plays a major role in your rise to more responsibility. When I was learning the business, every time somebody asked me to do something, I said "Yes." My attitude was: "No" does not exist.

What experience did you bring to your profession as a producer?

I got *The Black Book* and I started at "A" and worked my way through the names of photographers who had ads in the book, whose work I could see. In the "Gs" I got to photographer Gary Gross and landed an apprentice position there. It was a very prestigious studio at the time. He was doing very high-end advertising and fashion assignments with the top models of the day. It was my way of breaking into the business. His excellent first assistant taught me the ropes. Once you've got that down, and they know you're going to be standing there when they hand you the lens, then you can begin to learn things—you'll be given more opportunities to become a first assistant.

At the Gross studio I had learned to make good black-and-white prints, so I moved on to work in a custom lab, where we printed for all the high-end fashion photographers of the day.

Next, I went from assistant in a major fashion studio to being the studio manager of that studio. The difference between a studio manager and an assistant is that when you are an assistant you are completely focused on lighting technique and all the elements of what a photographer needs at the moment of the shoot. When you are the studio manager, you're thinking about how the business operates, about the different elements that need to come together for the photographer and the operation of the studio. It's an expanded way of thinking. You begin to think more like the business owner. That brought the business of photography into it for me in things like casting, styling, and location scouting. Also I was involved in hiring and supervising crew, including stylists and location scouts. I scheduled the production and handled all logistics of the shoot. Later, when photographers cut back on their studio staff, some of those duties fell to a freelance producer hired for each shoot.

There were so many experiences that followed. As an assistant to a photographer's rep I reviewed portfolios and helped with advertising and sales for the photographers. As a photo editor for Black Star, an editorial stock agency, I developed targeted presentations to market photojournalistic-style photos to advertising clients. All of this was interspersed with stints of freelance work producing shoots for photographers and television commercials.

Then I was offered the opportunity to go in house with a stock photography agency called The Stock Market as a photo editor. I managed to "morph" my job from editing into developing their stock-production department. It was an exciting and energizing time collaborating with photographers on a job full of creative potential. During my five years there I became director of photo production, producing and art directing for the photographers producing stock. Now I divide my time between New York and New Mexico, producing shoots and perfecting my digital photography. It's a great life.

What type of background and education would you recommend?

There are a number of ways to prepare for being in production. It helps if you have some knowledge of photography, so you can visualize the impact of your decisions on the resulting success of the photograph. A degree in photography and at least one or two basic business courses are important, as well as a strong digital capability.

How does someone find work?

Advertise your work in as many ways as possible. Start by putting listings in the *New York Production Guide, The Work Book*, and *La Book* or in the production guides in other major cities. Also, personal contact made through previous jobs and membership in trade organizations. Word of mouth works well once you have a few successful jobs completed. When you have enough experience to really show a strong background, send direct mail to photographers, stock agents, and reps. Use your Web site to back up your promotions.

If you want to become an assistant in a high-end studio, look up names in *Archive, La Book, Work Book*, and *The Black Book* or editorial magazines or other advertising media. Then keep going back until you get someone to see you. I find that photographers are less interested in a producer's portfolio than in your resume and references.

Try to have as a broad a life experience as possible, so you know all types of people and can engage on an intellectual and creative level with every type of client. Understand art, music, and design as a foundation for building your own style. Style always supercedes technique.

My final advice to newcomers is never let yourself stagnate or it's all over. Remain fully engaged—in whatever part of the business of photography you choose.

PROFESSIONAL PROFILE
NAME: Sam Willard
PROFESSION: photographer
WEB SITE: *www.samwillardphoto.com*
HOME BASE: Berkeley, CA

Did you start out in a career in photography?

No. I have a liberal arts and a business degree. My first few jobs were in consulting, corporate marketing, and management in the high-tech industry. I am self-taught as a photographer. I always had it as a sideline, but only went full time after several years in the corporate world.

What is the value of your work as an assistant?

When I first made the transition to a photography career, I spent three years as an assistant. Starting out as an assistant has two big advantages that I see: First and most obviously, it fills in any gaps in your education. I my case, I was self-taught, so I had a lot of gaps! Even coming out of photography school, one will find that the theoretical world of academia and the real world of shooting are different. Assisting is a crash course in identifying and learning to cope with those differences.

Aside from watching skilled photographers do things well, assisting occasionally allows you to see a photographer mess up. You learn as much or more from mistakes as you do from successes, and it's infinitely better to learn the lesson while it's somebody else's ass on the line. Learning from both the good and the bad, and being paid while you learn, is just about the best education deal I can think of.

Second, I think that assisting is just about the best way in the world to learn two big keys to success in any field: *improvisation* and *professionalism*.

All photo shoots, big and small, involve improvisation. As an assistant, more than anything else you are a professional problem solver. Location not working out and you suddenly need to build an artificial set? Shooting outdoors, but it just started to rain? Shooting out in a field, and you suddenly need a fill light but the nearest electricity is a quarter mile away? Your job as the assistant is to fix the problem, allowing the photographer to focus on his shot, stay connected with his/her subject, and be attentive to the client. The improvisation skills you learn as an assistant will reward you when you are the photographer and it is your reputation on the line.

Professionalism is a prerequisite for success in any business. And all the professional attributes that make a desirable assistant also make a desirable photographer. In this way assisting is great prep for a career in photography.

What is the importance of business experience to a photographer?

Every enterprise that exists to grow and profit is a business. I learned that early on by going to business school. I don't think everyone needs an MBA to be a photographer. However, it is important to understand and embrace certain business fundamentals.

For most people running their own photography business, taking pictures will only be about 20 percent of their time—that's one day out of five. The rest of their time will be spent on what every other small business owner does: bookkeeping, sales and marketing, strategic planning, etc.

What's the best way to handle the business aspect of photography?

Many photographers plan to offload this work to bookkeepers, accountants, and reps, so they can focus on the creative work. That's a great aspiration. But it is important to realize that these folks represent overhead that you won't be able to afford when you first start out. And certain tasks—like sales—you can never fully offload. No matter how much you may hate sales, you will always be the best person to sell your creative vision.

I recommend taking at least a couple of business classes. Local junior colleges, private schools, SBA offices, and local small business development centers all offer classes on business fundamentals. ASMP, APA, and other professional organizations also offer business-related seminars for photographers, and have valuable information, including sample contracts, etc., available online to members. Sign up!

Getting business savvy is not only good for running your business. It also provides you with a competitive advantage. There are lots of brilliant creative talents competing with you for photography work. There are far fewer brilliant business talents. If you focus as hard on being a better business as you do on improving your photography, you'll do well.

Does business include pricing your work?

When you first make the move from assisting to shooting, one of the biggest— among many—panic attacks you are likely to suffer is on the subject of *how much should I charge*? I think that budgeting and estimating are particularly difficult skills to learn in school. If you assist for a while and gain the trust of the photographers you are working with, they may be willing to share their pricing with you. You may even get to see estimates and contracts

for jobs you actually work on. Having a base of knowledge is invaluable when you first start pricing your own jobs.

How does one handle the transition from assisting to shooting full time? When do you take the plunge?

It is not an exact science. In my experience, the transition was based upon a combination of preparation—shooting my own work, assembling a portfolio, writing a business plan, thinking about my target clients and ideal type of work—and following my gut instinct.

Even with all there is to learn from assisting, I think a day comes where you come home from a job and realize that you didn't learn anything new. You did a good job, you got paid, but that's it. I think that when you start getting that feeling, it's time to think about moving on.

I believe in the old adage that says, "Luck is preparation meeting opportunity." You still have to wait for the right opportunity to strike before you can fully transition to shooting full time. But if you prepare and keep your eyes open for that opportunity, the proverbial "lucky break" will come. Be patient.

What kinds of shoots are worth doing?

When you reach that point where you're ready to transition to shooting, you have to look at those early shooting opportunities with a little perspective. Some shoots may not be as spectacular as you had dreamed. But I think that a good rule of thumb is that if it's a close decision between taking a good-paying assisting day and a so-so shooting day—shooting always wins out over assisting.

When transitioning to shooting, you have to evolve your reputation. You have to show clients that you are a shooter. You also have to prove to yourself that you are a shooter—you are the creative and professional decision-maker.

I think that taking jobs, any job that involves shooting, helps drive home that realization. And who knows, a small pro bono gig may produce a connection that leads to exciting and well-paying work. Be open-minded, because your lucky break may come in disguise.

PROFESSIONAL PROFILE

NAME: Victor Frey

PROFESSION: photographic retailer

WEB SITE: *www.Adorama.com*

HOME BASE: New York City

What do you find most satisfying about your career in the retail photography business?

What I have enjoyed most about the job is my involvement with photography professionals. Over the years I've been able to work and become friendly with a lot of interesting and creative people.

Another thing I love is doing shows all over the country that are held in locations such as Las Vegas, LA, San Francisco, Texas, Florida—everywhere. Generally I go to Photo Expo NYC (a.k.a. Photo Plus Expo), the Wedding and Portrait Photographers International (WPPI, *www.wppionline.com*) and the Professional Photographers of America (PPA, *www.ppa.com*). At these shows I meet interesting photographers from all over the world. And, of course, the Photo Marketing Association show (*www.pmai.org*) gives me a chance to see all the new equipment the minute it's out.

You have quite a family history in the business, since both your father and uncle are considered legends in the retail photo business.

Yes, Sam and Lou Frey, my father and my uncle, founded the family business, Advance Camera, which was on West 46th from the 1960s through the early 1990s. Sam and Lou were identical twins, and they enjoyed the slight confusion when even long-time customers had trouble telling them apart [Author's note: Sam had a small wart over one eyebrow]. They are very warm and friendly people and built up a reputation for service that brought in many of the greats in the business.

From those early days, we worked with Magnum and had many of their photographers such as Burt Glinn, Burk Uzzle, Elliot Erwitt, and Mary Ellen Mark as customers. We also worked with *Newsweek* magazine, *Parade* magazine, many of the Time Life photographers, and the movie company United Artists. We had a number of celebrities who came in for their personal photographic equipment, such as Alan Alda, Woody Allen, Diane Keaton, and, of course, Brian Hamill, who shot the stills for many Woody Allen films.

Where else have you worked in addition to Advance Camera?

I've been at Alkit and am currently at Adorama, both in New York City. My main goal when making a change has been to find a place where I could get the best customer support for my long-time professional customers.

What's your criteria for a good retail dealer and store?

In the early years it was all about customer service and relationships. We prided ourselves on providing on-time deliveries, advice on the latest equipment, good prices on materials, and generally being at the beck and call of the customer. I remember one time a customer was on a shoot in Manhattan and a small piece of equipment wasn't functioning. It was probably a thirty-dollar item. But she was on the set with models and the client waiting. So I sent someone in a cab uptown with the piece. We always went out of our way for the customer.

How has the business changed?

Now everything is about price and availability and the Web site—it's critical that all information is clearly presented on your Web site. There is much less opportunity for customer service. Though I think my habit of giving extra service has earned me continuing customer loyalty. Many of the customers I have today started with me and have moved to each new store with me.

When possible I still try to provide the special extras. Recently, a customer needed a special lens sent overnight to LA for his Academy Awards coverage. It was too late in the day for store shipping, so I took the lens home to send it from my local FedEx office. He had the lens in time.

How big a contribution can a dealer make to a professional photographer?

Credit is a continuing issue. From the early days, helping young photographers get credit has been important contribution a dealer can make. We often took a look at the seriousness of the customer and sometimes took a chance extending credit. Even now it's still something we can do for entry-level photographers, finding ways to give them a chance within corporate credit restrictions—just to offer a chance to the newcomer. I've been able to explain to my management that new professionals, given the opportunity, can become loyal customers.

Advice was something valuable that dealers offered customers in the past. But that was before the Internet and Web site chat rooms. The dealer was an essential source of information on the latest equipment from manufacturers. Also we could report on what our other professional customers had to say about their experience with different films or equipment. Now they often use chat rooms to exchange information themselves.

However there is still a place for advice, and I don't hesitate to suggest different approaches to a customer or help them out with additional needs—such as suggesting when to rent before buying.

Careers in Teaching and Writing about Photography

There's a sage bit of advice often given to would-be novelists: "Write about what you know." So, too, in photography: before you can teach or write about photography, you must know it.

BEING A PHOTOGRAPHY EDUCATOR

It almost seems as if teaching is in the genetic make up of people who love photography. In professional photographers the impulse is especially strong. A remarkable number of photographers spend at least a part of their careers teaching. It's a thread that runs throughout this book. Almost all of the professionals I interviewed have taught or are teaching now—and I include myself.

Some photographers become instructors from the beginning of their careers, making education a major portion of their life in photography. Others turn to teaching at the end of their careers, using the culmination of their experience in the commercial world to provide valuable lessons for newcomers. Others balance teaching and professional photography work, blending the two, throughout their careers.

Within the world of photography education there are various roles to be played. Instructors in photography often have different strong points to their teaching: some are adept at teaching the technical skills of the craft, whereas others are skilled in teaching the composition, graphic quality, and emotional impact of photography. Finally there are those who have years of experience running a business in photography and who share the secrets of handling marketing, stock, copyright, and business forms. Today, of course, every aspect of digital photography is taught not just to the student but also to experienced professionals.

Some people even take a straight path into teaching. These are the students who attend a photography school, learn the skills, and enjoy the academic atmosphere so much that they stay on to become teaching assistants and then full-time instructors.

If you take a look at the list of photography schools and workshops in the appendix you'll see the opportunities. Instructors are needed in colleges, in photography specialty schools, and for all the workshops and online schools.

Qualifications

One appealing aspect to teaching photography is that the same level of teacher training you need in other academic settings is not always required. Certainly, colleges and universities will require at least a master's degree in photography or fine arts for their full-time instructors and professors in the art and photography departments. Though it's useful to have a degree, it may not be essential. Your knowledge of the field and an ability to articulate that knowledge may be sufficient. Colleges, photography schools, and workshops have spots for visiting instructors who are able to teach from their professional experience in photography, including technical, aesthetic, and business skills.

Technical schools, online learning schools, and workshops make use of many established professionals who do not have degrees but offer the inspiration and real-life career guidance in photography. So, though you may not choose to be a teacher at this moment, as you gain experience in the field, the opportunities for teaching will open up to you. In this chapter, Chuck Delaney profiles his journey from photographer to passionate educator. Then in chapter 13, Jeff Wignall and Bryan Peterson present their experience and photographic expertise in online learning.

WRITING ABOUT PHOTOGRAPHY

Both writers and photographers use their skills to tell stories: there is a natural affinity. In the nineteenth century, from the earliest moments in the development of photography there were writers ready for the new medium—ready to comment on its usefulness or critique its artistic value. Some of those writers went on to use photography, sometimes to illustrate writing itself! That continues today. For a profession that carries the maxim that "A picture is worth a thousand words," the many thousands of works written about many of those pictures may belie the maxim. Or do they? Perhaps they, the writer and photographer, have been meant to be bedfellows from the start.

At any rate, many of us who love taking pictures also love writing about the process. We proselytize our ideas, extol the virtues of equipment, or explain new trends in photography. As a photography professional, you learn from written materials. Your special interests in photography may lure you into writing about that specialty.

The number of books on all aspects of photography is staggering. In looking at the magazines and trade press, month after month, you see articles on subjects from trends in fashion photography to developments in imaging software. And that's just for professional consumption. The national press includes regular features about

photography. Many photography dealers have Web sites with articles on photography. Even *Consumer Reports*, in addition to its evaluation of equipment, offers teaching articles about photography on a regular basis on its Web site. Photography is truly of global interest.

The photography trade publication *Photo District News* (PDN) is essential for anyone involved in professional photography. You can't start reading it too early. Browsing through three or four of the monthly issues will give you an idea of the written material available to you as well as the range of reporters, writers, and writing styles they use. See David Walker's profile in this chapter for a look at the career of an experienced and widely read journalist and writer on photographic subjects.

The types of writing in the photographic world include:

• Columnist in the trade press, photography magazines, or newspapers

• Reporter for photographic trade press, magazines, and newspapers

• Commentary on fine art photography trends, reviews of gallery shows

• Technical writers on new equipment for magazines and newspapers

• Writers on digital topics, from workflow and data asset management to creative uses of Photoshop.

• Photography critic writing for photography magazines and newspapers, both for the trade and for the general public.

• Writers of books about photography, including the history of photography, fine artists in photography, the "how to" technical books on photography as well as art critique.

Teaching and writing are ways photographers express their consuming interest in photography. It may be too altruistic to attribute this tendency to a love of sharing with others what we hold as a passion—but certainly that is what many of us feel.

PROFESSIONAL PROFILE
NAME: Chuck Delaney
PROFESSION: instructor, photographer
WEB SITE: *www.NYIP.com*
HOME BASE: New York City

You are the Dean of New York Institute of Photography; how does your school approach teaching photography?

We use what's currently called "distance learning" or "distance education." We provide printed books as well as a full multimedia package of learning

materials. The students receive assignments, in class as well as online, and send in prints—the physical results—of their assignments. Their instructor sends back an audiotape critique about fifteen minutes in length.

We believe strongly in having a student return a physical output, whether they are shooting film or digital. It's the only way to judge exposure, sharpness, and color balance. The color renditions of low-resolution images sent online are undependable. Also there is a practicality matter: sending large, high-resolution files with an enrollment of 20,000 students would crash any server. In addition there are color-management issues with how the student judged their color—on which monitor? And how does it look on the school's monitor?

Online courses are not as successful as everyone once thought they would be. We find that students still want books, they want to be able to underline them, make marginal notes, go back to a marked or folded page without having to scroll back through hundreds of pages on screen. With regard to "random access memory," there's still a lot to be said for the printed page.

What's the makeup of your student body?

There is no prerequisite study or expertise for joining a course. About one-third are advanced hobbyists wanting to improve. Often, they are well-to-do doctors or lawyers with good equipment who want to perfect their technique. Another third are semi-pro: they love photography and they want to defray some of the costs with some sales plus have the thrill of publication but are not ready to quit the day job. The final third are on a career path—just burning to be pros.

What level of emphasis do you place on business of photography and copyright?

Very strong. We teach them to be good business people. Help them understand how and why they are succeeding. This holds true for in-person classes as well as the distance learning. I've done both over the years. You have to share every bit of guidance you have in terms of business acumen. I may see a guy who says to me: "Would you look at my portfolio, I'm just not booking the wedding jobs." His portfolio is fine. The problem is his breath is bad, and it's my job to say: "Let me talk to you in private." Of course, we give advice on business issues and market research, as well as issues like breath because they can be difficult to broach and addressing them in a learning atmosphere can provide essential help to a student.

What's the best thing about being a teacher?

The greatest thing of working with students in a classroom is the delight of seeing when a student really "gets it," that dawning of understanding of, say, reciprocal aperture and shutter speed—to see it going in.

Also, when you have a lecture class of 100 students you realize—and I tell them this—that at least two to four of you will have your lives changed forever

by this class. I don't know who you are, but you will know. You'll be changed, not by me, but by the power of photography.

What's your background?

Since appointing myself family photographer at age eight with a Brownie Reflex, I have been essentially self-taught. I learned from everyone around me. Early on I had the luck to apply for and land a job with the Floating Foundation of Photography. The purpose of the group was teaching photography in alternative communities. I spent time teaching in prisons and mental hospitals. Being a non-profit, the foundation raised money to provide equipment and materials to students. In the prisons we started them with Polaroid cameras, then went on to film cameras, including darkroom work. One convict who in his career as a burglar had stolen and pawned many a camera, remarked that if he had understood the delight of photography back then might have kept one or two of the stolen cameras.

I've been very lucky—my life in photography has been like swinging vine to vine. When the prison photography job was drawing to a close, I got a query from a prisoner about the New York Institute of Photography. Following up for him led me to talk to teacher at NYIP that resulted in a job there. Some good turns *are* rewarded.

Over the years I've had a studio and done everything from weddings, dance, and grip-and-grin to architectural photography. And I've been teaching since 1975 at NYIP.

Photo schools seem to be divided in their approach teaching both film and digital. What's your approach?

Digital is a tool. It gives new opportunities that have new consequences. But it's all photography. Asking if it is *film* photography or *digital* photography may be like a hundred years ago asking is this glass plate photography or celluloid photography. It's photography. There are technical innovations but the techniques haven't changed since 1850, so we try to teach both. We teach some of the principles of photography through using film. Anyone interested in learning photography should have the experience of the black-and-white darkroom and the thrill of seeing an image appear.

We are leaving in some courses on film development and all traditional information about wet darkrooms. It's my experience that students learning Photoshop who have experience working in a black-and-white darkroom have an inherent understanding of contrast issues relating to tools like levels and curves and get it much more quickly than students who don't have that experience. They understand the concepts more deeply.

Working in the digital darkroom is a little like the phenomenon of photography itself. From my vantage point, and unlike painting or opera singing,

photography has a certain seduction from the standpoint that it's easy to get good but the step from good to great is a long one.

The problem with that is that it allows a lot of people who are only good, and who probably don't have the talent to be great, to beat their head against the wall for a longer period of time. Because if you want to be a violinist or a high jumper it's pretty clear, pretty soon, how much potential you have, but with photography it can be easy to fool yourself. And the digital darkroom makes it even easier to get enough results to kid yourself. Judging how good the results are is the challenge.

Another problem with trying to master Photoshop is that it's like having a tool set that is adequate for everything from repairing watches to working on 747s. There are tools in Photoshop that are really more for graphic artist or prepress person but seem all scrambled together. We try to teach only those skills that photographers need.

What is success to you?

I define success in photography, first and foremost, as the ability to make wonderful photographs that please you as the creator of the image, and that bring joy and pleasure to the people with whom you share those photographs. Actually, the longer I've worked in the field, the less difference I see between the so-called professional and the amateur. We are all makers of photographs.

At the beginning, don't be overly concerned with where you want to end up in photography. Rather, imagine that you are on a trip that doesn't have a guaranteed destination. Anticipate that you may experience a number of different directions at different times in your career, and that they may all be perfectly valid.

PROFESSIONAL PROFILE
NAME: David Walker
PROFESSION: senior editor, *Photo District News*
WEB SITE: *www.pdnonline.com*
HOME BASE: Pennsylvania

What is your background in the field?

After college I had no interest in using my geology degree. I wanted to be a writer. My start was as a reporter for a small town newspaper in Maine. Introductions by friends led me to a job as a staff writer for *Adweek*. But advertising wasn't an enthralling topic. So my long-time passionate interest in photography eventually led me to *PDN* [*Photo District News*]. I didn't have a master plan or a strategy. I went where the work took me—ending in a place that suited me.

Magazine writing is a discipline. Early on I had more than one editor stop taking my calls after only one freelance assignment, just because I wasn't good enough yet. But I was just bound and determined to be a writer. There were editors along the way who taught me invaluable things. Eventually I figured it out. I overcame my limitations by sheer determination.

What is the best thing about your profession?

The best part of the job is being involved in the photographic community. I get paid to look at pictures and tell stories, both of which I love to do. As an editor of a well-known trade journal, part of my job is to talk to photographers, which I also enjoy doing because photographers tend to be passionate and interesting.

What is the worst thing about your profession?

The industry is in constant flux, so I have to endure a certain amount of complaining about the sky falling. That can get tedious.

What is the future of the field?

Technology is going digital, obviously, and photography is turning into a commodity business. Top photographers will always be in control of their destinies. But most photographers have to get used to being treated not as artists but as interchangeable suppliers of an abundant commodity. That, by the way, is why photographers are complaining so much these days: they're losing their status as artists, and it's understandably painful.

What is your advice to newcomers?

You have to find what resonates, what feels comfortable, and what you love to do—and stick with it.

Part IV
Starting a Career

A young person coming into the field of photography today has certain advantages over some veteran photographers. You will enter having a familiarity with the digital world. Being adept at digital will allow you a quick start. Though you don't have experience of the veteran photographer, you do have this one edge, so use it to your advantage.

For older beginners, those switching into photography from another career, you may be reluctant to embrace current technology. It's a pill to be swallowed but the medicinal benefits are fantastic. It's both liberating and stimulating. Go into learning digital with gusto, because it will transform your life and open your photography to new levels.

Entering a career in photography means starting a business. Pay close attention to the discussions of business skills in these chapters.

13

Education—Traditional and Online

Not so very long ago, in your parent or grandparent's generation, it seemed that the way to become a professional photographer was to buy a camera and start shooting. A generation later you might have learned absolutely everything on the job as a photographer's assistant. However, for many years now there have been not only technical schools and distance-learning courses for studying photography, but also many college programs (some two-year and others four-year) offering degree programs. In addition online photography schools are popping up everywhere and being conducted by top professionals. Photographic education is available for every style, temperament, and pocketbook.

FLEXIBILITY

There is great fluidity in the photographic world. It's common to move from one area to another or to work in several branches at one time.

As you get your training, keep in mind that no matter what your current choices there is a chance for movement as long as you have the skills. Once you are trained you can be ready for the chances that are around the corner. You might start by assisting a clothing catalog photographer and move on later to doing fashion for the Web. Or, if you work in a photo agency, helping to keyword images (which may not seem thrilling at the time), it may be the stepping-stone to a job with a magazine needing organization of digital images, then on to a post as photo editor. The paths within the field of photography crisscross and double back again, providing extraordinary variety. Have patience, be flexible, stay alert and get educated.

Today, there is much more emphasis on the need for some academic background or skill training to provide basic techniques for the understanding of the

photographic process. The greater your understanding of the process, the more valuable you'll be in any part of the field—this is equally true for photographers and picture professionals.

EDUCATIONAL CHOICES

The good news is that there are many choices for photographic education—choices to fit your geographic region, pocketbook, and schedule. The three basic categories of photography schools and programs are: traditional college/university programs, professional photography schools, and online/distance schools.

In the appendix you'll find a listing of some of the major photographic-education institutions compiled by my colleague Jeff Wignall. It's an excellent cross section. This is just a sampling. In your region there will be many other excellent colleges and photography schools with programs that will give a thorough preparation. Don't be discouraged if you are not near one of the "majors." Your commitment is the central ingredient to success in learning photography.

Colleges and University Degree-Granting Programs

Most colleges and universities offer some type of photography program: some have photography degree programs through their art departments, whereas others have separate photography departments with degrees in photography as part of a liberal arts program. Of all the avenues for getting a photographic education, this one often requires the greatest commitment of time and money. But if you can swing it, there are great benefits to be gained from a full college or university education. A competitive edge may come with the level of sophistication and awareness you acquire through a broad education. College courses should teach you to think, to organize ideas, and to present them in a coherent way, whether in written or visual form. Remember that often you have to communicate with your client in words, words that express concepts or outline logistical plans, through memos or proposals and which requires verbal skills beyond what you use for text messaging!

Professional Photography Schools

There are many specialized photography schools that teach photography exclusively or with some related art programs—such as writing and filmmaking. The difference from a college or university is that these are primarily designed to train professional photographers, usually in one- or two-year courses. These schools provide a learning environment that is typically more intense and career-oriented, and instructors who are often well-known practitioners. These schools offer the quickest route to acquiring specific photographic skills and to get started taking pictures or working with pictures.

See the appendix for the names of some professional schools. As with all schools, check to see how well rounded the courses are and the variety offered.

Online and Distance Learning

There are some differences between distance learning and online. The standard method of distance-learning institutions is to provide teaching materials (books, outlines, instructional CDs) and a series of lessons with photo assignments. The student turns in physical results of the assignment and is critiqued by an instructor. The critiques often take the form of an audiocassette returned to the student.

Generally, online classes are taught by well-known professional photographers. Students receive lessons and submit their assignments via e-mail. The photos are critiqued by one or more instructors per class. The program emphasizes learning directly from working professional photographers who share their experience and tips. The advantage of studying photography through online or distance learning is that you can work on your own time and in your own location (the comfort of home). It's especially suited to those who are working full time while they study photography. Also, they are great for anyone in a rural area who may not have the easy access to a physical campus offering a traditional teaching facility.

To take advantage of the courses, you'll need to be self-motivated, doing the full assignments and going beyond. What you lack is the face-to-face interaction with an instructor and the other students. Though you'll see the virtual classroom comes awfully close.

Two Points of View

There is a debate among the practitioners at online schools and distance learning institutions regarding the value of having students sending in physical prints to be critiqued. The question is whether providing prints of their assignments is an essential teaching method or not.

The distance-learning instructors see printing as an essential part of the learning process, one that tells the instructor about the student's ability with color balance, exposure, sharpness, in a way that's better than online learning. These instructors argue further that printing is a part of the creative aspect of photography.

However, the point made by online instructors is that the student must master the essential photographic skills and develop a creative eye first. That's critical. Their thinking is that without the "eye" it doesn't matter how good your prints are—and that creating an "output" print is a technical skill easily learned once the student is proficient as a photographer.

Also, since so much of photography is distributed to clients electronically, printing is not essential in many parts of the business, except for the much needed match

prints that accompany the digital files submitted. (A match print represents the exact color balance, exposure and overall quality a photographer wants from his or her image. It will guide the printer who works with the digital file of that image.) For those who want to go into a career selling prints to consumers, there are many opportunities to learn printing through specialized courses.

Your decision between on-line or distance learning will depend on whether you have a natural inclination toward working in a totally electronic environment, or if you enjoy the prospect of creating physical prints as part of your education.

EVALUATING EDUCATIONAL PROGRAMS

Here are some basic questions to ask, when you are looking at learning institutions:

- How complete is the photographic training?
- How strong is the digital imaging component? How many classes are provided? How up to date is the digital lab?
- Are there any courses in film and darkroom? (Is that important to me or not?)
- Are there graphic arts and photo composition courses available?
- Are there courses specifically on the business of photography?
- Are there courses available on economics and general business?
- Are there liberal arts courses in writing, in art history, in media?

The Darkroom

Where is the "darkroom" in all this? Do we work wet or dry? With the digital darkroom available, some argue that there is no need anymore for chemical-based processing and printing. I'd suggest that certainly the emphasis should be on digital, heavily on digital, but for a fuller understanding, even of the terms of the digital darkroom (burn tool, dodge tool), some experience with traditional darkroom is useful. And there is the joy factor. The experience of seeing your picture appearing mysterious and magical in a tray of chemical solution is not to be replaced by any other photographic moment. It will enhance your digital experience.

A one-third/two-thirds emphasis might be ideal—with one-third of your course time devoted to experience with film and a wet darkroom processing (at the beginning) and two-thirds of your attention spent on acquiring the digital skills There are schools that have gone 100 percent digital and others that still teach mostly traditional darkroom with only a few courses in digital. The trend may be to all-digital education soon, but as long as film labs exist I heartily encourage you

to take a basic course or two shooting film and processing in a wet darkroom. When you are looking at schools, ask their position on wet versus dry and make your decision.

WORKSHOPS AS CONTINUING EDUCATION

If you want to taste the joy of photography in a safe and (usually) beautiful setting, give yourself the enormous treat of taking a workshop. By "safe" I mean the environment is encouraging—and as removed as possible from the harsh world of client judgment and the cool winds of polite rejection, such as the dreaded "Thanks, we'll keep you on file."

By and large, I find that photographers are generous people. They'll help a willing newcomer by sharing just about everything but their client phone numbers. This big-hearted tendency from photographers flourishes in a workshop setting, where you meet top professionals from all specialties who will share years of experience, critique portfolios with candor, and liberally give advice about ways to improve. You get critiques with the comfort of knowing that no money rides on it. It's one place where you are free to make mistakes and figure out why, without losing a client.

You have access to an extraordinary number of professionals to critique your portfolio. In addition to the specific workshop you sign up (and pay) for, you can have your portfolio reviewed by dozens of other professionals who are on campus that week. There are photo editors from major magazines, power players from major stock agencies, and the photographers whose work you've admired for years. From first-hand experience teaching on several occasions at The Maine Photographic Workshops, I know the level of energy and encouragement coming from the teachers and the participants to each other. The atmosphere is unique and extraordinary. There are weekend seminars/workshops or full-week, total-immersion, hands-on photography courses. The established workshops also sponsor travel workshops in delicious places like Italy, France, or Spain.

A workshop can help you measure your progress, whether you've just finished photography school or are keen to switch to photography from another career. They are a great investment—and the best vacation a lover of photography can imagine. Just to know what's available, get the catalogs for two of the best-known workshops: The Maine Photographic Workshops, in picturesque Rockport, Maine (*www.theworkshops.com*), and Santa Fe Workshops (*www.santafeworkshops.com*). See the appendix for details.

There may also be good workshops in your area. Just google "photo workshops" for some leads. The online magazine Apogee Photo (*apogeephoto.com*) offers a listing of workshops by geographic region—from just around your corner

or as far flung as The Venice School of Photography or the Art Workshops in Guatemala. At whatever stage you can benefit or afford it, a workshop experience should not be missed.

ON-THE-JOB TRAINING

Working as a photo assistant is covered in chapter 11 but needs to be discussed here as another method of training to become a photographer—and also some related fields like being a stylist, producer, or talent scout.

An internship, boiled down to basics, is working for no pay in order to learn and gain experience from the inside—by having access you wouldn't otherwise get. You'll hear vastly different assessments of the value of internships as a learning tool. Some hold that it is barely more than indentured servitude, exploitation of the lowest sort, and to be avoided. Others promote it as a very useful way to get insight into the photographic world not available any other way. Most will agree that internships while in school are harmless at worst and very valuable at best. If, after school, you seek an internship, make sure that you are learning enough to be worth your commitment.

EDUCATION FOR PICTURE PROFESSIONALS

All of the previous information applies in many ways to you if you want to work in one of the allied photographic fields. A basic photographic knowledge will be very helpful for any work with pictures. Beyond that, the same broad education from any college hones your abilities to think, to analyze, and to use pictures effectively. Internships are available at some newspapers, magazines, and photo agencies.

ORGANIZATIONS—JOIN AS A STUDENT

Most photographic organizations have student memberships at reasonable rates. Though you may feel overwhelmed with what you have to handle already, do try to add this one additional resource. The organizations offer exposure to the real world of photography with information that would be en excellent supplement to your photography school curriculum.

Research the organizations that represent the kind of photography work that interests you. (The Web sites of ASMP, APA, ASPP, PPA, NPPA, NANPA, and PACA are listed in the appendix).

For example, based on your inclination to work in the field of publication photography, then ASMP (the American Society of Media Photographers) may be your

choice. If running your own portrait or wedding studio is a likely direction for you, then look into the Student Photographic Society, set up in 1999 under the auspices of PPA (Professional Photographers of America), which you can join for a low annual-membership fee. But all of the organizations for photographers are very valuable.

BROADEN YOUR EDUCATION

Whether you choose to get photographic training through a technical school, distance learning or online course, or a college, you can enhance your value in the photographic world by staying informed. Don't shortchange yourself. Read as much as you can, and keep up with the trends in art, politics, and culture. Your greater understanding of the world will add to the depth of your pictures and improve your contribution if you work from a photo editor's desk, as a photo researcher, or as a an advertising photographer. Technical skills are only the beginning—style and intellect are what will separate you from the herd.

PROFESSIONAL PROFILE
NAME: Jeff Wignall
PROFESSION: photographer, writer, educator
WEB SITE: *www.jeffwignall.com*
HOME BASE: Connecticut

You have a wide range of experience in photography. How important is teaching to you?
Teaching is a way of sharing my photography. It is the culmination of all my experience in photography and writing. I have taught in person at photography schools, in continuing-education classes, and as an online instructor. They are all rewarding.

What is your experience with online teaching?
I've taught at two different online schools and enjoyed both experiences.

How do you design an online course?
My approach and the online courses I'm familiar with follow this general procedure:

• Write a lesson on your topic for that course

• Illustrate the lesson with your photographs

• Post the lesson online

• The student completes the assignment and turns it in as an e-mail

• The instructor critiques the assignment

- The instructor posts the assignment and critique so all the other students can see it
- All students can comment and can learn from other students' responses to each assignment.

Where do the online students come from?

One fascinating aspect of teaching online is the geographic spread. I've worked with students from all over the world: China, Japan, South Africa, Singapore, and Chile, as well as other parts of South America. I'd say the student body is 50 percent based in the United States and the other half over the rest of the world.

What is the makeup of the student body for online teaching?

I'd say it's roughly divided into three groups. About one-third are seriously interested in a professional career. Another third I'd call the serious semi-pro. They want to earn some money at photography but not necessarily quit their day job. The final third are the aficionados, serious amateurs who enjoy photography and are keen to be really good at it. For example, we have executives who travel the world and in the evenings do an online photography course. But it's always going to be an avocation for them.

What are the advantages of online schools?

They are especially good for students in rural areas, much less expensive. Online schools are excellent because they give students a one-to-one relationship with a working photographer. In some cases a mentoring relationship develops between the teacher and student, as it has a few times in my case. Finding a mentor online can even lead to assisting jobs.

How many books have you written?

I am the author of more than a dozen books on photography. The two most recent are *The Joy of Digital Photography* and *The Kodak Most Basic Book of Digital Photography*. It's another way I teach and share my passion for photography.

What are your thoughts about the review process for online teaching and how time consuming is your review process?

It's a great help to the student to hear directly from the instructor. I have been at fault sometimes by spending too much time on the critique, but I have a tendency to get friendly with the students and give extra help. Sometimes I tend to be too loquacious. But I think it gives the student a greater sense of interaction with the instructor.

PROFESSIONAL PROFILE

NAME: Bryan Peterson

PROFESSION: photographer, teacher, writer, and founder of the Perfect Picture School of Photography (PPSOP), an online school

WEB SITE: *www.ppsop.com*

HOME BASE: Lyon, France

What do you see as the direction of online education?

On-line education is fast becoming the number-one priority of both public and private colleges according to recent newspaper reports in both the *Wall Street Journal* and the *Financial Times* of London. Many institutions are investing thousands if not million dollars into building and maintaining Web sites for the sole purpose of online education. It has everything to do with the mobile world we live in.

You've recently established an online school. What is your philosophy for teaching online?

The Perfect Picture School of Photography has already responded to the many needs of photographers, both amateur and pro, who are seeking online education by staffing the school with some of the most sought-after professionals in the industry.

What changes in technology have you initiated?

We have state-of-the-art technology that allows students to view their lessons in both the standard HTML formats as well as video streaming. Additionally, the courses allow for real-time interaction between students and instructors via instant messaging. We recently began a first for online education, "audiovideo critiques," where the students will actually hear as well as see the instructor's comments and critiques of their work, as the instructor moves the cursor around each of their images. This will allow the student to clearly see and understand better why an image works or doesn't work. This method of teaching is close to a live classroom setting without having to leave home. Plus these same critiques will be visible to not just that particular student but to the entire classroom, so everyone will of course benefit from seeing and hearing the critiques of all of the images that were turned in for that week's lesson/assignment.

How does online learning solve the logistical difficulties of traditional physical photo schools?

Since all of the instruction is taught online, students can attend their classes at any time, as well as from anywhere in the world, as long as they have access to the Internet. And, of course, there is the convenience that students can attend in any manner of dress and in the privacy of their own home or office.

Does the lack of the physical presence of an instructor lessen the learning experience for the student?

No, the warmth and sense of contact with a professional instructor is still there. Technology has made it possible for an instructor to offer the approach and attitude of a mentor with real-time communication. An online instructor can fully satisfy the need for feedback and interaction with the students—but without the expense and hassle of going to a physical school at an appointed time.

Over the years I've taught online, I've seen excellent response and results from students. This generation is completely comfortable with online relationships. Online learning has truly come of age.

14

Finding Work in Photography

Every year there are openings and possibilities for you. People leave the field of photography. A new crop of photo editors, art directors, and stock agents replace the veterans who fade away. These new young turks in the business are looking for other young turks. They want unabashed enthusiasm, top-level skills, and people who speak their language. So there are definitely opportunities. But that doesn't mean just being young and fresh is a passport. You have to prove your worth. There are learning curves and dues to be paid by taking jobs that help you earn your way in. The important point is *not* to get discouraged, because if you are burning to find a place in the world of photography, it's up to you to make it happen. However, if you picked up this book with the casual thought that it might be "kinda cool to go around taking pictures," then save your energy. This is a field for the passionate and dedicated.

ASSISTING AND INTERNING

Throughout this book you have seen that the value of assisting is a recurring theme. The life of an assistant has evolved in the past ten years, but it's still a tried-and-true route to becoming a photographer. For those looking for a career as one of the picture professionals, assisting can serve the same useful purpose. In chapter 11, you learned information about the role of the assistant and the need for a strong photographic background; and you've also seen advice on the importance of a positive attitude to your success as an assistant. Taking all that to heart, now we'll concentrate on finding work as an assistant.

Finding Work as an Assistant

Whether you're looking for work as an assistant with experience to offer, or just starting out as an intern, try to approach photographers with a reason (other than

needing work). Have something specific to justify your interest in them not merely because you found their name on an organization mailing list. You will get more attention that way than if a photographer thinks you are merely making them part of your spam. I work mostly on location. When I get a resume from someone wanting work in a still-life studio, it's clear that I'm part of a blanket mailing and generally I'll ignore the letter. Find out something about the kind of work a photographer does before you get in touch. Visiting Web sites is the easiest way.

Networking to Get Internships or Assisting Jobs

To the degree that you have any contacts in the industry, use them (with permission, of course—always check to see if your contact is willing for you to use their name). Connections are invaluable: use 'em if you got 'em. But what if it's a blank slate? Maybe you did well in school but you don't know anyone to call. If you send out a blanket mailing to organization mailing lists—will anyone pay attention? Not many.

There are two good approaches at this moment. One is to go to the organization meeting I keep preaching about (ASMP, APA, ASPP, etc.). You can join as a student member or can attend as a member of the public for a few dollars more. Some programs are about technical developments, others are panel discussions about industry issues; on other evenings these organizations host presentations of a top photographer's work. You can introduce yourself to the panelists and ask questions, and you can mingle with the audience and ask questions. There are occasions (without being a pest) for connecting with someone who might give you a lead to an internship.

Making Contact

When you've identified some people to contact, whether you're looking for work, an assistant with experience to offer, or just starting out as an intern, approach photographers by e-mail or letter but *not* by phone.

Send a resume that should include:

- education and training
- technical skill level in all photographic formats, lighting, film and digital, printing
- computer skills with software for imaging (Photoshop) workflow and data management
- the names of any photographers you've already worked for
- your Web site address

- driver's license (You may want to include a photo copy of your license)
- passport (You may want to include your passport number or a photo copy of the passport)
- additional languages spoken and level of fluency
- other skills

Once you've sent an e-mail or a letter you can follow up by phone. But be prepared for the fact that the studio manager or photographer may not have time to talk. Suggest to them that you'll send periodic updates of your resume for their file.

What a Photographer Wants to Know about *You*

Photographers often need referrals to assistants in other cities and countries. My system for finding a photographer is through networking. I contact any photographer I know personally in the destination city and I also get in touch with an ASMP chapter president or board member.

These are some of the questions I ask a colleague in another city about assistants they are recommending:

- How much experience do they have?
- How much have you used them? On what kinds of shoots—studio or location?
- How good are their lighting skills?
- What's their computer level? Workflow? Photoshop?
- Are they good at hustling and moving fast?
- How's their attitude?
- How do they work with and around clients?
- Do they have a professional manner, dress appropriately?
- Are there any weaknesses, do you have any reservations?

After I get recommendations from colleagues, I do one or more phone interviews to narrow down the list to a final choice of assistant.

STARTING IN FREELANCE

Going freelance as a photographer or a picture professional can be puzzling and even frightening, but it also can be extremely exciting because you are on your own and because it is strictly up to you to make it work. But before going freelance a lot of planning and preparation is necessary.

Presenting Yourself

Preparation of a portfolio is especially important and should be done with great care, as you'll see in the marketing chapter (chapter 16). You may distribute your portfolio on a CD-ROM, in print form, or online, but no matter how you do it, the key issues are:

- Don't show anything on your Web site or in other materials unless you have samples to back it up.

- Portfolio depth is important to give client confidence. Show any published work that helps underscore your photography skill and experience in setting up shoots.

- Balance out published work with dazzling samples of your work from personal or self-assigned projects.

- Make a point of the experience and skill you have in handling logistics, budget, and schedule.

- Include a client list (if you are starting out, some pro bono work for organizations will help fill the gap).

There are many opinions, often at odds, about the value of published work in a portfolio. To a prospective client, published work indicates your ability to carry off a project. Also, the fact that someone else hired you and spent money on your work speaks to your talent. On the other hand, published work may have distracting or detracting elements such as poor design, type face or printing quality which the client won't or can't overlook. If you think some published work looks really dreadful you might leave it out. You can also offset the published version by including an excellent print of the original photograph.

GOING FOR A STAFF JOB

Working as a staffer you are part of a team. You will be called on to be the photography specialist working with writers, editors, and producers. Staff work provides for a more secure income and a more defined job. Whether you earn more or less as a freelance or on staff depends on which aspect of photography you choose. The recognized value of a staff job is the safety net it provides. Though there are relatively fewer staff jobs available, if that is of paramount importance then stay determined to find one.

RUNNING YOUR OWN BUSINESS

Drawing up a business plan is an essential first step to building a *profession* that is a *business*. (There is detailed information later in chapter 15 with emphasis on learning your overhead and then skills in negotiation and pricing.) But first, to set up a business,

you can get help from sources such as the U.S. Small Business Administration (*www.sba.gov*) for general guidance on good business practices.

For more specific leads in the photographic industry, there are seminars given regularly by the photo organizations. The American Society of Media Photographers runs a variety of educational and business seminars on a regular basis. Find the ASMP chapter in your region for more information or on the national level go to *www.asmp.org*. Professional Photographers of America (*www.ppa.com*) has a particularly interesting program called "Studio Management Services" geared to the consumer photography studio. For a moderate fee you can have the services of a certified public accountant and a book keeper to assist in setting up your business— with advice available on an ongoing basis. The unique aspect is that you have access to a business consultant knowledgeable in photography. Check at PPA also runs a conference titled "Make More Money in Photography™," which was created with "the goal to provide photographers with the necessary resources, information, and motivation to jump-start their business, increase sales and become more profitable."

If you investigate these and other Web sites, you'll find there are programs for students available in all the major trade organizations. Take advantage of these industry opportunities for learning the practical methodology to put your creative and technical skills to use—and to make a living. These resources may be more important to you starting out than they would be after you are in business. You can begin with good habits instead of later having to break "bad habits." You can have your business plan in shape so that most of your energy is devoted to the creative aspects of your career.

Determination, absolute determination, is the essential ingredient to your next step in the rewarding world of photography.

PROFESSIONAL PROFILE

NAME: Maria Lyle

PROFESSION: photographer

WEB SITE: *www.marialylephotography.com*

HOME BASE: Sarasota, FL

What do you value most about your life in photography?

That I can earn a living doing what I have loved since I first took pictures, as a child, in Santiago, Chile. Early on I became obsessed by the possibility of capturing a moment, making time stand still inside the camera. It was magical to a child of eight and continues to be my passion.

What is your background?

I'm self-taught. After I came to the United States on a high school scholarship. I knew that if I could imagine myself into the reality of living in the U. S., then I could imagine myself into a career in photography. But it's been a long, slow process, first learning English living in the New York area, and finally settling in Sarasota, Florida.

How you get from there to building a photography business?

It took years in a camera store before I felt trained enough to become a shooter. My school was the counter of the camera store. Actually, I first started to work in a

Maria Lyle on location.

© *Daniel Perales*

camera store so that I could buy my camera gear, and before I knew it had spent twelve and a half long years behind the counter. It was long but necessary, since I realized how much technical information I needed before I could call myself a photographer.

All the top shooters came into the store. I had to really hustle to research the facts they needed about new products. I studied manufacturer's manuals and gleaned every crumb of information I could from the conversations around me in the store. I began assisting on weekends and all my vacations—at first just dragging gear, later earning trust enough to handle full assistant duties.

How did you make the transition from store to staff job to your own studio?

I was building a reputation with store customers of being personable and accommodating. Having met the head of photography for the hospital, I was very bold and called her to say: "Listen, if your staff person leaves, I'm very

interested in working for you." Then one fine day she called to ask if I could come to work in the hospital. I was in heaven.

It was there that I had to put into action everything I had learned in theory at the store. Sometimes I had to wing it. I did everything from surgical procedures, to grip-and-grin, trustee portraits, medical technology, advertising photography, even the kids in the hospital childcare center. The hospital was a great training ground for being a generalist. I was able to practice corporate and advertising photography doing the hospital's projects. In addition, I was able to go from not being able to turn on a computer to learning every one of the programs needed for photography. I am now completely digital due to that great experience at the hospital.

When a studio space became available in the building near the camera store where I had worked, I grabbed it and took the plunge. Since then, working night and day, it's paying off. Now I have a thriving photography business.

How does someone find work?

By making the time to market yourself. Don't show the prospect every single "good shot" you ever took. Be *very* selective and critical of your work. Keep it short. Have the prospect ask you for more. Then, you just may have the job. Always have a stack of business cards in your person, camera bags, car. Wherever I go, I always bump into people I know, people that I worked with long ago, and there always a spontaneous conversation that happens. In the end they all go home with two business cards. One for them, and one for a friend.

When talking to people, be excited about what you are doing, without being obnoxious. People will recognize baloney but respond to genuine enthusiasm.

PROFESSIONAL PROFILE

NAME: Tracy Mack-Jackson
PROFESSION: photographer, photojournalist, teacher, Internet marketing consultant
WEB SITE: *www.theidpgroup.com*
HOME BASE: Long Island, NY

What do you value most about your life in photography?

My first and continuing passion is photojournalism, with teaching photography a very close second.

What are some of the job titles you've held?

Currently I am principal of the IDP Group, my own Internet marketing and development company, and I have clients within the photo industry. Previously, I was senior manager for internet development and programs at Nikon Inc.,

managing photography instructor for the Disney Institute in Orlando, and director of photography for the *Daily Commercial* newspaper in Florida.

How did the various jobs influence your career?

The greatest thing over my entire career path is that I've had the opportunity to grow—to evolve and change. I learned that in the photo world, if you like pictures you can work with pictures—in so many different ways.

What are the best things about your profession?

There is such flexibility in the photo world. It's exciting that you don't have to do the same thing forever. There is always something different you can try. I went from newspapers, to Disney, to Nikon, to my own business.

The joy of teaching, which I learned as a graduate teaching assistant at Syracuse University, has been a great experience. My work at the Disney Institute really inspired me as a teacher. The guests we taught at Disney were passionate about photography. There is nothing like the thrill of seeing how proud they were as their work improved, producing incredible pictures. Then another great opportunity came at Nikon, when I worked on their Internet marketing, creating a suite of Web sites. One of the favorite pieces I developed was the monthly series "Legends Behind the Lens."

What do you see as the outlook for the industry?

Well, it's a digital world. Get all over it. Embrace the technology. Make it work for you.

Film: Is there any place for film in career photography in the next five years?

Not for me. I am 100 percent digital. There is nothing I need from film any more. Others may still find it useful for some time.

Any specific lessons you learned along the way?

Be persistent. Be thick-skinned. As with all forms of art, you need to be able to take rejection. Use it to learn and grow. To this day one of the best lessons I've learned was from an eye-opening event. I had an assignment from my paper to cover an event. They wanted a picture to run in black and white, inside, very small. I only got one workable shot but it was badly lit. I figured it was passable since it was only for a small black and white. But then they ran it in color, large, on the front page with all its glaring flaws. The editor's anger was painful but justified. Until then my philosophy had been: "You have to come back with a picture." After that I changed it to: "You have to come back with a picture good enough to run on the front page." I stepped up my quality scale with that lesson always in my mind.

C H A P T E R

Building Your Business: Overhead, Pricing, and Negotiating

If you elect to go into business for yourself rather than seek the somewhat safer shelter of working on staff, you will need special skills beyond photographic technique. In this chapter we'll concentrate on how a *photographer* runs a business, but the principles hold true for any independent or freelance picture professional, whether photo researcher, stylist, or location scout. You must make an income that exceeds your expenses. It's a simple concept, but to make it happen takes discipline, an understanding of basic business principles, and a certain amount of courage.

THE ECONOMICS OF PHOTOGRAPHY

There is an interesting truth that photographers (and perhaps all creative people) should commit to memory: photographers can be artistically successful with a moderate amount of technical knowledge, but they can only be financially successful by learning, honing, and applying business skills as much or more than they do artistic ones.

Many creative people look at business as an evil to be shunned or ignored, and far too many photographers take some sort of perverse pride in boasting about their lack of business acumen. This is less so today than it was ten years ago, but lack of attention to business is still a stumbling block. It's really too bad because business dealings are a necessity for anyone who wants to make some money from photography; frankly, business can even be fun. Treat establishing and maintaining your business as a goal worth achieving, because it is. You and your family will be the winners.

A businesslike approach will go a long way toward dispelling any unstated anxieties your clients may have, whether it is their stereotypical ideas about creative individuals dressing sloppily, being poor business people, or simply wondering if you are really competent to handle a complex assignment.

Doing What You Like

While the different markets of photography discussed in this book—publication (advertising, corporate, editorial, and stock), consumer, service, and fine art—each generate varying degrees of income, making money shouldn't be the major determinant when deciding what field to concentrate in. Generally, you will be happiest doing what you like and what you're good at, rather than just aiming for the highest fees.

OVERHEAD

Knowing what it costs to open the doors and turn on the lights is your first task. You have to know what it costs you to be in business before you ever take an assignment, license a stock photograph, produce a digital image, accept a wedding date, or schedule a portrait sitting.

The importance of calculating overhead as a basis for establishing your price structure is stressed primarily because most photographers ignore this basic business premise.

Pricing Guidelines

There are pricing books and software to give you ready-made price lists for publication photography. (There's even a price chart in the book *Pricing Photography*, which I wrote with co-author David MacTavish. You'll see it listed in the back of this book.) Price guidelines are also available from associations for consumer photography.

Price lists, however, are just for general guidance, no matter how handy and tempting they may seem. Your first emphasis should be on understanding and calculating overhead.

All businesses must calculate their overhead; but this is a calculation that photographers routinely ignore, relying only on published price lists. But because photographers who depend upon such pricing aids remain ignorant of their overhead requirements, they too often engage in price-cutting. Again and again, however, these photographers struggle to get ahead, go out of business, and depress photography fees for everyone.

Overhead consists of many things that you have to make enough money to cover, from your salary to camera and other equipment purchases to utilities and many other things you take for granted—but you can't afford to take them for granted if you are in business.

If you only consult pricing charts without knowing your overhead, you are on a short track to nowhere.

What Is Overhead?

Overhead, for photographers, is comprised of all of the costs that you incur that aren't directly attributable to specific assignments or stock licensing or album prints for a customer. The total of these costs are typically thought of as what it costs to be in business for one year, but it can also be figured on any other time basis—monthly, weekly, or daily. Overhead it is a combination of two kinds of costs: fixed and variable. Fixed costs are inevitable and are incurred day to day regardless of whether you are shooting for a client. Rent or studio/office ownership costs, for instance, are as inescapable as telephone bills, business insurance or heating. These are fixed costs not chargeable to a particular photo assignment or product. Variable costs are considered "cost of sales," that is, direct cost of your product or service. Variable costs will change depending upon the level of your activities. For example, you will spend time testing lighting, experimenting with new techniques, or printing materials for promotion use. The costs associated with this work such as quantities of paper and ink for printing digital files, CD's and DVD's for delivering images, and occasionally new memory cards are inevitable. The costs will vary week-by-week, month-by-month, but you will need to estimate and budget for them even though many variables can only be estimated.

Note that fixed and variable costs are not the same as those expenses billed to a client that will be incurred in support of an assignment. Since assignment expenses are usually reimbursable, they are billed to your client and therefore do not become part of your overhead commitment.

After you have listed all of your overhead costs, fixed and variable, add them up to derive your overhead subtotal.

Once you have calculated your overhead use it as a guide to knowing how much you must bring in on an average each week. Be sure there is a salary for *you*, the photographer, in that overhead. Only after this point do you calculate profit. The general rule is to apply at least 10 percent to the total overhead figure for profit. That's a minimum. Profit isn't gravy or easy money. It's what's needed so you can invest in making your business grow. Otherwise you are working to just break even. When you have that total figure, you see how many days you can work, how much usage you might bill, or how many days you must book weddings or events to reach that goal—and surpass it.

NEGOTIATING

Once you calculate overhead you know how much money you need to stay in business and to grow. But getting clients to pay you those fees rests on your talent and often more importantly, your ability to negotiate.

Negotiation is an art. It is also an essential skill in business. Any photography business, whether assignment or stock, wedding or event, will flounder without a good flow of income derived from the successful negotiating of prices. Naturally you must start with excellent photography and good marketing efforts, but for your business to flourish the keys are knowing what price to charge and being able to negotiate to get that price.

Price Lists versus Negotiation

As mentioned above, there are books and computer programs with price lists for publication photography and guidelines for wedding and event photography. They show the range of fees being charged by your colleagues throughout the industry, but they are merely a starting point. Without strong negotiating skills, you may find the prices in various books to be of little help. Picking a figure out of a list may seem the easy answer to a client's request for a price quote. But a price list price can't possibly offset the intimidation you'll feel from a client who pretends to faint or who barks, "You're charging what?" if you don't truly and fully understand why you've selected that price. At that moment, your adrenaline starts flowing and fear takes over. Without the information to back it up, your price, if plucked from a list, becomes a mere straw in the wind. At this moment you need a firm grasp of the economics of your own business including your bottom line. The term *bottom line* can mean the lowest amount you will accept in a negotiating situation, or it can mean the total cost for a business or project. You want to be aware of both definitions because the bottom line of your business will determine what you must earn to keep afloat, as well as how much to ask for in a fee negotiation.

You also want some skill in using negotiating techniques to make you comfortable answering that client's confrontational question calmly and from a position of strength.

Usually, customers for wedding and portrait photography won't confront you about prices with quite the same ferocity as a publication client. But a look of shock or dismay will be enough to cool your enthusiasm when you are first in the business. Rather than immediately slashing your price, try to explain to your customer the reasons behind it and offer options for cutting some coverage to come closer to their budget.

Attitudes Toward Negotiation

Strength comes from understanding and believing that the figure you've quoted is a reasonable one. It comes from being able to articulate why you've quoted that price and from knowing your bottom line.

The first step in building that negotiating strength is to break the chains of stereotypical attitudes. Negotiating may be a photographer's least favorite aspect of the business—and his single greatest weakness. Often, we are our own worst enemies when it comes to dealing with money. A combination of myth and misconception intrudes on our ability to require a fair price for our work. A fortunate few are born with a natural skill at negotiating. They like the challenge and the excitement that comes with making a successful deal. As surprising as it may seem, negotiation is second nature to them. But the majority of us must learn how to negotiate. With time and training anyone can become an effective negotiator. It's done by practicing technique and by summoning courage.

The first step is to throw off the yoke of misconception that holds us back from acting in our own best interests. Some of us work with the naïve belief that our talent will be recognized automatically and justly rewarded. Also, we may buy into the myth that it is undignified for a creative person to talk about money or that if we don't accept this deal, the buyer will never call again.

Fear is the culprit here—fear of what a client might think of you, fear of taking risks, fear that paralyzes. The effects of fear are far reaching. They get in the way of clarity, preventing you from asking the right questions and from getting the information you need to quote an accurate price.

It has not been routine in our culture to negotiate prices for consumer goods. Historically, we have been more likely to accept and pay a fixed price than to assume we could bargain. In addition, a few arrogant or unpleasant photographers have made negotiating a dirty word. But there are many fainthearted photographers who by their lack of courage have done equal damage to the climate for negotiating. By this attitude, clients have been led to believe that they can dictate photography fees, sometimes to a level below what it costs to run a business. These photographers have accepted the underlying message that we can't sell our work if we dare to question what buyers offer.

Successful, amicable negotiations occur every day in the photography business. To learn the tactics necessary to emulate these transactions, we must first shed old habits.

Changing Attitudes

To change the attitude, face the attitude. A first step in taking the risks necessary to becoming a good negotiator is to change the way we view the world of negotiating. Consider that reality is the opposite of the myths mentioned earlier. Consider that it

is fair and reasonable to charge enough to earn a living and that it is possible to say "no" courteously to buyers and still have them call you again.

If you are still having trouble justifying your right to a fair price, consider an enlightened self-interest approach. Getting a good fee allows you to improve your service to the client. It allows you to invest in new equipment and in new software to improve the workflow you offer the client. It allows you to experiment with new creative approaches. Explain to your client why you need to maintain a fee structure that allows for investment in research and development and how it benefits them. But, make sure you believe it first.

Role-Playing

In order to feel comfortable making your negotiating points to a buyer, some photographers role-play a buyer/seller situation with each other. The "buyer" writes down a type of photographic usage, the top price the client's company is willing to pay, and the low price that is buyer's goal. The "photographer" writes down the lowest acceptable price as well as the highest price that seems even remotely possible for the usage—the dream fee.

They begin discussions. When an agreement is reached, the winner is the one who came closest to his or her goal price. It is a great, entertaining technique for polishing the rough edges of negotiating.

Role-playing as a technique for learning to negotiate should not be dismissed lightly. It is enormously valuable and can break down the stage fright one may encounter when talking with a client.

Be vigilant when negotiating—given half a chance, photographers needlessly tend to sell themselves short. With clients, your tone should be pleasant and accommodating—holding absolutely firm when they can't meet your bottom price, but standing your ground all in a cordial manner. The reasons? It's a better negotiating tactic to be pleasant. But the more important reason is that this is your world, this is how you spend your days, and these are your clients. They sometimes become friends. Why not make the time and process enjoyable? Being contentious won't add any joy to the day, license any more photographs, or land any more assignments.

Negotiating Strategies

You may think, "What's to negotiate? The buyer has a price and a budget in mind. That's what the buyer will pay, and I can simply take it or leave it." Wrong. Every time you discuss price or assignment specifications, it is a negotiation. The only question is how successful the outcome is for you. There are some basic steps that take place in every negotiation, whether handled in ten minutes or over a period of

days, and they are crucial to the process. These principles apply to consumer and service photography as well as publication. They are: establishing rapport, gathering information, educating the client, quoting the price, and closing the deal.

Establishing Rapport with a Publication Client

This is the first step in any contact with a client. These days getting a client on the phone, much less getting in to see him, is a rarity. But once you are being seriously considered for the job, you will have contact and these premises apply.

It may seem self-evident, but start any conversation with a friendly, welcoming tone. Find some common ground—the weather, the holidays, recent events. Next, express your interest in the client's project. Show interest in the company, in the client's publication, and in this particular request.

If you set a good tone, the client will enjoy the exchange and remember that it is pleasant to work with you. Removing a little stress from the day will stand you in good stead. Learn to read the mood of the client through voice inflection or body language. When a client is busy and not inclined to small talk, pick up the clue. Stay cordial, but conclude in a quick, professional manner. However, don't let a buyer rush you into a price quotation before you get the facts. It's perfectly legitimate, and to the client's benefit, to ask for time to give thoughtful attention to figuring a price.

Establishing Rapport with a Consumer Customer

When you are meeting a customer for your consumer photography for the first time, it may be on the phone or in your studio. Even if a customer drops into your studio, no matter how hectic your day, stop and greet them in a relaxed, amicable manner. Set up the same type of friendly welcoming atmosphere with your appointment customers. In this case your customers may be the ones who are uneasy and not sure where to start. Your job is to help them relax so they can understand that you will offer them options. They may be afraid of a high price but intimidated by the thought of looking cheap if they question it. Make sure they realize it's ok to have a budget and that they aren't expected to get a second mortgage to pay for family portraits. Help them see that you can design a photo package to meet their needs; however they must understand that they will get what they pay for—and some of the bells and whistles might have to go if they want to conserve funds. Explain that you might save by cutting out the prints to be given to the wedding guests at the end of the reception, which would relieve you of the need for an additional assistant to do the printing, or reduce the number of prints in the album or reduce the amount of candid coverage at the reception. Showing sample albums with the styles of photography they might forego in the effort to limit the cost price will at least give them an appreciation of your pricing structure. It is also a strong visual argument for not cutting but reinstating those wonderful once-in-a-lifetime pictures.

Gathering Information in Publication Photography

This is the critical step. Ask about usage. You must know where, how big, for how long, how many times, and for what purpose the picture will be used. Make clear that you can't quote without this information, and explain why. Let your clients know that price depends on usage, size, and many other factors. Make the point that by being very specific with usage you may be able to give them a better price.

When quoting an assignment, explain that it's not only usage that affects the fee but the complexity of the shoot and preproduction and postproduction logistics as well. In stock, the fee can also depend on which of your photographs they are considering—one produced under normal conditions or one involving high model costs, travel expenses, or other costs.

Gathering Information in Consumer Photography

Once you've made the customers comfortable, find out how they envision the event they are planning (wedding, bar mitzvah, sweet-sixteen party) and, hopefully, what importance they want the photography to play in the overall scheme of things. Let them tell their story—the number of guests invited, the duration of the event, whether it is an interior or exterior location, whether it is being held at home or at a hotel. Once they outline their planning, you can begin to ask questions. Do they want complete coverage, soup to nuts, or simply the main players?

Give the customer a list of the basic types of photography you offer, such as formal portraits (single and group), setup scenes, and documentary-style or candid coverage.

The setting for this exchange of information is critical. You're more likely to land the job if you can speak in a calm and pleasant environment where the customer is not disturbed and can listen to your message.

Educate the Client in Publication Photography

When you are dealing with a knowledgeable long-time client or with a new one who clearly knows the ropes, you may not have to do any educating. But if you suspect that the buyer is new to the field or inexperienced in the area you're discussing, then it will help if you clarify industry standards as the groundwork to negotiating.

One sign of inexperience (or an experienced but tough negotiator) may be a reluctance or inability to give you information about the project, particularly about usage. "Just tell me how much—I'm not sure how we'll use it," is a giveaway. It's more likely to stem from inexperience than toughness it still creates an impossible negotiating atmosphere, for you at least.

Explain that it is industry standard to price by usage as well as by your cost to produce. Let such clients know that it works to their advantage to limit the rights they need. Explain that vague, sweeping, all-encompassing usage can be

more costly. If your clients aren't sure about future uses, create a range of fees for additional usage to help them in planning. Indicate that potential future rights, negotiated now, will be lower than if they come back to you in a few years. Say something like, "We could create a package deal for you with any future uses for posters rated at $X and brochures at $Y." This approach relates to assignment usage rights as well as to stock fees. It is vital that you focus everyone's attention on the disparity between the enormous cost of media placement and the cost of photography. Doing so reminds your clients of an obvious fact they may wish to ignore, and it helps reduce any insecurities you may feel about asking for a fair deal. After all, it's the image-maker that provides the emotional resonance of the advertiser's message or the impact in a magazine or corporate brochure; you deserve a fair share for that contribution.

When negotiating assignments, pay very special attention to any request for *work for hire, all rights*, or *buyouts* from any client. To clarify these terms, work for hire, or "work made for hire" is the language in copyright law and means that the client owns everything and also makes him or her the creator, as if there was no photographer. However, some variations can be worked out between the client and photographer. Sometimes a client will request a limited buy-out, so the photographer would have some residual rights, such as the right to show the work in a portfolio or publish it in an art book. Since it is an ambiguous term, be as specific as possible.

Use the reasons listed above for limiting rights for sake of controlling the client's costs. It's enough to say here that buyouts should be avoided like the plague. When you sign away all rights, you are dramatically limiting your future earnings by killing off residual usage from the assignment client as well as potential stock use.

Here's another red flag that may indicate inexperience in assigning photography: "We need the Pittsfield facility photographed, and it's a one-day job. No, the corporate communications VP will be out of town. No, we don't have the plant manager's phone. He'll show you around when you get there." Let these types of clients know why vague, free-floating arrangements can cause expensive assignment problems and that part of helping them get the best price is to avoid such disasters in the making.

When educating an inexperienced client, handle it in a subtle, friendly manner. List the factors that affect a stock price or assignment fee. In order not to appear condescending or didactic, use the phrase, "As I'm sure you understand . . ." to preface your comments. This lets you present information in a way that helps inexperienced clients relax and possibly save face, so that they can hear your information in a neutral environment.

Why might you be dealing with inexperienced people? In today's fluctuating economy, many advertising agencies, corporate communications departments, and editorial art departments have eliminated various levels of support positions. An overworked art director or photo editor may even use a trainee or secretarial assistant to

do groundwork. You are helping yourself when you help the caller become informed. Don't hesitate to give objective backup to your position by referring an inexperienced client to this and other books or sources. (It might be wise to do this—if you can—before pricing comes up.) It's easy to say, "You might find some of the ASMP publications useful. They provide a good background on what we're discussing . . ."

If it's necessary to refer to your costs, do it in a positive way, to underscore your persistence in holding firm to a price: "I'd love to help you with a lower price, but given the extraordinary costs of materials and overhead, it isn't practical for me to go any lower."

Educate the Client in Consumer Photography

If your customer for a wedding already has two married daughters, then you're dealing with an old hand. Both of you can get down to business. And maybe, hopefully, you were the photographer on previous weddings, and they were delighted with the photography. If you were not the photographer, find out what was not successful in the last wedding coverage. Make clear what your solutions would be to the problems they encountered.

Even first-time customers for weddings or events have a rough idea of the principles of having a photography package, with a base fee plus so much for additional prints and the albums. But the new products available through the use of digital technology on the site of an event may not be common knowledge. Be sure to let the customer know (always with samples) of the wide variety of products they can take away at the end of the event or send home with guests.

Explain quite openly that perhaps they shouldn't decide on price alone. Not that it isn't important to stay in a budget, but make the point that since they are planning a one-time, never-to-be-repeated event, they must have complete confidence in their photographer which you are about to demonstrate. Tell them you understand how important the event is to them and the family. Since they may not have articulated it to themselves, Explain that they need to be satisfied with a wedding or event photographer in three crucial ways: personality, quality of the photography, and *then*, price.

Quoting the Price in Publication Photography

Though basic approaches still apply, the actual discussion of numbers is where stock, assignment, and consumer photography price negotiations will differ. When negotiating stock prices, you are usually discussing a specific picture. The buyer will use the photograph, or not, based on how closely the perceived value to the client matches the reproduction fee you quote.

However, assignment pricing is complicated by many factors, including costs of preproduction planning, props, models, crew, rental fees, location fees, travel time, creative fee, and photography expenses, such as digital postproduction. In pricing

either area of the business, stick with the principle of having all the information. Don't be rushed into a quote. Quote a range, to leave some leeway for movement. And have a bottom line. You must guard against taking the shortsighted attitude: "It's good for me if I can just cover my overhead, plus a little extra, and save the client. Why not?" This attitude continues to cost photographers—from the amount of money they can put in their pocket to the amount of money they will be able to make in the future. Why? Clients use previous production budgets to calculate current and future budgets. Many art buyers have said that once the account executives and clients have gotten accustomed to getting good, usable photography at the fire-sale prices that have prevailed for the past few years, it's almost impossible to increase budgets for future productions. So whether it makes sense or not, art directors are given smaller and smaller budgets to work with and are still told, "Make it happen! Find a photographer to do it for less." And the downward spiral continues. As long as there's no resistance from photographers, pragmatic buyers will continue to squeeze more from the overall budget (at your expense) to cover the ever increasing cost of media space.

Quoting the Price in Consumer Photography

If you have set the stage properly (above) in your emphasis on the importance of the personality of the photographer and the quality of the photography, you're well on your way to discussing price. Underscore that having confidence in the personality and quality of a photographer leads you to confidence in their pricing.

Veteran photographer Chuck Delaney makes this point when talking to customers for a wedding or special family: "You wouldn't hire a baby sitter whom you didn't trust based on a low price. Chances are you wouldn't hire any professional whose personality gave you doubts based on a low price quotation. So it should be with wedding photography."

Reinforce the idea that they can be confident in the price you quote. There are no hidden traps. Price depends on what they need or feel they want.

Though it's still a delicate matter to balance the needs of the customer with your own to make a profit from each day's event, consumer pricing is best the more straightforward you are.

Closing the Deal in Publication Photography

Closing the deal is an aspect of negotiating that some photographers let slide. It can cause messy repercussions through misunderstanding. Once you have negotiated a fee, make sure it is clearly understood by both parties. For stock usage, ask the buyers if they will be sending a purchase order. Assignments often include complex and detailed estimates as part of the negotiating process. In addition to asking the clients to sign off on your final estimate and to provide you with a purchase order, send your

own follow-up memo confirming specific aspects of the assignment, such as who handles what—researching locations, booking models, making travel arrangements, and so forth. Note that the exact license of usage rights must be spelled out in your invoice both for stock and assignments. At this stage you are merely summarizing what you will be billing for later.

Closing the Deal in Consumer Photography

This will depend in large part on your personality. Customers may be overwhelmed by the number of choices they have. Judge the blend of soft sell and hard sell needed for each customer. If they aren't sold by the time you've finished your presentation, present two options to them. One, explain that, as a special courtesy, you will hold their date for two weeks while they decide. If they can't respond within that time, you'll be open to booking another event. The second approach is to acknowledge that they need time to mull it over and look at their overall budget. Say: "I'll give you a few days to ponder it all and will call at the beginning of the week to see if you have more questions." This warns them that you will call, so that when you do they won't feel they're being nagged. "As I said I would, I'm just checking in to see if you have any questions or I can clarify the package for you." The ploy of asking if they have more questions removes a bit of the pressure, since you aren't asking if you got the job but merely if you can assist them in the decision.

Follow-Up

An often overlooked final step in negotiation all types of photography is letting the client or customer know you are interested in the outcome of the photographic project. On an assignment, call shortly after the finished work has been received to see if the client is as pleased as you were with the photographs. You often receive some follow-up response from the customers while they are reviewing the proofs. If you are new to the field and have the time for extra follow-up, offer to deliver the album in person. This kind of service and obvious interest may translate to referrals to their friends.

Some wedding photographers send out a card about a month or so after the event saying it was a privilege to photograph their special event and wish them good luck.

Negotiating in Hard Times

Price cutting is not the answer to a tight economy. It's easy to say, because it's true, that to get work in a tough climate you must be better, more original, and more creative than the next photographer. It certainly helps. However, in assignment work personal attributes are valuable to a client as well. A reputation as someone who is easy to work with will give you an edge, perhaps even over a very creative, but

arrogant, hotshot. Competence and dependability are highly valued, especially when money is in short supply. Make sure you let clients know your ability to meet deadlines and solve problems. Buyers may be less likely to take risks during hard times, so promote your dependability, along with your creativity.

Starting Out

If you are new to the business, you may, as you read this book, be wincing at every reference to "experience" and wondering how you'll get it. As a new photographer, you can use all the techniques we mention, simply modified to your circumstances. If you are looking for assignment work, you have probably done some assisting for established photographers. When working for another photographer, learn all you can from the experienced pro's business habits and negotiating style. If you haven't assisted, try to connect with some experienced photographers through the organizations mentioned repeatedly throughout this book. These contacts may also shed light on the stock business.

If it seems more difficult to take the plunge with stock pricing, remember that it doesn't hurt to be honest with a client. In some cases you may even let the client know you are new to the business, but do so with this caution in mind: If the client wants to use your photograph, it has value, no less value for the client's purpose than if you'd been in business for twenty years.

Even as a newcomer, you shouldn't give your work away. You may consider a slight break for volume, or a slight percentage off (10–15 percent, tops) and let the client know why: "I am breaking in and want tear sheets for my portfolio, which is why I can give you a better price." Always negotiate a trade when you adjust your price, and put on your invoice that the discounted price must be accompanied by X number of tear sheets or reprints, per your discussion. But use this technique only if you are really being pressed on price. A client may simply like your photography and pay a standard fee. So don't rush to assume your clients know how green you feel. Playing the novice card is only for the rare tight pinch.

Consumer photography can present the same pitfalls to a beginner. The temptation is to canvas your region, see what prices other wedding, portrait, or event photographers charge and place your self one rung down so that you'll be chosen as the lowest bidder.

Once you establish yourself as the cheapest, you'll find it hard to rise above the low estimation of your work you've put out there. Try an approach where your prices are at least in the mid range of what others are charging. Then be honest and say to the client, "I've got good skills but not quite as much experience as some others in town. "I'd like to offer you an additional set of prints for giving me the privilege of photographing your wedding. You won't be disappointed."

BEING IN BUSINESS

Learning to manage your business is an ongoing process that improves with experience. There are numerous excellent books and workshops listed in the appendix to help you add to your understanding of pricing and negotiation. In particular, *Pricing Photography* has a number of helpful business forms designed for photographers.

Finally, remember that being a good businessperson is not at odds with the creative aspects of photography. Believe it or not, there are many photographers who are good photographers, skilled negotiators, and nice people.

Marketing

In the photographic world, marketing is simply letting people know who you are, what you can do—then convincing them that they should hire you to do it.

While marketing may be the least pleasant part of a creative person's life, it is arguably as important as all your other skills. This is true for all freelance professionals, whether photographer or picture professional. Staffers only go through this process occasionally when they change jobs. However, in any of these professions it helps to take a serious marketing approach to your job search. In the process be sure that your marketing materials are presented using strong graphic design.

Don't put off marketing efforts, because the longer you wait the more painful it can seem. Also, it takes time for your prep work to yield fruit, so the sooner you begin the better. If you wait until you have time to do it, you are already too late. That's the advice you'll hear, phrased in lots of different ways, from any successful professional.

There is some variation in marketing strategies among the types of photography, whether for publication, consumer, service, or fine art. But for the most part, though the audience you want to reach may be different, the strategy and tools are essentially the same. You need to put what you do in front of those who need it.

If your thought is, "I'll get around to it when I have time," then, sadly, it's unlikely to happen in any coherent way. Start early, make a plan, take it in small steps. Marketing is not so overwhelming if it is integrated with the rest of your professional life. You wouldn't hesitate to do the billing and expenses at the end of an assignment, though that's not a delightful task. You are forced to do if you want to get paid. Nobody forces you to do marketing—but if you want to get paid in the future you must force yourself. Think of marketing as an income-producer for next month or next year. Don't lose heart, there are some very useful books listed later in the chapter to help when you are ready to outline your marketing strategy. But first you must believe in its value.

You will have different marketing challenges in the beginning when you are fresh out of school with little or no experience than later when you've got a track

record. The primary difference is how much you have to show clients and how much money you think you can afford to spend on marketing at various stages in your career. When you are starting out you will have more time than money. At a later stage when you get busy you'll have more money to devote to marketing but may kid yourself that there's no time to do it. Do what you can at each stage.

BEGIN WITH DESIGN

An early step, and one of the most pleasant, because there is less pressure on you, is to develop a visual identity for yourself. If you are still in college or art school, chum up to a graphics major and see if they want to take "you" on as a design project. This is a great way to go when you are new and don't have much money. You can trade services with fellow students.

As you progress into your career, you'll want to get professional design advice for all your materials. And who knows—by the time you are ready for your next career step, your school chum may be working for a high-end design firm. The point is, don't be the proverbial plastic surgeon who takes photos on the weekends. You probably resent the idea of amateurs setting themselves up as photographers. Then don't let yourself be an amateur designer. Have respect for the abilities of other professionals by understanding that you need their expertise. You are putting precious time and money into your marketing, so skimping on the design is worse than foolhardy—it's self-defeating. Art directors have a keen graphic sense: if you make a clumsy presentation with poorly designed work, it will strike a sour note.

Design begins by simply choosing the color and type face you use for your name on letter head, business cards, mailing labels, and Web site.

WHAT'S IN A NAME?

A name for your business is very important. Don't feel shy about naming a business before you have any business—every hardware store had to put up a sign before opening its doors on the first day. You want to be ready to open your photography doors. It can be a simple combination of your name with the word "photography," or a word that denotes your type of business. Experienced photo researcher, Chrissy McIntyre, in New York City, uses a straightforward name for her services, Chrissy McIntyre Research, and her Web site is *www.imageresearch.net*. There's no doubt about what she is offering. Then her Web site backs up the name by providing clients lists and examples of her experience. Another approach to naming is to try a catchy play on your last name. Photographer Andy Sacks in Michigan uses *www.saxpix.com* for his Web site, "Sacksafone@ . . ." for

his e-mail, and "Photography SAX PIX" as his business name. It connects the name to the business, is eminently memorable, and it's fun.

Later, in the section on Web sites, you'll see how critical your name will be in helping you be recognized for what you do and the kind of clients you want to attract—and to keep from getting lost in the crowd.

Next you should find or an icon or logo that represents what you feel about yourself and your work, or ties in with your name. Here's where your collaboration with a good designer will help. Bounce around concepts and they'll often surprise you with an arresting logo or icon. Long ago an art director friend drew an elegant silhouette of a bird called a heron (my last name), which I used on my materials for many years.

The process of defining yourself never stops and should be reflected in your logo. A successful photographer friend had been using a logo that intertwined her name and a roll of 35 mm film with sprockets. Certainly not a unique image in the business, but hers was clean and well executed. A few years ago she knew she had to jettison that film image, since it might place her in the past and obscure the fact of her digital capacities. She and her designer came up with a fresh digital icon giving her a more current look.

PLAN YOUR WORK AND WORK YOUR PLAN

"Plan your work and work your plan": this tired old adage still holds true. If you are lucky enough to be in a photography program that includes business and marketing in its curriculum, you'll get a good head start. If not, do your best to work out a marketing program at an early stage. Help is available.

MARKETING TOOLS

All of your marketing efforts and material should be integrated to reinforce the message of your talent, skills, and experience. There are a variety of materials and vehicles for carrying out your marketing plan. They include printed materials such as postcards, promotion pieces, public-relations press releases, and ads. Vehicles for delivering these pieces can be direct mail, source-book advertising, or simply "leave-behinds" sent with portfolios or left at an interview. Internet marketing includes your Web site and mini-portfolios in PDF format. The latter can also be delivered on a CD. All of which you'll find detailed, with step-by-step guidance, in the recommended marketing reference book mentioned below.

Decide which marketing tools you should (or can afford to) use now and which will be planned for later in your career. Most photographers use a blend of the traditional print materials and electronic marketing methods.

Remember: the primary marketing tool is you. Your portfolio or résumé is a close second. In addition to talent and skill, what you have to offer are your brains, your energy, and your enthusiasm. Clients are seeking the special quality that separates you from the run of the mill. They want to know that you have what it takes to get something done, done well, under pressure, on time, and under budget. You want to convey these qualities in subtle ways in all contact with clients, whether in person, in print, or online. There's a testimonial line on the Web site of a colleague, which I think says it all: "Hamill provides more than images; he provides ideas." When you have satisfied clients under your belt, don't hesitate to ask to quote them. Testimonials lend great credibility.

Whether the client is an art director hiring a photographer, a newspaper hiring a photo editor, or a photo agency hiring a photo producer, they want to know that you are there to solve their problems—aesthetic, logistical, and technical. Communicate this to them every way you can. Don't feel overwhelmed. Help is at hand.

Maria Piscopo, a specialist in the field of marketing, can lead you through the detailed paths of marketing in her excellent book *The Photographer's Guide to Marketing and Self Promotion*, 3rd edition (Allworth Press). See more advice from Maria in her interview in this chapter.

MARKETING CONSULTANTS

Reading the books on marketing is a great help, but you may still uneasy about applying the principles to your own work. Because of the psychological pitfalls that beset creative people in their marketing efforts, getting marketing consultation might be the best move you ever make. Keep reading. Before you start exclaiming, "I can barely pay off my college loan and I'm getting advice about spending money on consultants!!" just consider for a moment that you can't be an expert in everything.

The earliest stage in your career might be the best time to get a boost by seeking specific marketing advice tailored to your talents and goals. There are many ways to approach this, and not all of them will break the bank. Look for opportunities for less-expensive marketing advice. For example, if you take a photographic workshop, an added bonus will be access to portfolio reviews from established professionals. If you develop a mentoring relationship with a working photographer, he can offer tips on how he developed a marketing plan. Even consider trying to get an internship or apprenticeship with a photographer's rep one summer during school.

One positive trend, reported by Maria Piscopo from her students, is a tendency for students to band together in the creating of mini studio groups. It is a gathering

together of students in a photography program, pooling their talents. They know each other and face the same difficulties of developing technical skills and artistic skills as well as tackling marketing. Piscopo reports that some students develop a taste for marketing. These students say they enjoy the process of meeting and talking to people. Presenting portfolios is less daunting when yours isn't the only one in the batch. It's an approach that has great practical merit.

PORTFOLIO

The purpose of a portfolio is to show what you can do, what you have done, and what you would like to do more of. It's a powerful selling tool.

Though we think of portfolios mainly as a selling tool for photographers, most picture professionals maintain a portfolio of work on which they have collaborated—makeup artists, stylists, and photo researchers all need to show how they participated in a successful photo production or contributed to an article or book. The principles are the same as for photographers.

Traditionally, a portfolio was a physical presentation including various formats such as prints and transparencies. Today, the presentation of a physical portfolio and your portfolio online will overlap. Both are essential and serve the same purpose—getting you and your abilities in front of a buyer and convincing that buyer to use you.

Some basic factors apply to all portfolios:

- Show only your best work—be brutal. Have a colleague—or better, a marketing coordinator—review it.

- Don't show material you can't back up. If the client likes a tabletop shot in your portfolio and you have no other still life to show when she asks to see more, you will have muffed an opportunity.

- Show as much published work as you can to indicate that you have experience. Whether small local assignments or pro bono work, if it's been published, someone liked your work enough to use it, and a prospective client will find that significant.

Since just getting a client to look at your portfolio is a significant accomplishment—make sure it has the impact to make an impression, and that it tells something about you. Photo buyers will generally concentrate on images in your presentation rather than read written materials. But some information is valuable in writing:

- A list of clients indicates that you have experience (even pro bono). Showing that someone else spent money on your services gives confidence to a client.

- A very brief introductory letter or written piece could indicate special skills, including digital expertise, language fluency, and special logistical experience.
- A "leave-behind" card that accompanies the portfolio is a good place for a very brief mention of this information, though it should be primarily a photographic piece.
- A brief list of stock photography categories, if that is one of your specialties.

All of this information should be integrated to appear as part of your overall marketing strategy on all pieces, promotion cards, ads, and Web site. You never want to miss the opportunity to reinforce your message.

Art Directors can be more impressed with other people having spent money on you than they may like to admit. This truth hit me right between the eyes very early in my career, and it's a lesson I'm grateful to have had. Have patience with the lengthy anecdote that follows, since it makes an important point.

Going for an interview with my carefully pruned portfolio of (I thought) stunning work in original print and transparency formats, I was vying for a location assignment in New Mexico. I had a few nice tear sheets but my other published work wasn't well enough designed to suit me. Misguidedly, I decided to show only transparencies and "explain" that it had all been shot on assignment without any published tear sheets to back it up.

The situation was rescued thanks to the foresight of my life partner who said: "Take that series of books you did for the xyz publishers." I countered, "But they're so ugly, the covers look like garish Easter eggs, the paper and printing is terrible . . . it makes the photos look drab."

He said, "You're foolish not to show that someone else had faith in your ability to carry off a job." He had hit the nail on the head, but I stuck the books in the back of my case without any intention of showing them.

The meeting: the art director looked through my "lovely" work, leaned back in his chair and said, "Ok, nice, you take good pictures—got anything else?" Sensing his unmet expectations, I reached into my satchel and brought out handfuls of small, trim-size children's books, thirty-six pages each in a series of twenty-four books. It was as if lightning had struck. He sat up in his chair, rifled through each book, saw the competing publisher's name, called in a colleague and became animated discussing how we'd do the assignment. Apparently he was impressed that someone else spent the money to produce my work, even though I thought it looked dreadful in final form.

The moral is to show the best balance of what you have at each stage of your career. This may seem to fly in the face of the advice earlier of only showing your best work, which is still true, but use balance and judge each situation based on what you have to offer at each stage in your career.

WEB SITES

A Web presence is an obligatory part of your marketing plan. It pulls together all aspects of what you want a client to know about you. There are technical and pragmatic considerations. Web designers will help with the technical side, but you must hold on to the reins of content and presentation. You are the visual person and can best understand how you want your work to appear and to try to judge how the client wants to see it. Though the word "design" is part of a Web designer's title, some of them are less graphic and more electronic experts. Be cautious about relinquishing your influence.

Names on the Internet

Going back to the subject of "naming," realize that in the pre-Internet days, print was the major marketing medium. In print your name didn't carry the same weight as it does today. Previously, a simple name, such as "Jane Jones Photography," was fine for marketing when buoyed up by strong design, fine photographs, and a good client list. Today, because of the competition on the Internet, it's hundreds of times more important to have a name that can be positioned well. You must find a name that works for you on the Internet in two ways. First, the name must be clear about who you are and what service you offer. Next you must get positioned where that name can be found, not lost in the teeming masses.

Just now, working on this chapter, I googled the words "stock photography" and was told that there were 95,600,000 listings. I noticed that the first two were from the mega stock agencies: Corbis and Getty.

I decided to labor on to see the last entry of the 95 million listings. But Google stopped at entry number 469 with a cautionary note: "In order to show you the most relevant results, we have omitted some entries very similar to the 469 already displayed. If you like, you can repeat the search with the omitted results included." So if you are not in the first 469 of the 95 million, what art director will ever see you?

Also, while you (or your prospective art buyers) are getting a headache in an agonizing scroll through these entries, you'll be offered a chance to enter Google's own portal, "Google Image Search." A click here takes you pages and pages of single images (some of them rather weak, others quite professional) with links to each photographer's Web site.

During the Google search you'll see the right side column with "sponsored links." Also, the first agencies on the page were the mega agencies Corbis and Getty highlighted as "sponsored links." These sponsored links gain considerable prominence but for a price (check the current home page for Google and they'll direct you to ad pricing). It's not unlike the old yellow pages, where the large ads took your attention away from the single-line entries. But the principle is the same. Find out how best to use positioning on the Web to place yourself at best advantage.

An excursion into Google or other search engines should hammer home the need for a good name and good placement in the hierarchy. When an art buyer is searching the Web for fresh photography, you want them to have a chance to find you. Your goal is to find the newest ways available to overcome getting lost in the shuffle. Right now one way is to investigate the costs of being a sponsored link, which will put you in the special group to the right side of the column.

Things change so fast that by the time this book is in print this information about Google may be different. Undoubtedly, there will be other methods for bringing your Web site name closer to the top of the list. Find a truly sophisticated Internet-savvy person to help you.

WEB SITE DESIGN

There are several components to designing a good Web site. To get a feeling for the style you like, first research as many Web sites as you can of professionals in your field (photographers, stylists, photo researchers) to see which appeal to you. It's helpful to have a client's view on their Web site preferences. As soon as you have done some work with clients, pick their brains. Ask what they like and don't like about sites—what attracts them, brings them in, keeps them looking; and what frustrates or turns them off. Most of it is common sense. Following are things I've heard from clients and what I've experienced. A good Web site has:

- Good organization—and a structure that makes sense. It should be easy to figure out where to go and how to go back. Make sure that lettering and prompts are clear enough to see. There are Web sites where the go back arrow is in such a subtle color that it was all but invisible—very elegant but a pain in the neck. As a tech person might phrase it: the interface should be clear and simple.

- Speed. There is nothing more frustrating than a Web site that is sluggish in loading images and text. So many Web sites are lightning fast that if yours isn't, a client probably won't stick around to see your work. The goal is to have pages that load instantly.

- High-quality pictures. As with all portfolio presentations, put only your best work on your site. You can include tear sheets with magazine covers, book covers, or ad pages to show published work. The lack of good design or bad printing won't be so detrimental as it is in a physical portfolio. Plus the original of the published image can be displayed as well as the tear sheet.

- Coverage. Make sure that you have enough depth of coverage in a topic. Follow the home page photos with a gallery that shows additional images.

- Clarity. Written information on a Web site should be brief, to the point, and add to the visuals. Web sites can include:
 - contact information
 - a client list
 - client testimonials
 - a vision statement from the photographer or picture professional (be brief)
 - a biography (different from the vision statement) with background, experience with any special skills, pilot license, languages, etc.

Give your prospective client easy access to your information. Don't make them have to stop and look up anything. All information should be at their fingertips. All your e-mails should have a footer with your contact information in full, including a link to your Web site.

Research Tools

Help is available. There are a number useful books to give you an in-depth look at how to market photography. If you can only choose one, make it Maria Piscopo's *The Photographer's Guide to Marketing and Self Promotion*, 3rd edition, from Allworth Press. She also has companion books, which you can find on the Allworth Web site, *www.allworth.com*.

Maria explains in great detail how to build a marketing plan from soup to nuts. The book covers self-promotion, advertising, direct marketing, public relations, and the Internet—as well as promotion pieces, portfolios, researching and winning clients, negotiating rates, and finding and working with reps. It's eminently usable, informative, and full of sage advice.

Also very helpful is the *Photographer's Market*, published by Writers Digest Press, which comes out annually. It lists specific buyers and how to approach them, a glossary of industry terms, and a wealth of other research information.

PROFESSIONAL PROFILE

NAME: Maria Piscopo

PROFESSION: photographer's representative, marketing workshop speaker, and author

WEB SITE: *www.mpiscopo.com*

HOME BASE: Costa Mesa, CA

How early do you recommend planning a marketing strategy?

It's my strongly held belief that someone starting out, as a photographer or a picture professional, should understand all the marketing tools available to them

even if they aren't in a position to use them yet. For example, I might not recommend buying a two-page spread in a national advertising source book when someone is just starting out—that's their entire marketing budget. But they should know what it is, where it is, and how much it costs. For picture professionals the principles are the same—to highlight their background, experience, and get their name in front of people through the various marketing tools such as source books and Web sites.

How are the photo schools integrating marketing into their photography programs?
Some are doing it very well, and the students benefit from the early exposure to the business of photography. I teach marketing courses in four colleges in my area. However, unfortunately, I still find that there are some instructors in the photographic arts that are telling students that all they need is a brilliant portfolio and some names to call. They downplay the need for marketing. If students aren't given an emphasis on marketing and promotion in school, they'll need to learn it on their own.

What are the basic divisions in marketing?
I explain to my students that there is a strong division between two types of marketing tools: the nonpersonal marketing tools like ads, direct mail, and Web sites, which touch the potential client without your being there. Then there are personal marketing tools, which include phone calls, portfolios, and interviews.

Nonpersonal is the most visible, but at an early stage in your career you may not have as much material to show in visual form. So the first thing I do is emphasize personal marketing. At this early stage they must try any means they can to meet a prospective client. Cold calls can sometime yield results, but I prefer to use really targeted research and working out client-oriented "scripts" of what and when to ask. Another approach is working on pro-bono projects or attending organization meetings where clients are speaking. Using whatever initiative they have to get near a client.

How does language affect the students?
When you're starting out, the word "selling" doesn't work well with students. I never use the word "selling"; I call it "helping people hire you."

Changing the language then takes away the sting. Creative people aren't interested in selling anyway, and that word throws up emotional blocks. In using the phrase "helping people hire you," I'm looking at something they *can* do. Also, I tell them: leave your feelings at the door. Our feelings can really sabotage us.

Next I discuss the balance of the two, nonpersonal and personal and how eventually they're going to do it all in a full marketing mix, but that they really

will need to prepare themselves by looking at all the creative possibilities in photography to find out want to do. Then they can research the clients that buy that type of photography and approach them.

Is there a difference between your approach to freelance or staff?

I make very little distinction in my classes between staff and freelance when it comes to the premise of "helping people hire them." Career advancement shouldn't stop with getting hired. If you want that next big project or to move up in your staff position, you have to do everything you can to satisfy the client/boss.

The creative professional is always in a marketing mode. Sometimes it's set on very low because when you are working on a project you can't be out there calling people right in the middle of a project. But that would be a good time to have a direct mail campaign going. Sometimes the flame is turned up. When there's no project coming in, that's when you turn your marketing up to high. Just don't let the pilot light go out. I've seen photographers in business twenty years who let the pilot light go out. It's very hard to restart.

The idea of marketing mix means it's not about full out, calling people forty hours a week or nothing at all. There is an in-between. If you wait until there is absolutely no work, then you can be tainted by a desperation mode, and clients smell it. If you have something on going, they see that it's part of the continuum.

When should you map out a marketing campaign?

There is no reason for an entry-level person in any of these fields to avoid the ground work of mapping out a Web site, even if they have no money. Mapping out a direct mail campaign can be done without having to design, produce, and print it right now. Just find a concept. What's the "big" idea for your campaign? All of this should be started even while you're in school.

How many entry-level people can have personal contact with buyer?

It is absolutely an option. It's a lot less easy than it may have been years ago, but it's possible. The difference is timing. For a freelancer, the point at which you actually meet someone is closer to the actual project they have for you to work on.

A lot of the preliminary steps, which used to be done through personal contact—such as seeing your portfolio—are not often done in person any more. Much of it can be handled on a Web site, by sending the client a PDF of your work with your background information in an e-mail, or by sending a promo piece. There are lots of initial steps done online now instead of with personal contact.

There are still personal meetings, but fewer and closer to the actual project— then everyone is in panic mode. The client waits until they have the project in hand to call you in for an interview. Now that puts students on the spot. They

haven't had the sheer exercise or practice the rest of us have had in presenting our-selves, in negotiating and closing the job. At that point you don't have the luxury of building up a personal relationship to the point where when the project comes up and you have a little calmer meeting. You can get a personal interview, but it might go like this: "Give us an estimate and production outline by tomorrow."

They may not have worked on their "scripting" conversations to help them be ready for this moment—or done the role-playing I suggest in my book and classes. The answer to this is to do all the practicing you can with fellow students and within your professional organizations.

Is this a different trend on the part of clients?

Yes, people—clients and employers—are not taking the time, as they did in the past, to do what I call "making a short list." That is, to interview people for the sheer learning process. That would give them experience with photographer and their portfolio, so they could create a short list of good people to call in when a project comes up and it's a rush.

How valuable is personal work in a portfolio?

Certainly, when you do your own personal work for a portfolio, that has some value to show your creativity and skills and it's important. But the client realizes it wasn't produced under the stress of a real job. Without a client in the process, it lacks the chemistry of having solved problems together. All the more reason to search out pro bono work or any kind of real job, even at entry-level fees.

What is the best way to get experience to show in a portfolio?

In an interesting reversal, the old-fashioned way to get experience seems to be in high gear right now. Entry-level people in all disciplines are doing community service. Pro bono projects, all around the country, are actually quite sought after, not just by entry level but sought after by the working professional as well. It's a place to show off your creativity, it's for charity, and the client is paying produc-tion costs. You donate services, get great tear sheets, and are making good contacts with high-level people. The invaluable part is that an entry-level person can expe-rience a real job, with a real budget, real production specs, and a real deadline. Finally, you are working with real clients who can give you real testimonials.

Last year, I had first-hand experience working on a pro bono project with photographers and graphic designers. They got to stretch their own creative and technical abilities, got the pleasure of working on a well produced job; the charity got a great program, and the creative professionals got a credit testi-monial. There were photographers on the project—I would recommend any in a heartbeat. They performed brilliantly under extreme pressure. To find a

photographer so attuned to the event, on his toes to catch all the right moments, well, I would give that photographer a testimonial they can't buy.

The old method of "Give it away, to get it back" in today's economy becomes a ten-fold return now, since they can make great contacts. Pro bono can be a great way to show your stuff and prove your worth.

What is your outlook on the business for students to consider?

Understand that things are changing. Advertising agencies are changing dramatically, in some ways, they are structurally turning into design firms. Also, the method of "client direct," which is working directly with companies is a huge, untapped market. I beg my students to stop lusting after the Nike commercials. I'm tempted to say "get over yourself," there other clients besides Nike. So many students say, "I want to be an advertising photographer; I want to be a fashion photographer; I want to be Annie Leibovitz." Then I have to say, "Maybe, maybe not." There is room for so many interesting career paths in the world of photography. Explore them. Advertising is so linear, it's just a one-line song, and I'd like to get them to stop singing that song.

How might they fill the gap of learning marketing or even getting a rep at an early stage?

One possibility is to consider becoming a rep. It's a wide-open field right now. There is such a need for reps, and there aren't enough people interested. If marketing is "Find a need and fill it," well, there is a need for reps. There is a shortage of people to represent or market other photographers.

I've had young people approach me at workshops with an interest in becoming a rep. They'll say to me: "I see the need for reps, I feel a passion for it. I have photographer friends who don't like to quote, to sell, and I do. I've studied photography but I like to talk to people, to be out front. I wouldn't mind taking portfolios to clients."

When students have gone to school together they know each other's abilities. It's a way for entry-level people to band together in small groups, when they leave school to create sort of a mini studio, to share the tasks, letting the one who likes marketing develop as a rep.

You have a concept in your book called scripting. How does that work?

In all my classes and seminars this handout walks away as a "keeper." Some students consider it the most useful advice they get. I point out that no matter how good they are as a photographer, they will need to talk with clients, and they must get information in order to estimate a project.

Scripting helps them clarify their use of language and builds their confidence for questioning a client. I suggest that they practice with a friend to role-play the

client and the photographer. This helps them get used to the intimidation that might arise at the moment of an interview. The good news is that changing that way of speaking is changing a habit, it's not hard-wired; it's the one thing in my book that gets the quickest return on their investment.

What about consumer photography? Is there anything special about marketing for this area of photography?

The marketing principles hold true for many parts of the business. But there has been a shift in the wedding and portrait areas of consumer photography. The market is growing on the high end.

Digital pushed the low-end portrait photographer out of business. Retail took over, with companies like Sears and Wal-Mart pushing the prices so low one couldn't compete. So in today's business, the consumer photographer had to get better and work with style and in unique ways that you can't get at Sears.

There has been an explosion in the high end of this business but virtually no low end left. I met a woman recently doing high-end family portrait photography who was so successful she was working with a rep!

The use of digital has increased the variety of products a customized consumer photographer can offer. If you add a product line—a full service line of products, not just prints—it gives a marketing advantage. That's true for weddings and all events such as bar mitzvahs, sweet-sixteen parties, quinceañeras—all of them.

Are there other changes in marketing strategies for the consumer photographer?

Database marketing has become so sophisticated that you can now buy mailing lists of people just *thinking* about having their first child. So if your specialty is baby portraits, here's a targeted market.

The idea came from the Direct Marketing Association about five years ago. They used to call it psychographic data but that term wasn't well received, so it's now termed "behavioral" data. They study how you, as a consumer, behaves: where you shop, what you read, what you buy. And sell those targeted lists.

What are the other marketing tools?

Consumer photographers used to rely on ads in the yellow pages. Today the primary marketing tool for consumer and wedding photographers is people searching the Web.

Do you have a final word for photography professionals regarding marketing themselves?

Start early and work with your colleagues or fellow students to share the load. Join professional associations and get on every committee you can to participate in your professional community.

Copyright: What Do We Own?

Taking care of the legal formalities is a necessary part of your photographic business—one which, if handled properly, will allow it to run more smoothly. This, in turn, will give you more time and creative energy for your photography. This chapter presents the basics of copyright law and also what you need to know about invasion of privacy and the importance of model releases; it gives sample releases to clarify your business dealings and help to avoid misunderstandings; and it offers some thoughts on where to turn for legal help if things go sour. For further legal information, consult *Legal Guide for the Visual Artist* by Tad Crawford, as well as the legal section in *Starting Your Career as a Freelance Photographer* (both published by Allworth Press).

Understanding copyright is good business; but more important, knowing about copyright is a way of showing respect for your photographs. Your photography is your creation. For most photographers, their photographs are the tangible result of a life's work, with economic, artistic, and sometimes historic value. They can be a legacy and an annuity—and thus they deserve respect.

It is important to understand that you cannot copyright an idea, only the tangible expression of an idea—which for photographers is the photograph. The copyright is actually composed of a bundle of rights, which can be separated and portioned off for different purposes—and licensed to a variety of clients for a wide range of reproduction fees.

It's good to remember that while we casually refer to the "selling" of pictures on an assignment or to the income from "stock sales," those terms are misleading, however convenient and commonly used. The correct terminology is that you "license" rights for specific usage, usage which is then spelled out in your invoice to a client. The same photograph has a virtually unlimited number of uses over its lifetime.

In stock photography, the picture, the actual physical property of the photograph (digital file, transparency, or print) is merely on loan, and the fee paid is not for the "sale" of anything, it is for usage permission only—that is, reproduction rights.

COPYRIGHT OVERVIEW

In general, the following section will center on copyright information applicable to the freelance photographer. It may not apply if you are employed as a photographer by someone else; in most cases your employer will own the copyright to any work done "on the job."

You, the photographer, own the copyright in your photograph from the moment of creation (the second the shutter closes). The exceptions are:

• If you are an employee and create the photos within the scope of your employment

• If you are freelance but have signed a work-for-hire contract

This ownership of the copyright from "the moment of creation" was legislated by Congress in the Copyright Act of 1976 (which took effect January 1, 1978).

The term of copyright for works created on or after January 1, 1978, is the photographer's lifetime plus seventy years. There are also exceptions to the term, such as works published anonymously, under a pseudonym, or as work for hire.

What Are the Rights of the Copyright Holder?

The copyright owner has the exclusive right to control the reproduction of the image; to control the first sale of any copies (such as fine art prints) of the image; to resell that print; to control use of the image in derivative works (such as when an artist uses your photographs as the basis of an illustration); and to control displays of the image (subject to the fact that someone who has purchased a physical copy, such as a fine art print, has the right to display it to people who are present at the location where the display is taking place, as in a home, gallery, or museum). The rights to digital photos are much the same as those to traditional images. As explained by Tad Crawford and Laura Stevens in *Starting Your Career as a Freelance Photographer*:

> A copyright owner may control the distribution of his or her photographs on the Internet in much the same way as would be done with respect to books or magazines. The Digital Millennium Copyright Act, enacted in 1998 extends the copyright protections, which already existed with respect to traditional media (e.g., books, photographs) to their online counterparts (e.g., e-books and photographs made available on the Internet). Although the DMCA contained some specific limitations on liability for a particular class of parties, it may be generally be assumed that a use that requires permission offline (e.g., to include a photograph in a magazine) would require permission on line (e.g., to include a photograph in an e-zine).

What Is Work for Hire?

Work for hire means the client, not the photographer, owns the copyright, as if the client had, in fact, shot the photographs—because under work for hire, the copyright vests in the client from the moment of creation. There is not even a copyright transfer to the client in a work for hire. This means that in the eyes of the law, the client was the photographer.

Employees, such as most staff photographers, do work for hire in the traditional employer–employee relationship.

Freelance photographers are never employees. (For this discussion we are concerned with work for hire as it applies to photographs taken on assignment. It can never apply to stock photographs taken on your own time.)

The only way work for hire can come into being for a freelance photographer is if there is a contract that (1) is written; (2) states that the work being done on an assignment is work for hire; (3) is signed by both the photographer and the client. The assignment itself must fall into one of a limited number of categories, the most likely to apply to photographers being: (a) as a contribution to a collective work such as a magazine, (b) as part of an instructional text, (c) as part of a supplementary work (which is a work intended to supplement a larger work), or (d) as part of an audiovisual work or motion picture.

If the work you do on an assignment does not fall into one of the categories specified in the law, then it is not work for hire, no matter what contract a client may ask you to sign. The best protection is not to sign any work-for-hire contract—but in the rare instance that you consider doing so, read the contract carefully to make sure that it is binding only on the current job.

Copyright Notice

Copyright notice is the statement of copyright ownership in a photograph. A significant value of copyright notice is symbolic—it warns the public or any potential user not to use the image without permission of the copyright owner. It also has the practical value of letting a potential user know whom they should contact in the event that they want to reproduce the image.

Also, the use of a notice will benefit you in the event of a lawsuit by eliminating the defense that the user was an "innocent infringer"—i.e., they didn't know they couldn't use it.

A proper copyright notice has three elements:

1. The word "copyright," the abbreviation "copr.," or the symbol ©

2. The year of first publication

3. The name of the copyright holder (you)

In the case of some usages, the date may be omitted. Examples of properly worded copyright notices are: "© 2008 Pat Photographer," "Copyright Pat Photographer 2008," or "Copr. 2008 by Pat Photographer."

The date to be used in a copyright notice for unpublished photographs is the year of creation. You may wonder whether using the year of creation may not shorten the term of copyright. However, since the copyright term is measured by the life of the photographer plus seventy years, it will be the same no matter what date appears on the photograph. When a work has been unpublished and is then published, the year of first publication should be put in the copyright notice.

A copyright notice should be on all photographs leaving your studio, whether prints or transparencies or digital files, and should be required as a part of your photo credit accompanying all publication. Many photographers attach the copyright notice to the digital file of the photograph or imbed it in the metadata, and in some cases overlay the photo with a watermark with the copyright notice. (Consult the book *Business and Legal Forms for Photographers*, 3rd edition, by Tad Crawford for more on copyright.)

Copyright Infringement

Infringement occurs when your photograph is used (published) without your permission or that of your authorized agent (such as a stock agency). You will probably only learn that you are being infringed by being alert—and if you're lucky. You may notice a usage that you didn't authorize. Often a friend will recognize your photograph and bring it to your attention. But there may very well be infringements that you never see.

If this happens to you, consult a lawyer who is expert in intellectual property law especially as it pertains to photography. You may not have to go to court; there are sometimes quick, amicable solutions. But knowing about an infringement and doing nothing could jeopardize your right to sue.

Copyright Registration

There is no requirement to register photographs with the Copyright Office, whether photographs are published or unpublished—your copyright ownership is not jeopardized by lack of registration. However there are certain benefits to registering photographs. Further, they can be registered in groups, to make things less complicated and to save fees.

If you have registered prior to an infringement's occurring, the benefits of registration include certain presumptions in a lawsuit and certain rights to damages and legal fees that might not otherwise be available to you.

The U.S. Copyright Office provides "Form VA" for works of visual art. With the form and fee you have to provide copies of the images being registered (generally one copy of unpublished work and two copies of published work). Group application

registration can be made using CDs or DVDs. The form, the fee, and the deposit copies of the photographs must all be sent together for the registration to be valid. Registration, by the way, will take effect on the date that these three items are received by the Copyright Office, even if the Copyright Office takes some time to mail the certificate of registration back to you.

For more information about copyright and to download forms, go to the Web site of the Copyright Office, *www.copyright.gov*.

A final piece of advice, don't think copyright infringement is just a fantasy or something that happens only to other people. In fact, there have been a rash of infringements. The typical story is that after the infringement has taken place, the photographer is offered merely the fee that he or she would have gotten in the first place had the infringer come to the photographer for that photograph. This is completely unacceptable. The best way to deter infringement is to use a copyright notice and to register so your threat of a suit will have teeth.

MODEL RELEASES AND INVASION OF PRIVACY

An area in which photographers should exercise most caution—where they are most likely to put themselves at risk—is in the area of the law known as invasion of privacy. Individual citizens have rights of privacy—that is, the right to live free from unwanted publicity. This right to privacy overlaps with another right held by all individuals—one that, for this discussion, is of particular interest to creators. This is the right to free expression under the First Amendment of the Constitution.

Which right takes precedence, and when, is complicated and sometimes requires a decision by the courts. Photographers can avoid most of these problems associated with the risks of invasion of privacy by obtaining proper model releases and by observing certain cautions, as we'll see below.

When You Need Releases

From a business standpoint, model releases increase the value of your stock dramatically, so you should make every effort to obtain them. It is also very important to understand your vulnerability in *not* having releases for stock photographs, in terms of the legal protection consequences that can ensue they can provide. It is not always clear legally when a model release is required, but the following guidelines will help.

1. If the use of the photograph is commercial, for purposes of trade or advertising, a release is needed for any recognizable person (and, in some cases, property).

2. In a noncommercial situation where the use can be considered newsworthy or a matter of public interest, a release is generally not needed. In photographic terms, that generally means editorial usage: books, newspapers, or magazines.

However, many photographs could have commercial application down the line, and you would be wise to have a release available.

There is an exception if the person is portrayed in a false light to the public. The exception applies to otherwise protected use, such as editorial. This most often takes place when a true photograph, one which has not been altered, is connected with a caption that makes it untrue. For example, a caption describing the family-destroying effects of crack is connected with the photograph of a mother and child—when, in fact, neither of these actual people has ever had any relationship with crack. Even though the usage is editorial, it is not in the public interest to say false things about particular people. Even a signed model release would not provide protection from this extreme and defamatory usage unless the release specified the models' consent to portrayal as crack users.

Also know that if the depiction puts the subject of the photograph in a demeaning light then you may also be open to a claim for libel.

3. Physical intrusion, such as trespassing or obtaining entry by fraud to take photographs, can also be invasion of privacy.

4. There is a different set of rules connected with celebrities. A celebrity used in photographs for commercial purposes of advertising or trade is protected under the laws of privacy as is any other individual, but this leads us into another interesting, and somewhat murky, area of the law. What has been termed *the right of publicity* is the right that well-known people have in the value that has come to exist in their names and images.

And while the rights of privacy exist only for living persons, in some states the rights of publicity to the persona of a deceased celebrity exist as property rights, which descend to the heirs.

Photographers should be aware that the rights to license the images of certain famous people who are deceased are often held by special agencies set up for the purpose of controlling the commercial and artistic exploitation of the celebrity's persona—such as John Wayne, W.C. Fields, Babe Ruth, Albert Einstein, and others. There are laws in several states, California being among the most active in this area, that recognize these rights of publicity. It isn't yet known whether a model release obtained while the celebrity was alive will be valid after death. This area of the law is in flux. If you specialize in celebrity photography, be sure to consult your lawyer and watch closely the developments reported by ASMP.

Property Releases

Property does not have rights of privacy or publicity. However, a property owner may have the right to prohibit commercial exploitation (use for trade or advertising) of his or her identifiable property.

A house, a pet, or a piece of jewelry or sculpture may require a release for advertising use. A horse running in a field, silhouetted against the setting sun might not need a release—unless that field is on a Kentucky horse farm and the horse was a famous brood mare. Then a release would be advisable.

A property release may not always be required legally, but such releases are a necessity if your stock is to have maximum value—which means being available for advertising users. Certainly, you should obtain property releases when shooting interiors, especially since the release can also serve as a contact with the owner. But releases can add value to exterior photographs, especially of buildings, since clients will prefer a photo with a property release to a photo without one.

In any case a release should be signed when the property is photographed, and some payment, even if very small, should be made to the owner.

What is the final word on releases? Simply put, you as a stock photographer should always obtain a model (or property) release for any subject appearing in any image that you create. Since advertising is the most lucrative market, clearly you, and your stock agency, will want to have your images available to sell in that marketplace. Make the effort.

Business Forms

Nuisance though it is, paperwork is more than just a good idea—it's essential. The most important reason for having a good "paper trail" is that it protects you with models; with clients over questions of usage, payment, or holding fees; in disputes over lost transparencies; and in many other ways too. Further, you can create an impression of professionalism by using clear, thorough agreements, presented on nicely designed forms.

Don't let the concern that you'll alienate a client keep you from using detailed paperwork. Photo buyers are already used to receiving forms from photo agencies. Why should they expect less from you? And why should you expect less from yourself! An experienced photo buyer will appreciate the clarity of good paperwork—and will take you seriously if that's how you run your business.

You can, and should, make any changes in these sample forms that work well in your business. However, when deciding on the terms and conditions for your forms or the wording for your model releases, be sure to work with a lawyer. This is not the time to be casual.

ASMP publishes sample forms and model releases for its members on its Web site, *www.asmp.org*, and in its publications available through Allworth Press. The releases included in this chapter are a model release for both adults and minors and

a property release. These releases have been adapted from *Business and Legal Forms for Photographers* by Tad Crawford (Allworth Press).

The model release that follows is similar to the one that I use. Some photographers use a scaled-down release, sometimes called a pocket release, which will fit on a 3" × 5" card. It is very convenient and not so formidable to a model, but doesn't offer as much protection as you might want. When possible, especially if you work with professional models or plan to sell to advertising clients, use the strongest possible release.

In addition to the language that protects you legally, I add an introductory paragraph to soften the harsh tone of the legal language. I find it helps to put nonprofessional models at ease and seems to make the release easier to get signed. Such an introduction might read as follows:

～～

Dear Friend (or Parent):
Thank you for your cooperation in allowing me to photograph you (or your child) for use in my stock photography project. Would you please sign the form below to show that you give me and the user, my photo client, permission to use these pictures.

～～

Or, if you are short of space, you can put the friendly introduction on the back of the release along with an explanation of your project and a definition of stock as existing photography. The definition might read: "Stock photographs are existing photography. These photographs may be placed in my stock photography file or that of my agent to be used for publication." Vary the introductory language according to your own prose style and the particular project.

The release shown here adapts for use with an adult or child model. Or you can make two versions, one for adults and another for the parent (or guardian) of a minor. If you work with children a lot, you might want to have the separate version for minors.

Once you add any introductory words that you may want to this release, have it printed or photocopied on your letterhead. This adds a professional look. Be sure to have your name in the space for the photographer's name, so the release will be valid. Also, it is wise to give something of value (even a small amount of money such as a dollar or complimentary copies of the photographs) to make the release as binding as possible on the model or the property owner. Some releases do not mention giving money, but simply say, "For valuable consideration received. . . ." Be certain, in fact, that you give something of value to the model and keep a record of what you gave as consideration.

MODEL RELEASE

In consideration of _____ dollars ($_____), and other valuable consideration, receipt of which is acknowledged, I _____ (print Model's name) do hereby give _____ (the Photographer), his or her assigns, licensees, successors in interest, legal representatives, and heirs the irrevocable right to use my name (or any fictional name), picture, portrait, or photograph in all forms and in all media and in all manners, without any restriction as to changes or alterations (including but not limited to composite or distorted representations) for advertising, trade, promotion, exhibition, or any other lawful purposes, and I waive any right to inspect or approve the photograph(s) or finished version(s) incorporating the photograph(s), including written copy that may be created and appear in connection therewith. I agree that the Photographer owns the copyright in these photographs and I hereby waive any claims I may have based on any usage of the photographs or works derived there from, including but not limited to claims for either invasion of privacy or libel. I am of full age* and competent to sign this release. I agree that this release shall be binding on me, my legal representatives, heirs, and assigns. I have read this release and am fully familiar with its contents.

Witness: _____

Signed: _____

Model

Address: _____

Address: _____

Date: _____, 20 _____

Consent (if applicable)

I am the parent or guardian of the minor named above and have the legal authority to execute the above release. I approve the foregoing and waive any rights in the premises.

Witness: _____

Signed: _____

Parent or Guardian

Address: _____

Address: _____

Date: _____, 20 _____

*Delete this sentence if the subject is a minor. The parent or guardian must then sign the consent.

PROPERTY RELEASE

In consideration of the sum of _____ dollars ($_____) and other valuable consideration, receipt of which is hereby acknowledged, I, residing at do, irrevocably authorize (the Photographer), his or her assigns, licensees, successors in interest, legal representatives, and heirs to copyright, publish, and use in all forms and media and in all manners for advertising, trade, promotion, exhibition, or any other lawful purpose, images of the following property: _____

_____, which I own and have full and sole authority to license for such uses, regardless of whether said use is composite or distorted in character or form, whether said use is made in conjunction with my own name or with a fictitious name, or whether said use is made in color, black-and-white, or otherwise, or other derivative works are made through any medium.

I waive any right that I may have to inspect or approve the photograph(s) or finished version(s) incorporating the photographs, including written copy that may be used in connection therewith.

I am of full age and have every right to contract in my own name with respect to the foregoing matters. I agree that this release shall be binding on me, my legal representatives, heirs, and assigns. I have read the above authorization and release prior to its execution and I am fully cognizant of its contents.

Witness: _____

Signed: _____

Address: _____

Address: _____

Date: _____, 20 _____

Appendix A

PHOTOGRAPHY SCHOOLS/ DEGREE-GRANTING INSTITUTIONS

Art Center College of Design
Hillside Campus
1700 Lida Street
Pasadena, CA 91103
(626) 396-2200
www.artcenter.edu
Undergraduate and graduate
programs

**The School of the Art Institute
of Chicago**
37 South Wabash, 7th floor
Chicago, IL 60603
(312) 899-5219
www.artic.edu/saic/index.php
BFA and MFA

Brown College
1440 Northland Drive
Mendota Heights, MN 55120
(800) 935.5021
www.browncollege.edu/index.asp
Undergraduate programs

Chester College of New England
40 Chester Street
Chester, NH 03036
(800) 974-6372
(603) 887-7400
www.chestercollege.edu/index.php
BFA and graduate programs

College of Visual Arts
344 Summit Avenue
St. Paul, MN 55102
(800) 224-1536
(651) 224-3416
www.cva.edu/index.htm
BFA

Paier College of Art, Inc.
20 Gorham Avenue
Hamden, CT 06514
(203) 287-3031
www.paiercollegeofart.edu/
Two- and four-year programs

Pennsylvania College of Art & Design
204 N Prince Street
P.O. Box 59
Lancaster, PA 17608

(717) 396-7833
www.pcad.edu
BFA

Rhode Island School of Design
Two College Street
Providence, RI 02903
(401) 454-6100
www.risd.edu/index.cfm
Undergraduate and graduate programs

San Francisco Art Institute
800 Chestnut Street
San Francisco, CA 94133
(415) 771-7020
www.sanfranciscoart.edu
Undergraduate programs

School of Visual Arts
209 East 23rd Street
New York, NY 10010
(888) 220-5782
(212) 592-2000
www.schoolofvisualarts.edu
Two- and four-year programs

Rochester Institute of Technology (RIT)
One Lombard Memorial Drive
Rochester, NY 14623
(585) 475-2411
www.rit.edu
Undergraduate and graduate programs

University of North Texas
School of Visual Arts
Undergraduate Admissions
P.O. Box 311277
Denton, TX 76203-1277
(940) 565-2681
www.unt.edu/pais/insert/uphot.htm
Undergraduate and graduate programs

Professional Photography Schools

Brooks Institute of Photography
801 Alston Road
Santa Barbara, CA 93108
(888) 304-3456
(805) 966-3888
www.brooks.edu/index.asp
BA and MS

Hallmark Institute of Photography
At the Airport/
P.O. Box 308
Turners Falls, MA 01376
(413) 863-2478
http://hallmark.edu/
Professional programs

International Center of Photography (ICP)
1114 Avenue of the Americas at 43rd Street
New York, NY 10036
(212) 857-0001
www.icp.org
Undergraduate and graduate programs

New England School of Photography (NESOP)
537 Commonwealth Avenue
Boston, MA 02215
(800) 676-3767
(617) 437-1868
www.nesop.com/
Two-year Professional program

Rockport College
P.O. Box 200, 2 Central Street
Rockport, ME 04856
(877) 577-7700
(207) 236-8581
www.rockportcollege.edu/pcert-photo.asp
AA, MFA, and a one-year professional certificate degree

University of the Arts in Philadelphia
320 South Broad Street
Philadelphia, PA 10102
http://www.uarts.edu/
Undergraduate, graduate, and continuing
education programs

Online and Distance Learning Schools

BetterPhoto.com, Inc.
16544 NE 79th St
Redmond, WA 98052
(425) 881-0309
www.betterphoto.com/home.asp
Online only (some workshops)

New York Institute of Photography
New York Institute of Photography
211 East 43rd Street, Suite 2402
New York, NY 10017
(212) 867-8260
www.nyip.com/
Distance learning

Penn Foster
Enrollment Information
(800) 275-4410
E-mail: *info@pennfoster.com*

Perfect Picture School of Photography
Bryan Peterson
www.ppsop.com
Online learning (with some in-person
workshops)

The Profotos.com Web site has an
extensive list of over 300 schools that
teach photography in person and online.
*http://www.profotos.com/education/
referencedesk/photographyschools/
index.shtml*

Appendix B

WORKSHOPS

**The Great American Photography
Workshops**
902 Broyles Ave
Maryville, TN 37801
(866) 747-4279 (GAPW)
www.gapweb.com

Midwest Photo Workshops
28830 West 8 Mile Road
Farmington Hills, MI 48336
(248) 471-7299
www.mpw.com/home.htm

**Boyd Norton's Wilderness
Photography Workshops**
Africa, Bali, Borneo, Komodo Island,
Peru, Galapagos, Siberia, Belize and
Venezuela
(303) 674-3009
www.nscspro.com/workshops.htm

**The Palm Beach Photographic
Centre**
55 NE 2nd Avenue
Delray Beach, FL 33444
(561) 276-9797
www.workshop.org

Santa Fe Photographic Workshops
Santa Fe Workshops
PO Box 9916
Santa Fe, NM 87504-5916
(505) 983-1400
www.sfworkshop.com

**The Workshops (Formerly: The Maine
Photographic Workshops)**
P.O. Box 200
Rockport, ME 04856
(877) 577-7700
(207) 236-8581
www.theworkshops.com

Appendix C

ORGANIZATIONS

**Advertising Photographers
of America (APA)**
606 North Larchmont Boulevard
Los Angeles, CA 90004
(800) 272-6264
www.apanational.org

**American Society of Media
Photographers (ASMP)**
150 North Second Street
Philadelphia, PA 19106
(215) 451-2767
www.aspm.org

**The American Society of Picture
Professionals (ASPP)**
117 S. Saint Asaph Street
Alexandria, VA 22314
(703) 299-0219
www.aspp.com/index.lasso

**The British Association of Picture
Libraries and Agencies (BAPLA)**
www.pbf.org.uk/aboutbapla.shtml

**National Association of Photoshop
Professionals**
NAPP Headquarters
333 Douglas Road East
Oldsmar, FL 34677
(813) 433-5006
www.photoshopuser.com

**National Press Photographers
Association (NPPA)**
Durham, NC 27705
(919) 383-7246
www.nppa.org

**North American Nature Photography
Association (NANPA)**
10200 West 44th Avenue, Suite 304
Wheat Ridge, CO 80033-2840
Tel: (303) 422-8527
Fax: (303) 422-8894
www.nanpa.org/index.html

**Photo Marketing Association
International (PMA)**
3000 Picture Place
Jackson, MI 49201

(517) 788-8100
www.pmai.org

**Picture Archive Council of America
(PACA)**
23046 Avenida de la Carlota, Suite 600
Laguna Hills, CA 92653
(949) 282-5065
www.pacaoffice.org

**Professional Photographers
of America, Inc.**
229 Peachtree St. NE, Suite 2200
Atlanta, GA 30303
(404) 522-8600
www.ppa.com

**Society for Photographic Education
(SPE)**
SPE National Office
126 Peabody Hall/The School of
Interdisciplinary Studies

Miami University
Oxford, OH 45056
(513) 529-8328
www.spenational.org

**The Society of Photographers
and Artists Representatives
(SPAR)**
60 East 42nd Street, Suite 1166
New York, NY 10165
www.spar.org

**Wedding and Portrait Photographers
International**
P.O. Box 2003
1312 Lincoln Boulevard
Santa Monica, CA 90406-2003
(310) 451-0090
www.wppionline.com

Appendix D

PROMOTION/SOURCE BOOKS

Workbook/Workbook Corporate Office
940 N. Highland Ave. Los Angeles, CA 90038
(800) 547-2688
323 856-0008
www.workbook.com

Workbook East
9 W. 19th St. 2nd Floor
New York, NY 10011
(800) 322-3470
(646) 230-1640
www.workbook.com

Workbook Midwest
600 N. Dearborn #1502
Chicago, IL 60610

(800) 752-0285
(312) 944-7925
www.workbook.com

The Black Book, Inc
740 Broadway, Suite 202
New York, NY 10003
(800) 841-1246
(212) 979-6700
www.blackbook.com

PDN Photo Source
Online sourcebooks
www.pdngallery.com/photosource/index.shtml

Appendix E

PHOTOGRAPHY PUBLICATIONS

General Interest

Adams, Ansel. *The Camera (Ansel Adams Photography, Book 1)*. New York: Bulfinch, 1995.

Doeffinger, Derek. *The Magic of Digital Printing: Great Prints from Shooting to Output*. Asheville, NC: Lark Books, 2005.

Eismann, Katrin. *Adobe Photoshop Restoration & Retouching (Voice that Matter)*, 3rd edition. Berkeley, CA: New Riders Press, 2005.

Heller, Dan. *Profitable Photography in the Digital Age: Strategies for Success*. New York: Allworth Press, 2005

Heron, Michal. *Digital Stock Photography: How to Shoot and Sell*. New York: Allworth Press, 2007.

Kieffer, John. *Mastering Nature Photography—Shooting & Selling in the Digital Age*. New York: Allworth Press, 2004.

Krogh, Peter. *The DAM Book of Digital Asset Management for Photography*. Sebastopol, CA: O'Reilly Media, 2005.

Monteith, Ann K. *The Business of Wedding Photography*. New York: Amphoto Books, 2002.

Monteith, Ann K. *Marketing Resource & Activity Planner for the Professional Photographer*. Norfolk, NE: Marathon Press. 2003.

Monteith, Ann K. *Professional Photographer's Management Handbook*. Norfolk, NE: Marathon Press, 2003.

Peterson, Bryan. *Understanding Digital Photography: Techniques for Getting Great Pictures*. New York: Amphoto Books, 2005.

Peterson, Bryan. *Understanding Exposure: How to Shoot Great Photographs with a Film or Digital Camera*. New York: Amphoto Books, 2005.

Poehner, Donna, editor. *Photographer's Market.* Cincinnati, OH: Writer's Digest Books, annual.

Wignall, Jeff. *The Joy of Digital Photography.* Asheville, NC: Lark Books, 2005.

Willmore, Ben. *Adobe Photoshop CS2 Studio Techniques.* Berkeley, CA: Adobe Press, 2005.

FINE ART PHOTOGRAPHY BOOKS

Baldwin, Gordon. *Looking at Photographs: A Guide to Technical Terms.* Los Angeles: J. Paul Getty Museum; London: The British Museum Press, 1991.

Bright, Susan. *Art Photography Now.* New York: Aperture, 2005.

Cotton, Charlotte. *The Photograph as Contemporary Art.* London: Thames & Hudson, 2004.

Fels, Thomas Weston. *Sotheby's Guide to Photographs.* New York: Henry Holt, 1998.

James, Christopher. *The Book of Alternative Photographic Processes*, 1st edition. New York: Thomson Delmar Learning, 2001.

Meyerowitz, Joel, and Colin Westerbeck. *Bystander: A History of Street Photography.* New York: Bulfinch Press, 2001.

Museée de l'Elysée, Lausanne (curated by). *reGeneration: 50 Photographers of Tomorrow.* New York: Aperture, 2006.

Newhall, Beaumont. *History of Photography: From 1839 to the Present.* New York: Bulfinch Press, 1982.

Rexer, Lyle Rex. *Photography's Antiquarian Avant-Garde: The New Wave in Old Processes.* New York: Harry N Abrams, 2002.

Szarkowski, John. *Looking at Photographs: 100 Pictures from the Collection of the Museum of Modern Art.* New York, New York: Bulfinch Press, 1999.

Szarkowski, John. *The Photographer's Eye.* Boston, MA: Little Brown, 1980.

Witkin, Lee D., and Barbara London. *Photograph Collector's Guide.* Boston, MA: Little Brown, 1981.

MAGAZINES

American Photographer *www.americanphotomag.com*
Aperture *www.aperture.org*
Communication Arts *www.commarts.com*
Outdoor Photographer *www.outdoorphotographer.com*
PC Photo Digital *www.pcphotomag.com*
PDN (Photo District News) *www.pdnonline.com*
Photoshop User *www.photoshopuser.com*
Popular Photographer *www.popphoto.com*

FINE ART PHOTOGRAPHY JOURNALS

The Photo Review, Stephen Purloff, editor, *www.photoreview.org*

Art in America, August Issue. Annual Guide to Museums, Galleries and Artists. New York: Brandt Art Publications.

AIPAD Show Catalogue, The Association of International Photography Art Dealers (AIPAD) *www.aipad.com*

Appendix F

PHOTOGRAPHY MUSEUMS

American Museum of Photography
www.photography-museum.com

**Center for Creative Photography
(CCP) University of Arizona**
*http://dizzy.library.arizona.edu/
branches/ccp/ccphome.html*

George Eastman House
www.eastmanhouse.org

**ICP International Center of
Photography**
www.icp.org

**University of California
Riverside/California Museum
of Photography**
www.cmp.ucr.edu

Appendix G

MANUFACTURERS

Adobe Systems (software)
www.adobesystems.com

Apple Computer, Inc. *www.apple.com*

Bogen Imaging (photo equipment, tripods, lighting) *www.bogenimaging.com*

Canon USA (cameras, lenses, accessories) *www.usa.canon.com*

Delkin Devices (storage media) *www.delkin.com*

Eastman Kodak Company (digital cameras, film) *www.kodak.com*

Epson America (printers, inks, cameras) *www.epson.com*

Fuji Photo Film USA (cameras, printers, film) *www.fujifilm.com*

Hewlett-Packard Development Co (digital cameras, printers, computers) *www.hp.com*

Leica Camera AG (cameras) *www.leica-camera.com*

Lexar Media (storage media) *www.lexarmedia.com*

LumiQuest (flash accessories) *www.lumiquest.com*

Nikon USA (cameras, lenses, accessories) *www.nikonusa.com*

Sony Electronics (cameras, storage media) *www.sonystyle.com/digitalimaging*

Index

abilities, 12
Adelman, Bob, 46
Advertising Photographers of
 America (APA), 20, 31
advertising photography, 35–36, 43
agency
 finding, 116
 marketing with, 117–119
 representation from, 115
 stock, 149–151
American Institute of Architects
 (AIA), 54
American Society of Media
 Photographers (ASMP), 20,
 31, 53, 55, 91
The American Society of Picture
 Professionals (ASPP), 20, 163
Amiel, Karen, 90, 95, 101, 163
animal photography, 7, 173
art collector, impetus of, 151
artistic vision, 14, 105
assessment, 12–13
assignment photography
 approach to, 56–57
 career of, 4
 converting to, 99
 job training for, 197
 passion becoming, 55
 stock and publication v., 8–9

baby photography, 76–77, 173
business experience
 building, 207–208, 223, 226
 importance of, 179
 of photography student/
 educator, 186
 savvy, 119–120, 213

business forms, 244–245
business world
 client appreciation within,
 24–25, 44
 consumer photography in,
 60–62, 219–221
 digital photography opportunities
 in, 130–131
 handling, 179, 205–206
 photographers in, 210
 research as training in, 18
buyer
 career as photo, 23, 143–146
 client relating to, 25, 30
 communication/relationship with
 photographer, 26
 contact, 26, 234–235
 explaining what's needed, 27
 photo examples of, 143–146
 prop, 172
 technical necessity of, 25

careers
 blending, 11
 digital artist, 134
 overlapping of, 7–8
 specialties of, 6–8
 starting, 191
 without camera, 10, 23, 143–146
catalog photography, 41
Cavanaugh, Jim, 54
celebrity photography 74, 75
 ethics in, 58
 high end shoots in, 57
 model releases for, 243
 paparazzi in, 58
 working in, 57, 74–75

chain of custody, 87
Chicago Architecture Foundation
 (CAF), 54
choices. See also assessment
 educational, 193
 flexibility in, 12
 freelance, 15–16
 of goals, 13–14
 joining organizations, 18
 life style, 15
 on staff, 16–17
client
 appreciation, 24–25, 44
 buyer relating to, 25, 30
 communication, 44–45
 digital photography
 view of, 129
 education, 44, 217–219
 skill level of, 129
collage photography. See university
 photography
color, 47–48
commercial photography
 career in, 11
 crew in, 171
 future of, 236
 v. personal photography, 45
commissioned photography. See
 assignment photography
communication, 26
consumer photography
 beginner pitfalls of, 222
 business aspects of, 60–62,
 219–221
 career of, 5, 7–8
 challenges in, 59–60
 establishing rapport in, 216

consumer photography (*continued*)
 marketing, 67, 237
 specialty v. generalist, 7
 word of mouth in, 68
contract job. *See* freelance
 photographer
copyright
 buyouts under, 218
 event photographer controlling, 5
 overview of, 238–245
 portrait photographer
 controlling, 5
 power of organizations over, 18
 work for hire in, 218, 240
costs, fixed v. variable, 212
creative manager
 becoming, 236
 career of, 147–149
 role of, 157–160
criticism, 14–15, 196
crowdsourcing, 123
curator
 building collection as, 163–166
 career as, 154
customer concern, 24–25, 181–182

darkroom, wet v. dry, 195–196
degree-granting institutions,
 248–251
Delaney, Chuck, 131, 184, 185
DeMaria, Catherine, 171, 175
digital photography, 43, 47–48
 artist in, 131–134, 174
 assist management of, 113
 assistant, 170
 career in, 10
 chain of custody in, 87
 clients view on, 129
 copyright of, 239–241
 creative manager in, 159–160
 darkrooms, 195–196
 evolution of, 48
 expense of, 51, 127
 v. film, 70, 86, 128, 159–160,
 187–188
 future of, 58, 127, 134
 manipulation in, 86,
 135–136, 156
 overview of, 9–10
 photo production specialist
 in, 135
 in photography schools, 128–129
 printing of, 136
 retoucher, 174
 small business opportunities
 in, 130–131
 software in, 131–132
 stock in, 108
 weddings, 62, 69–70
 workflow in, 130
direct Marketing Association, 68
distance learning. *See* online
 education

editorial photography
 books in, 38–39
 documentary in, 38
 ethics of, 40
 event photography v., 73–74
 fee structure of, 40
 future of, 189
 photojournalism in, 38
 travel photography in, 39–40
education
 choices in, 193
 client, 44, 217–219, 219
 flexibility of, 192–193
 importance of teaching, 198
 online, 192
 for picture professionals, 197
 traditional, 192
 university programs,
 193–195, 233
 workshops, 196–197
equipment, 17
ethics
 of celebrity photography, 58
 of editorial photography, 40
 in photojournalism, 156
 of a professional, 29
event photography 5, 64
 career in, 59
 celebrity involvement in, 74–75
 corporate motivation events in, 66
 editorial photography v., 73–74
 growth in, 75
 self-motivation in, 66
expenses, of digital photography,
 9, 51, 127

fee structure
 assigning, 179–180
 in consumer photography, 220
 in editorial photography, 40
 negotiation of, 214–215
 of publication photography,
 219–220
 starting out, 222
 in stock photography, 123
Ferrari, Maria, 130
film photography
 v. digital, 70, 86, 128, 159–160,
 187–188
 obsoleteness of, 128, 209
 as stock, 109
finding work
 assisting and interning, 202–203
 as photo editor, 157
 as photo researcher, 162–163
 as producer, 177–178
fine art photographer(s)
 becoming, 93, 105–106
 list of, 95–97
 vision of, 101
fine art photography
 attitudes towards, 102
 blurring lines of, 92

career in, 6–8
collectors of, 6
courage necessary for, 105
crossover potential in, 92
developing style in, 90–91,
 98–99
fabricated, 103
marketing, 94
purity of, 100
realistic expectations of, 97–98
specialty v. generalist, 7
underpinnings of, 103–104
fine art students, 101
forensic photography
 basic approach to, 80–81
 definition of, 84
 digital manipulation in, 86
 film v. digital, 70
 as service photography, 79–81
 training for, 85
freelance photographer, 19
 copyright protection for, 240
 marketing as, 234
freelance photography
 copyright in, 240
 starting in, 204–205
 working, 15–17
Freeman, Melanie Stetson, 48
Frey, Victor, 180
friendship, 30

gallery
 how to approach, 93–94, 105
 owning, 151
 representation in, 100
goals, 13–14, 137
Gould, Ron, 57

historical photo archivist, 154

imaging, 134
improvisation, 178
interdependence, 11
International Association of
 Professional Event
 Photographers/The Society
 of Sports and Event
 Photographers, 73
internet
 changes from, 126
 educational advances on, 201
 impact on marketing consumer
 photography, 67
 names on, 230–231
 as primary marketing tool, 237
 website design, 120, 230–231
internships
 finding, 202–203
 photographers assistant, 168–169
 in photojournalism, 52
intimidation, 28–29

Jupiter Media, 110, 112, 122

Keita, Seydou, 92
Kieffer, John, 119, 170
Kothari, Sanjay, 93, 131–134

LaFond, Jennifer, 157
Leet, Carl, 82, 88
life style, 15, 35
location scout, 172
Lyle, Maria, 206, 207

Mack-Johnson, Tracy, 208
Maisel, Jay, 46
manufacturers
 list, 258
 representative, 174–175
Marcus, Andy, 61, 68
marketing
 with agency, 117–119
 consumer photography, 67, 237
 fine art photography, 94
 selectivity, 208
 in stock photography, 110, 120
 strategic planning of, 232–237
 tools, 224–229
 web, 120, 230–231
markets, 34, 122
McCartney, Susan, 39
McIntyre, Chrissy, 160
medical and scientific
 photography, 83
Meyerowitz, Joel, 92
model releases
 for celebrity photography, 243
 example of, 245–246
 value consideration for, 245
 when to obtain, 242–243
museum photography, 6, 83, 257
mutuality, 30

National Press Photographers
 Association (NPPA), 20,
 52–53
nature photography, 7, 119–121
negotiation
 as creative manager, 158–159
 final steps in, 221–222
 inexperienced, 218–219
 strategies of, 213–216
North American Nature
 Photography Association
 (NANPA), 20

online education
 advantages of, 199
 difficulties inherent in, 200–201
 direction of, 200
 v. distance learning, 194
 printing and, 194–195
 student body make up, 199
organizations. See also power, of
 organizations
 approaching, 203
 choices in joining, 18, 197–198

involvement in, 24
list of, 252–253
overhead, 211–212
ownership, 17
Oyanagi, Jessica, 135, 135

"pack" journalism, 50
personal photography, 45, 235
Peterson, Bryan, 184, 200
philosophy
 approach to photography, 49, 132
 enjoy what you do, 211
 on personal success, 188
 of pricing, 71
photo buyer, career as, 23, 143–146
Photo District News (PDN), 35, 185
photo editor
 advice for, 155–157, 189
 background of, 188–189
 career as, 137
 joy of, 189
 role of, 155
photo manipulation, 86, 136
photo production specialist, 135, 137
photo researcher, 160–163
photo seller, 147, 174
photo writing
 determination of, 188–189
 in portfolio, 228–229
 types of, 185
photographer(s)
 assistant, 10
 building confidence, 236–237
 buyer and seller, 23
 buyer contact, 26, 234–237
 career start as, 178, 180
 choosing assistants, 204
 contribution from retail to, 182
 doing best, 29, 43–44
 editor, 10
 finding work, 208–209
 future for, 236
 getting along with, 30
 getting exposure as, 105
 goal of, 13
 job pressure of, 50, 207
 job titles held as, 208–209
 making contact with, 203, 204
 making difference as, 49
 nature of, 196
 needs of, 27
 overcoming difficulty as, 207
 passion of, 55, 206–207
 persistence of, 209
 picture professionals v., 3
 preparation as, 205
 romantic notions of, 34
 running business, 210
 as seller, 147
 sports, 7
 street, 46
photographers assistant
 definition of, 10, 167–168

digital, 170
finding work as, 169–170,
 202–203
moving to full time from, 180
value as, 178
working as, 176–177
photography
 artistic process of, 133
 business savvy, 119–120
 digital future of, 58
 economics of, 210–211
 finding work in, 202
 historical perspective on, 22
 museums of, 6, 83, 257
 outlook on, 209
 personal success in, 189
 philosophical approach to,
 49, 132
 real-estate, 78–79
 schools, 248–251
 starting out, 222
 uses and users of, 140–142
 writing about, 184
photography educator
 becoming, 183–184, 186–187
 film v. digital as, 187–188
 online v. distance learning
 as, 194
 rewards of, 186–187
 student body make up, 186
photography publications, 255–256
photojournalism
 in editorial photography, 38
 ethics in, 156
 internships in, 52
 miscellaneous, 51
Pickerell, Jim, 112, 121
Picture Archive Council of America
 (PACA), 20, 122
picture professional, 14, 16, 139
 career as, 10, 140
 education for, 197
 goal, 13–14
 photographers v., 3
Piscopo, Maria, 148, 228, 232
portfolio 229
 building, 235–236
 marketing, 228
 personal photography in, 235
portrait photography
 competition in, 64–65, 69
 copyright control of, 5
power, of organizations
 advocacy, 20
 choice in, 18
 networking, 20
 over copyright, 18
PR photography, 41
pricing, 71, 222
producer
 characteristics of, 175–176
 education necessary as, 177
 experience becoming, 176–177

producer (*continued*)
finding work as, 177–178
job of, 170–171
role of, 171, 175
of stock photography, 109, 126
Professional Photographers of
America, Inc. (PPA), 20, 31,
62, 206
professionalism, 178
project job. *See* freelance
photography
promotion/source books, 254
prop buyer, 172
property release, 247
public relations. *See* PR
publication photography
assignment v., 8–9
career in, 5–6, 8
client educating in, 217–219
commissioned photography v.,
8–9
deal closing in, 220–221
fee structure of, 219–220
gathering information in, 217
markets in, 34
miscellaneous specialties, 42
in museums, 6
price quoting in, 219–220
specialty v. generalist, 6

relationships
adversarial, 28
balance, 28
building, 181–182
buyer/client, 25
buyer/photographer, 26
representative. *See* creative manager
research
business training as, 18
marketing tools, 232
photography skills, 18
in stock photography, 109
retail photography, 182
retail sales, 11, 180–181
rights managed, 111, 124
risk, 9
Ritchin, Fred, 40
Roshan, Jim, 66, 73
Roth, Harold, 42
royalty free, 111, 122

Schneider, Joseph, 76
The Scientific Group on Imaging
Technology (SWIGIT), 86
Seide, David, 37, 53, *53*

service photography
career in, 5–8
definition of, 78
forensic photography as, 79–81
government photography as, 83
medical and scientific photo-
graphy as, 82
museum photography as, 83
real-estate photography as,
78–79
specialty v. generalist, 7
university photography as, 81–82
set builder, 173
Slayton, Joe, 76
Smith, Eugene W., 91

The Society of Photographers and
Artists Representatives
(SPAR), 149
Society of Sports and Event
Photographers, 66, 75
staff photographer, 19
challenges of, 89
going for, 205
marketing as, 234
role of, 88
university, 82, 89
wedding photography for, 72
working as, 16–17
stock agency, 149–151
stock photography
abundance of, 124–125
agent, 149
assignment v., 8–9
boutiques of, 111
careers in, 4, 108
change in, 126
concepts in, 114
copyright of, 238
definition of, 107
digital, 108
digital-assist management
of, 113
diversity in, 114–115
expense of, 9
fee structure in, 123
film images as, 109
getting paid in, 116
history of style in, 113–114
in-depth coverage in, 115
licensing rights in, 107
long term planning in, 117
market balance in, 122
marketing in, 110, 120
new economics of, 113

obtaining model releases in,
242–243
opportunities of, 9
origins of, 108
overview of, 8–9
pricing, 222
production of, 109, 126
research in, 109
setting your style in, 114
ubiquity in, 125
web portals dedicated to, 112, 124
street photographers, 46
studio, 54
style
building, 177–178
developing, 98–99
evolution of, 45
in fine art photography, 90–91
history of, 113–114
self-taught, 187
using your, 57
stylist, 173

teacher. *See* photography educator
Tenneson, Joyce, 90, 92, 93,
97, *98*, 100
trends, 21

university photography
programs, 193, 233
role of, 88
staff photography for, 82, 89

viewer, 4

Walker, David, 188
Walsh, Charlie, 79, 84
wardrobe buyer. *See* prop buyer
Webb, Drew, 79–81
wedding photography
bride handling in, 63
consumer, 60
digital changes in, 62, 69–70
dress code in, 63, 71
exceeding expectations in, 61
family portrait v. candid, 69
film v. digital in, 70
psychology of, 61, 63
staff necessary for, 72
Wignall, Jeff, 184, 198
Wilkes, Stephen, 43, 46, 92
Willard, Sam, 170, 178
work for hire, 218, 240
workshops, 251
writing, 118, 228–229

Books from Allworth Press

Allworth Press is an imprint of Allworth Communications, Inc. Selected titles are listed below.

How to Grow as a Photographer
by Tony Luna (paperback, 6 × 9, 224 pages, $19.95)

Starting Your Career as a Freelance Photographer
by Tad Crawford (paperback, 6 × 9, 256 pages, $19.95)

Publishing Photography: Marketing Images, Making Money
by Richard Weisgrau (paperback, 6 × 9, 240 pages, $19.95)

The Real Business of Photography
by Richard Weisgrau (paperback, 6 × 9, 224 pages, $19.95)

Photo Styling: How to Build Your Career and Succeed
by Susan Linnet Cox (paperback, 6 × 9, 288 pages, $21.95)

The Business of Studio Photography, Revised Edition
by Edward R. Lilley (paperback, $6\frac{3}{4} \times 9\frac{7}{8}$, 336 pages, $21.95)

The Photographer's Assistant, Revised Edition
by John Kieffer (paperback, $6\frac{3}{4} \times 9\frac{7}{8}$, 256 pages, $19.95)

Profitable Photography in the Digital Age: Strategies for Success
by Dan Heller (paperback, 6 × 9, 240 pages, $24.95)

Licensing Photography
by Richard Weisgrau and Victor S. Perlman (paperback, 6 x 9, 208 pages, $19.95)

Photographing Children and Babies: How to Take Great Pictures
by Michal Heron (paperback, $6\frac{1}{2} \times 10$, 192 pages, $19.95)

Creative Canine Photography
by Larry Allan (paperback, $8\frac{1}{2} \times 10$, 144 pages, $24.95)

How to Shoot Great Travel Photos
by Susan McCartney (paperback, $8\frac{1}{2} \times 10$, 160 pages, $24.95)

Please write to request our free catalog. To order by credit card, call 1-800-491-2808 or send a check or money order to Allworth Press, 10 East 23rd Street, Suite 510, New York, NY 10010. Include $6 for shipping and handling for the first book ordered and $1 for each additional book. Ten dollars plus $1 for each additional book if ordering from Canada. New York State residents must add sales tax.

To see our complete catalog on the World Wide Web, or to order online, you can find us at **www.allworth.com**.